TIME IN A FRAME

TIME IN A FRAME

Photography and the Nineteenth-Century Mind

Alan Thomas

SCHOCKEN BOOKS · NEW YORK

First published by SCHOCKEN BOOKS 1977

Copyright © 1977 Alan Thomas

Library of Congress Cataloging in Publication Data

Thomas, Alan.
 Time in a frame.

 Bibliography: p.
 Includes index.
 1. Photography—History. 2. Nineteenth century
I. Title.
TR15.T48 770'.9'034 77-75294

Manufactured in Great Britain

CONTENTS

ACKNOWLEDGEMENTS

Photographs courtesy of:

Science Museum, London: pages 7, 18, 26, 27

Notman Collection, McGill University: pages 8, 76, 77, 79, 95.

The Victoria and Albert Museum, London: pages 9, 16, 17, 23, 24, 25, 32, 33, 44, 45, 47, 49, 50, 51, 52, 53, 54, 55, 56, 66, 67, 69, 73 (right), 81, 83, 85, 86, 88, 90, 91, 92, 100, 102, 103, 105, 106, 107, 110, 111, 112, 142, 147, 148, 149, 152, 153.

International Museum of Photography, Rochester, New York: pages 10, 11, 14, 15, 31, 34, 35, 39, 40–41, 59, 60, 62, 63, 70, 74, 87, 139.

Duncan Galleries, Northfield, Illinois: page 12.

British Library, London: pages 20, 37, 97.

Public Library of Canada: pages 21, 75, 120.

Beinecke Library, Yale University: page 28.

Colorado State Historical Society: pages 29, 36, 118.

Oxford City Library: page 68.

Cadbury Collection: pages 72, 157.

Local Studies Department, Birmingham University: pages 140, 141.

Sir Benjamin Stone Collection, Birmingham Public Libraries: pages 159, 161.

Newton Collection, Leicestershire Museums: pages 78, 156.

Museum of English Rural Life, University of Reading: pages 93, 162.

Royal Photographic Society, London: pages 94, 96, 146.

University of Toronto Library: pages 101, 108, 113, 114, 115.

Francis Frith Collection, London: pages 119, 122, 123, 124, 125, 126, 127, 128, 129, 130, 131, 132, 133, 134.

Museum of the City of New York: pages 135, 138, 151.

Guildhall Library, City of London: pages 137, 154.

Dr Barnado's, Ilford: pages 143, 144, 145.

Master and Fellows, Trinity College, Cambridge: page 158.

Hereford City Library: page 160.

All the other photographs are from the author's collection.

1 THE EXPANDING GAZE

Photography is the common possession of ourselves and the men and women of the nineteenth century—a Victorian invention in the full meaning of a phrase which often, and justly, connotes the ingenious application of science to the uses of the daily world. The essential simplicity of the concept was well expressed in an early cognomen, 'Sun Pictures', which gave way about mid-century to the neat, one-word form devised by Sir John Herschel from a combination of the Greek *photos*—light—and *graphos*—drawing.

For much of the following half-century this simplicity of word and idea was belied by the complicated procedures necessary for sensitis-ing and exposing a surface to light and subsequently bringing out, or developing, the light-drawn images that had formed. The acids and other chemical agents used in these processes required care in handling and a range of special equipment: the fumes from warmed mercury, which developed the images on daguerreotype plates, were downright dangerous to health, and the vapours from ether and alcohol solutions were a hazard of the dark-room during the later era of the wet-plate. The camera also, the essential instrument, was, while simple in its function, an awkward combination of bulk and delicacy requiring a tripod for its operation and a box for storage.

Henry Fox-Talbot's studio in the 1840s: an awkward combination of bulk and delicacy. Note the head-clamp behind the sitter's head.

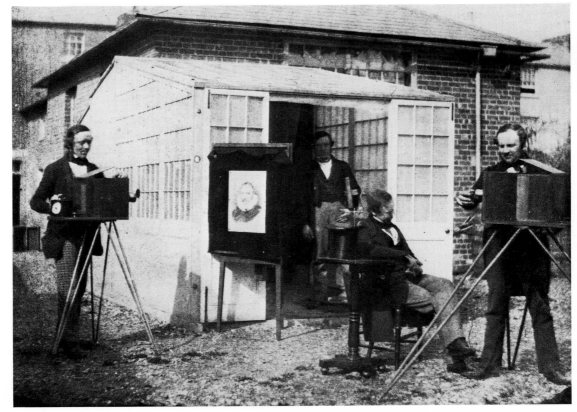

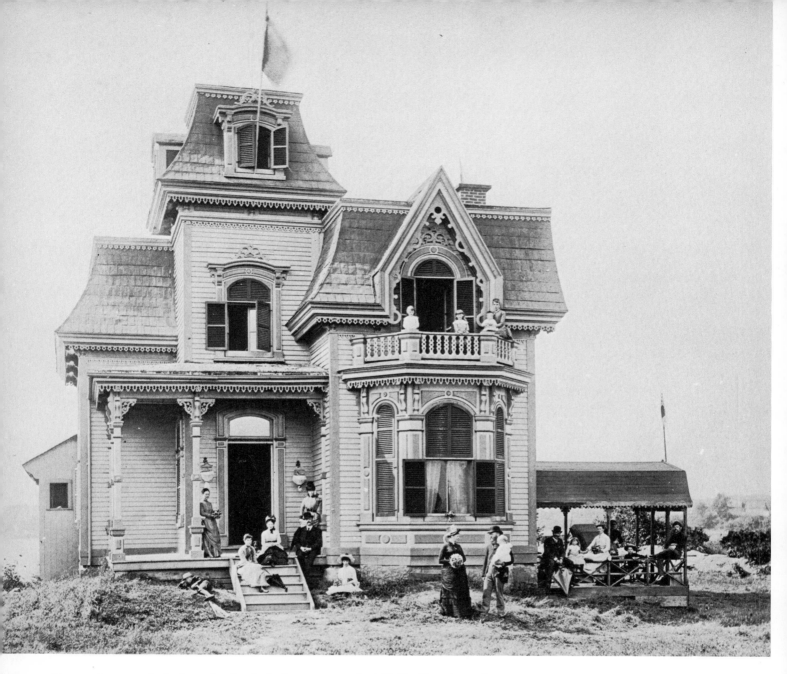

From these technical and physical factors, which imposed a discipline of procedure, stem the deliberate rituals of much nineteenth-century photography. The problem of movement was of crucial importance to the establishment, in portrait-making in particular, of the pace and tone of a solemn ceremony. This solemnity was often reinforced by the stiff postures and wooden expressions which arise from the self-consciousness of people aware that they may be exposing themselves to the gaze of their next-door neighbour. The men and women of that century did not, generally speaking, take appearances lightly: we have Baudelaire's judgement, indeed, that photography, that upstart art form, was the natural

and pitifully liberal medium of expression for a self-congratulatory, materialist bourgeois class.[1] For many reasons the Victorian photographer appears as a representative figure, to be associated with that period and no other: typically discovered sunk down on one knee on drawing-room carpet, head concealed beneath black cloth as he consults the viewing-glass, hand upflung in an appeal for stillness—fixing the image, as it were, with his gesture—the photographer expresses both the scientific capacity of the age and the restricted rigidities of its vision.

To take its technical capacity first: the ability to register with mechanical exactitude and reliability the detailed appearance of things was

The importance of appearances: a Quebec household presents itself to William Notman's camera c. 1880.

Opposite
Caesar, the last slave owned in New York in a daguerreotype by an unknown photographer c. 1850.

8

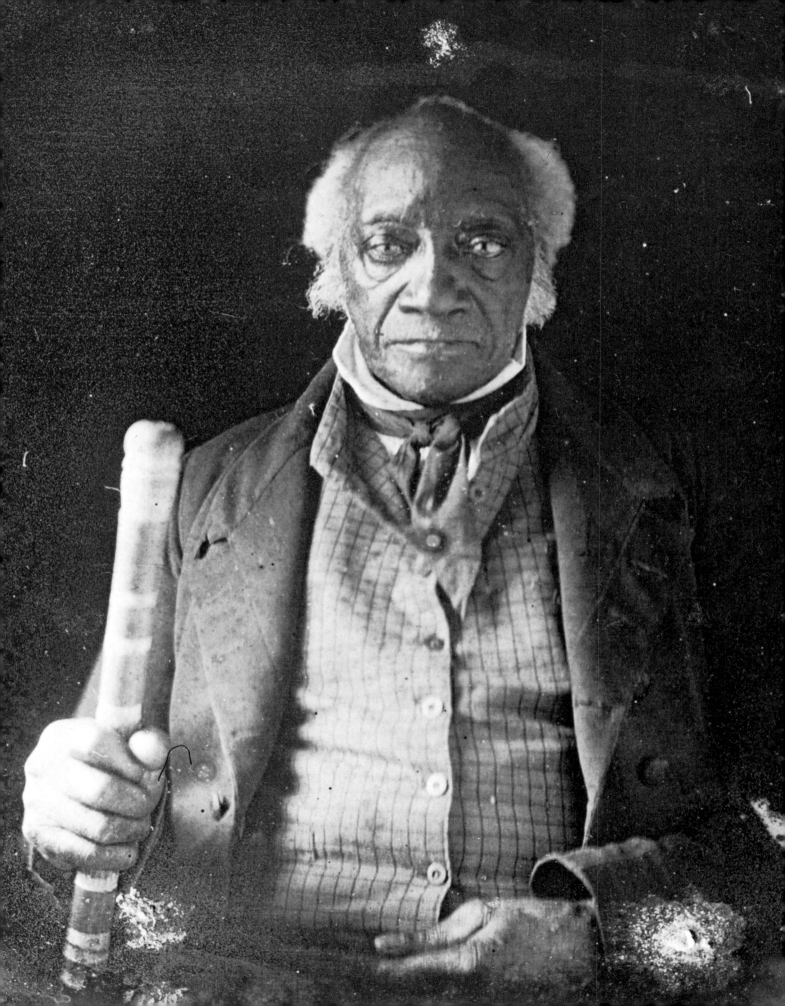

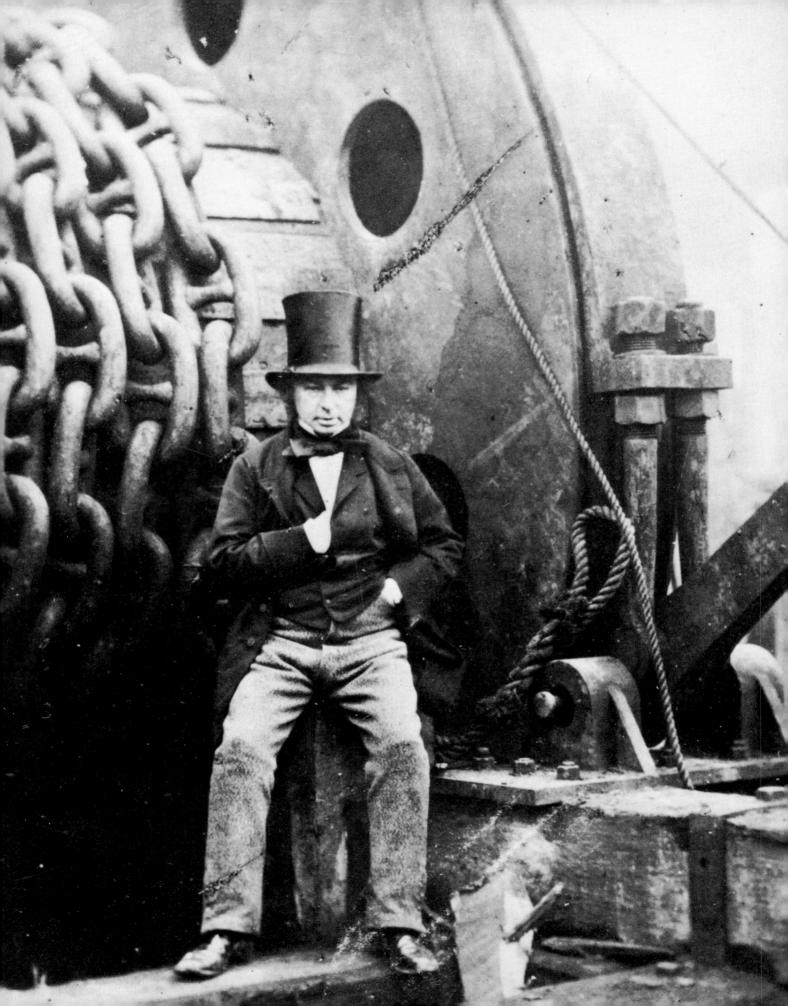

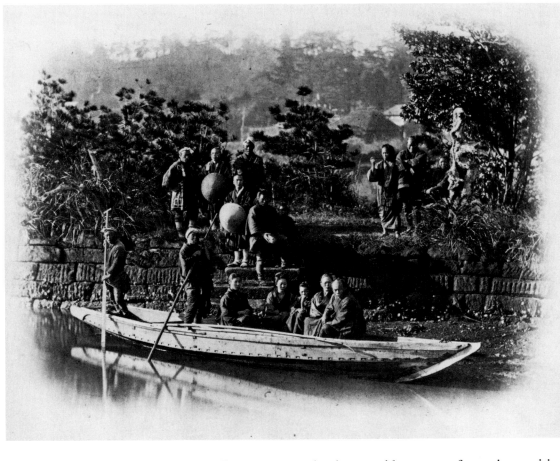

The variety of nations under the common gaze of the camera. A Japanese village scene by Felice Beato *c*. 1860.

Opposite
Technology triumphant, personified by Isambard Brunel, photographed against the chains of the *Great Eastern* steamship.

an astonishing addition to a Western European culture already rich in new technologies. The impact of photography was the greater by reason of the absoluteness of its command. Only with great difficulty and through many trials was a workable photographic process realised—once achieved, its products could be fully photographic. Daguerreotypes register the world of the 1840s with a clarity equal to that of photographs from the best modern equipment. In a sense, because of the absolute quality of its power, photography can be seen as having no primitive period. An awareness of the remarkable fullness of the power born into his hands is plainly evident in the exclamations of delight with which the early photographer noted in his diary his ability to record with the camera every line and crack of the brickwork in his neighbour's chimney. From trivial beginnings the uses of photography expanded. Even in the earliest decade, the era of the daguerreotype, it rapidly demonstrated its capacities, from the undemanding still-life to portraiture, landscapes (including foreign views), and the recording of public events. This expansionary movement shifted to simple enlargement of the industry, as it was becoming, with the in-

troduction at mid-century of negative-positive processes which could produce, from a single glass-plate negative, a flow of prints for the market. The great volume of photographs made at this time, and for the remainder of the century, issued from the studios which were multiplying in numbers throughout the civilised world. Every little town could have its own photographer.[2]

While photography established itself as a trade the impetus towards technical improvement was sustained by the onrush of belief in science. The series of world expositions, which were a phenomenon of the second half of the century, illustrate the power of this wave of technical self-congratulation. From the first, the Great Exhibition of 1851 in London, these expositions encouraged photography by establishing display *salons*, and, with wider effect, by advancing the universalist idea to Western peoples of a new global perspective: the world under one roof. The camera, the youngest child of science and technology, was the inevitable instrument for achieving this perspective by bringing the variety of the nations under a common gaze. As a harbinger of progress it was taken up by those scientifically minded gentry

in England who as a class had provided a base of support for study in the natural sciences a few generations earlier with their specimen collecting. Photography in the 1850s was 'par excellence, *the* scientific amusement of the higher classes', according to one of the newly founded photographic journals of the decade.[3] As a symbol of Western technology and an instrument of its expanding world vision, the camera accompanied expeditions which carried the Western presence into remote or unexplored territories. Only a decade after Daguerre announced his process—and the French government, in a grand gesture, gave it free to the world—the daguerreotype camera was being carried on overland expeditions through the great plains of the American West, a still unsettled region of nomadic hunters.[4] And this was by no means its earliest journey into danger: there is one daguerreotype in existence showing cavalrymen of the Mexican War of 1846 ready for action. Daguerreotypists also travelled into the Near East, where banditry was common, to record the Christian holy places.[5]

The continuing fact of technical difficulty must be placed against this background of a broadening, deepening usage. Absoluteness of command could only be achieved within limits: though the camera could always be depended upon to register what was placed before it, the registering of a blur was the common result, for much of the century, if the subject moved. The photographer of the 1850s presents an ambiguous figure—an emblem both of power and of its limitations—because in that decade virtually all of the possibilities of the camera known today were glimpsed, though only partly realised. Even the next technical step, cinematography, though remote from achievement, was in train of development. Take this question of the fixing of a moving image by a still camera—a capacity which appears to distinguish the photography of the nineteenth century from that of the twentieth. Its accomplishment depends upon a reduction in exposure time, and

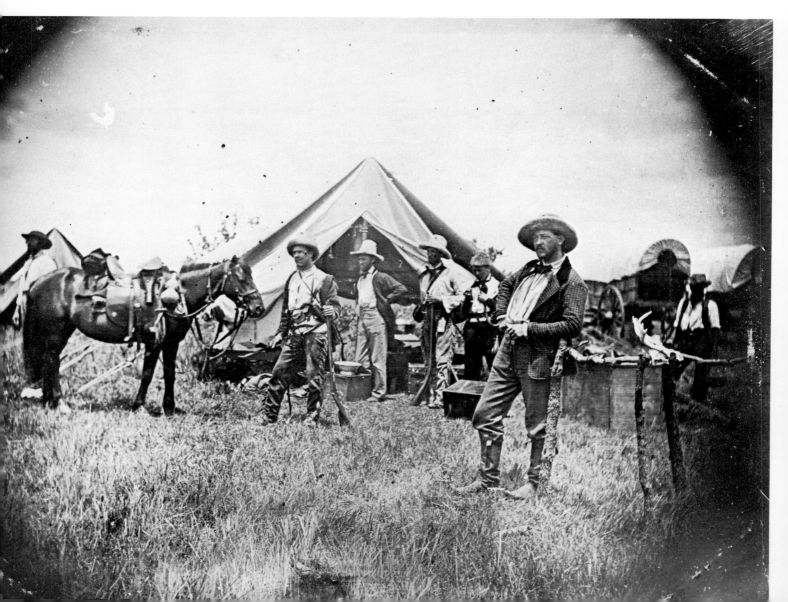

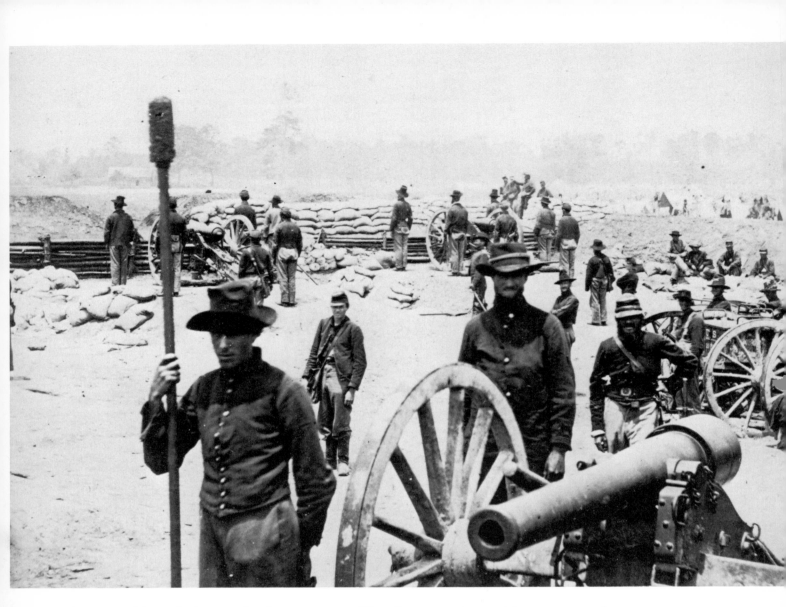

progress on this particular question began very early. The first still-lifes exhibited by Louis Daguerre in 1839 required 15 to 30 minutes of exposure; in little more than a year this period had been reduced to about 1 minute through the work of a British chemist, Goddard, who made the daguerreotype coating more sensitive to light. Portraiture was possible with the help of chair-mounted neck clamps and other studio furnishings of diabolical aspect. But painfully long exposures were the rule throughout the decade under any light but the bright sun. Plate sizes were also a factor, large plates requiring long focal lenses needed several times the exposure time of small sizes—we read, for instance, of a parade of troops and a top-hatted party of dignitaries at the opening of a new railway in Belgium being held still, under the daguerreotypist's command, for seven minutes as the ceremony was recorded.

The first negative-positive process, the calotype patented by Henry Fox-Talbot in 1841, did not immediately improve the situation, for the chemically treated paper which formed the negative—Fox-Talbot used a good drawing-paper—required exposures of from one to four minutes. But this revolutionary innovation of a double process led to Scott Archer's successful introduction, in 1851, of a glass negative plate, coated with silver salts in collodion. This wet-plate process—so-called because it was necessary to expose and develop the plate while freshly coated—was the single great factor in the spread of photography in the nineteenth century. With it, the minimum exposure time was reduced dramatically to as short a time as five seconds out of doors; indoors, the large-plate portrait required about a minute. Nevertheless, from its introduction, photography breathed a more natural air. The

The threat of war dramatically implied in a photograph of Union artillery by Mathew Brady *c.* 1862.

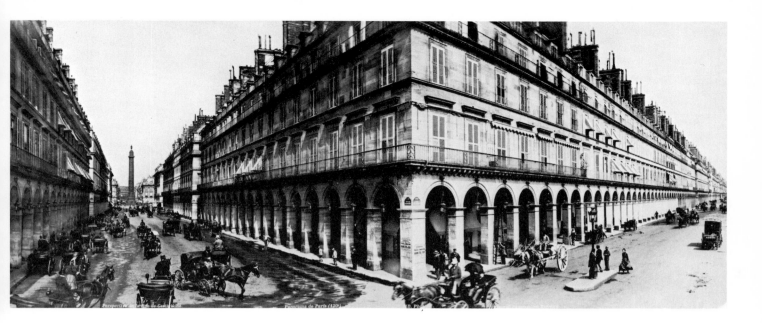

A striking combination of arrested action and depth is displayed in a panorama of the Rue Castiglione in fashionable nineteenth-century Paris.

chin-on-hand, shoulder-against-pillar poses which had steadied the subjects of daguerreotypes could be relaxed. Yet action could not yet be recorded. The effective representation of war by the Mathew Brady team was limited to mood pieces: the guard standing to arms amidst morning mists, or the battlefield, corpse-littered after the guns had fallen silent.

There were anomalies in the 1860s, however. The sitter in a portrait studio was obliged to hold still, perhaps for as long as half a minute, while the moving shapes of traffic and pedestrians outside could be successfully photographed without blur by a stereoscopic camera in, or rather, above, the street. This twin-lens, short-focal-length camera could freeze movement, provided it were not too fast or too close, on miniature plates. Some famous streets, Broadway, the Champs Elysée, and Princes Street, Edinburgh, were photographed full of people and traffic in the years 1859–60.[6] These scenes of arrested action were viewed with the effect of three-dimensional space in the stereoscope, an instrument of amusement extremely popular in middle-class parlours. Some stereoscopes were built to carry dozens of stereoscopic transparencies, and were rotated on a central pillar, the viewer taking his own time in working through a set of views. Rather different in principle, though also using rotation, was the zoetrope, a moving picture viewer, and a direct precursor of the modern motion picture: in this device a sequence of photographs of an action was rotated rapidly past narrow slits which framed the simulated movement of the scene.

These parlour toys of 1860 possessed large implications for the future of photography, but their uses were relatively trifling. Stereoscopy enjoyed a vogue for a decade or so, bringing the wonders of the world into the home in the manner of a glossy travel magazine. At the height of its success the London Stereoscopic Company offered for sale a stock of more than 100,000 slides of different views. But the fashion waned gradually, its influence and place in nineteenth-century society largely unregistered before its eclipse by the moving picture of the 1890s.

The capacity of the stereoscopic camera to freeze movement outdoors was largely passed over as a curiosity. In the early 1870s some photographic experiments in California showed how important this achievement could be. Eadward Muybridge's photographs of a famous trotting horse, made for the owner, shattered centuries of traditional representation of the horse in motion in painting. Muybridge used a battery of single-lens cameras, mounted two feet apart, and with their shutters opened by electrically charged wires broken by the moving horse. Muybridge's photographs were barely more than silhouettes, but they showed with absolute clarity twelve stages in the motion of a horse—and none resembled very closely the rocking-horse attitude depicted by traditional art. Inevitably they became the centre of stormy discussion among painters and photographers. A dozen years later Muybridge, with facilities provided by the University of Pennsylvania, carried out an exhaustive series of photographic studies of the human body in motion.[7] For this work, done from 1883 to

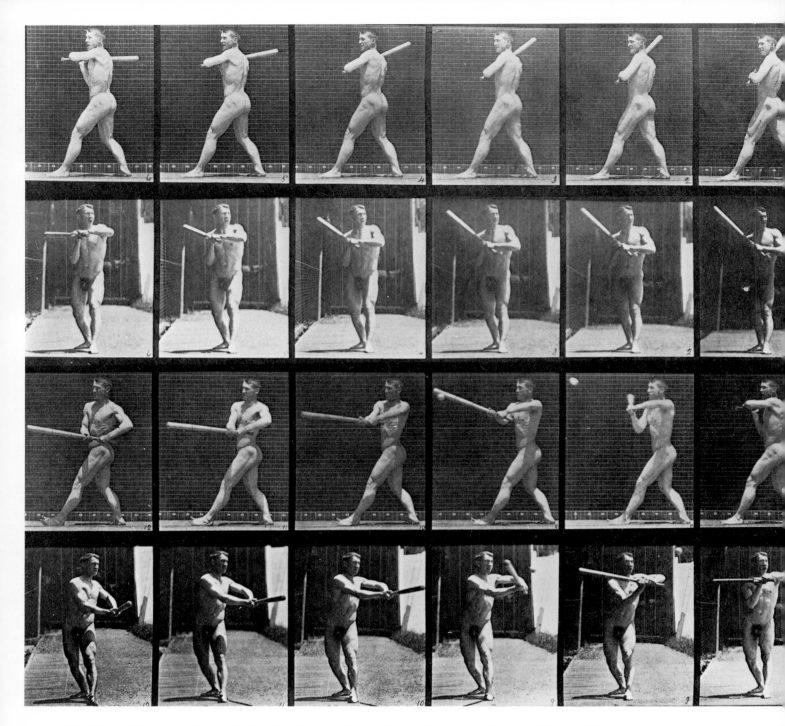

1885, Muybridge used the newly developed dry plates, which had brought about a revolution in photography equivalent to that caused by the innovation of the wet-plate process a quarter of a century earlier.

The exposure and developing of photographic plates while freshly coated, that is, wet, with a sensitive substance, had reduced exposure times, as we have seen, but attached photographers to their dark-rooms. The portable dark-tents and photographic wagons used by travelling photographers are a testament to human ingenuity and persistence. The problem of achieving sensitivity with portability remained obdurate for nearly 30 years, until a technique employing a gelatin emulsion was perfected in the late 1870s in Britain.[8] The cumbersome equipment of wet-plate photography could be dispensed with, and this new freedom consequently led to the production of light, hand-held cameras and prefabricated dry plates. Roll-film, a subsequent stage in this development, allowed for further simplification of both operation and processing. The Kodak

The human body in motion. Part of Eadward Muybridge's series taken at the University of Pennsylvania 1883–85.

system, perfected by George Eastman in 1889, removed all of the sensitising and development processes from the act of photography and placed in the hands of the public a simple box with a knob to be pushed. The nineteenth century, the age of spreading mass culture, had created a marvellously appropriate machine for recording its images *en masse*.[9] This revolution represented a distinct advance in technical command: Paul Martin, profiting from the new ease of movement, and using a box camera · named the Facile, went about London photographing scenes of ordinary street life. His exposure times were from one-quarter down to about one-tenth of a second: they effectively registered unblurred images at walking pace. At the end of the century the emblematic figure of the photographer, while still of conventional form in the studio, was about to disintegrate: the high ceremony of his ritual could be superseded by an action as casual as the striking of a match, and the hood of the viewing cloth could be doffed forever.

The technical history of the first 60 years of photography, briefly outlined here in only one of its aspects, reveals the limitations and also the capacities of the nineteenth-century camera. The photographs themselves reveal the uses made of these capacities. From the first days when the rooftops of Paris presented themselves to the eye of the daguerreotype camera there were choices to be understood and decisions to be made on grounds other than technical possibility. Photographs were created for many reasons—to please artistic taste, to suit a fashion in society, to respond to a public occasion, and so on. As the variety of uses multiplied through the century they became formalised and distinct—a fact which the structure of this book, in its chapter divisions, reflects. Distinctiveness of subject-matter and conventions of treatment characterise each form. In studio portraiture, for instance, standard poses and a standard, guiding social tone are plainly evident. In portraiture, too, the control of the photographer over the subject is

A cockney crowd at the sea-side by Paul Martin, 1892.

closest and firmest, and the range of intention stands most clearly defined, a signpost to the expected use of the photograph—a full-figure, middle-distance shot, standard gentlemanly pose for the market in celebrities; a group organised around father and mother for the family album; a head-and-shoulders close-up, with smile, to be sent in an actress's portfolio to a theatre manager.

Intention is not always a safe guide to the nature of a photograph; certainly it is not sufficient explanation alone for the history of photographic use in the nineteenth century. Two kinds of photographers, reflecting the double aspect of photography, made the earliest images: on the one hand there were chemists, optics engineers and all those who liked to dabble in science; on the other, former painters and art students. Yet it is by no means easy to distinguish the products of one intention—to record the visible world—from the products of the other—to create beautiful pictures. The refinement of specialisation, as the decades pass, does not clarify the matter: a photograph

of a botanical specimen, taken on a scientific expedition, may make a picture as true and as beautiful as the careful artifice of a portrait from a theatrical photographer's studio. The problem of the nature of photographic art bedevilled in particular the straight photographer-artist, for his direct technique could seem like no technique at all. Two of the better-known photographers of Victorian Britain—Roger Fenton in the 1850s and P. H. Emerson in the 1880s—retired apparently disheartened after years of labour at an art that refused to fructify.[10]

The problem caused no anguish to those who accepted photography as a trade. The tradesmen-photographers, a third interest group, dominated the field from the 1850s onwards; their mercantilist attitude had a great effect on the practice of photography. First, some photographic forms became defined by commercial labels, or were divided according to the market served. *Carte-de-visite* photography, for instance, describes the mass trade in celebrities which was a phenomenon of the

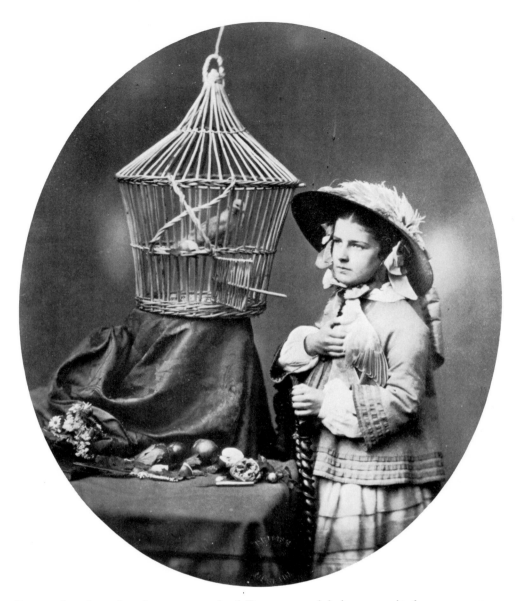

Innocence by Delamotte, 1855. A fine example of Victorian sentimental piety.

1860s; the term refers to the size of a cheap, marketable package. Views photography describes the making and sale of topographic photographs of wide popular appeal—not to be mistaken for artistic landscapes. The widespread commercial development of photography brought about a further and most important effect: it increased the volume of photographs made and created a huge traffic in the sale of photographs, which was of international scope. As trade, photography naturally reinforced formal divisions and created new ones, for commerce in images, as in anything else, requires standard categories of description. The range and movement of an international market, however, set up forces which tend to break down categories, or at least to allow photographs to be redefined—born again, as it were, on another continent. Distance increases allure:

standard European celebrity portraits become, on the frontier, glimpses or reminders of a fabulous, exotic land; prosaic records of life on the outposts of Western civilisation become charged, brought to the cities, with romance. Or, by contrast, photographs can be anti-romantic in their effect: some of Roger Fenton's photographs of British Army camp-life in the Crimea must have disappointed and disconcerted a public nurtured on the strong dramatics which characterise Victorian painting and illustration of such scenes. Under the cool gaze of the camera the Crimean mud looks very much like ordinary British mud, and the soldiers, officers and men alike, appear often not as glamorous, fierce warriors but as rough, slovenly figures, like railway labourers taking their ease.

The primitive power of photography, the

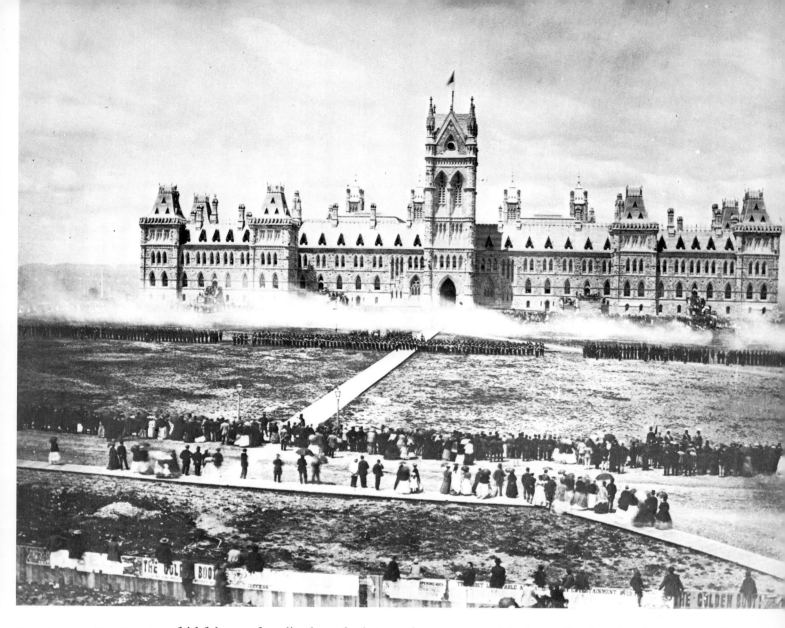

Early photo-journalism: Queen's Birthday Review at Ottawa, 1868—the 'Feu-de-Joie'.

faithfulness of replication of whatever is put before the camera, assists this disruption of context and erosion of categories. Trade exerts a pressure from without, dislocating the context of understanding and expectation in which the photograph was made, moving it physically up market and down and across cultural frontiers. Within, the spirit of photographic integrity lies ready—a deceptively docile steed—to toss the photographer who attempts to ride it too hard. This rebellious spirit is notably in evidence in pictorialist photography, that field of ambitious use which engaged the imaginations of talented men and women but which created few works of any importance and left no lasting tradition— unless advertising photography can be seen today as its unrecognised heir. Betraying the intent of the photographer, the hard eye of the camera reveals scenes of pictorial sentiment,

created in the studio, for what they are—crude representations, as thin as pasteboard, of love, pity, filial duty, innocence and other standard pieties of the Victorian cult of feeling.

The interchange of commerce exerted an exterior pressure on the pictorialist form, and on other forms. Destructive, or at least demoralising, where it brought the works of cheap mass production against those of careful artistry, as in the celebrity portrait trade, it could also be creative in stimulating new forms. Documentary photography, for instance, which had no real roots in graphic art, appears to have been nurtured by the market appeal which was gradually revealed for various kinds of photographic reporting. War early proved itself, in its unbeautiful aspects, as marketable; ethnographic studies made by government photographers went both to museum archives and to

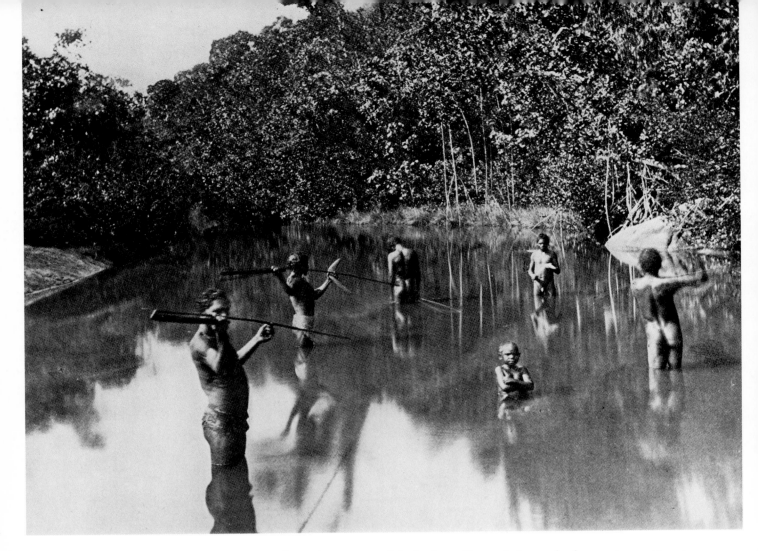

bookshops on fashionable boulevards, for the civilised West was curious about the remote and the primitive; closer to home, photographs of the poor, and of deplorable living conditions, though made for reports or institutional records, could attract the public eye and turn a coin or two. A documentary aesthetic, not originated by the marketplace but encouraged by it, became visible and worked its effects on other forms. One conventional assumption of documentary in particular—that photographs present actuality—must have borne hard upon studio pictorialism, remote as the two forms were, by shifting the whole range of expectation.

Such a shift has large implications. A distinguished photo-historian, C. H. Gibbs-Smith of the Victoria and Albert Museum, has written that photography furnished a new lining to the nineteenth-century mind. It is difficult to resist the truth of this suggestion as we look at the photographs of the period. These fixed, detailed images of the world possess a fascination arising from the fundamental artis-

tic power of imitation. Exerted in a single photograph, in a handful, or in the representative range of varieties presented in this book, that power makes itself felt. It is assisted by an historical fascination which comes from the ability to see back as far as the 1840s—to see the streets of London and Paris, the dress of the people and the details of furnishings depicted with an openness and exactitude no earlier period can match. It is delightful to see the nineteenth century with twentieth-century eyes, yet in this astonishing visual stretch lies a dislocation both to be appreciated and to be overcome. We cannot see these photographs exactly as they were seen in the nineteenth century: some, in the curiosity of their content, possess a heightened and ineradicable charm, while others, notably the views photographs, may quickly bore the modern viewer. Yet we must be sensitive to their first appearance and first uses: restoration of the context of the age reinvigorates these photographs, adds to their meaning, and allows a more accurate judgement of their impact in their time.

A photographic explorer captures human feeling and the detail of Aboriginal spear-fishing in Australia c. 1890. This picture is typical of a variety of ethnographic studies designed to stimulate the imperial imagination.

2 THE JOURNEYING EYE

The most important photographs of the nineteenth century are surely those first views of remote peoples and places brought back to the Western world by a pioneering generation of expeditionary photographers. Consider Felice Beato's wayside view of a porter with carrying panniers on a road passing through the countryside of Hokkaido. Taken in 1862 it is certainly one of the earliest photographs made in Japan—Felice Beato accompanied a British naval squadron assigned to open that country by force and persuasion to Western trade. Its

Rural Japan in 1862. Felice Beato's view of the countryside of Hokkaido.

novelty must have claimed attention for the photograph in addition to its undoubted pictorial merits. Prints, sketches, travellers' tales, *objets d'art*—not one of these earlier forms of evidence could match the power of witness of this and companion photographs which fluttered into the hands of the Western public in the 1860s: at one glance a foreign and exotic scene stands revealed. It is more than the simple distance they have travelled which invests Beato's photographs with a quality of the exotic. When one calls to mind the visual aspect

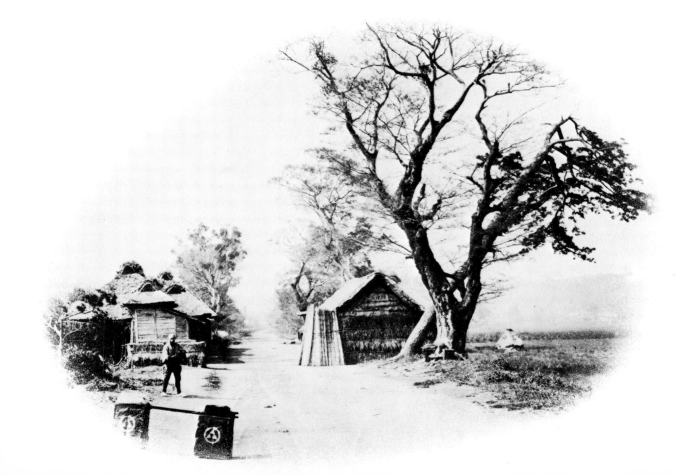

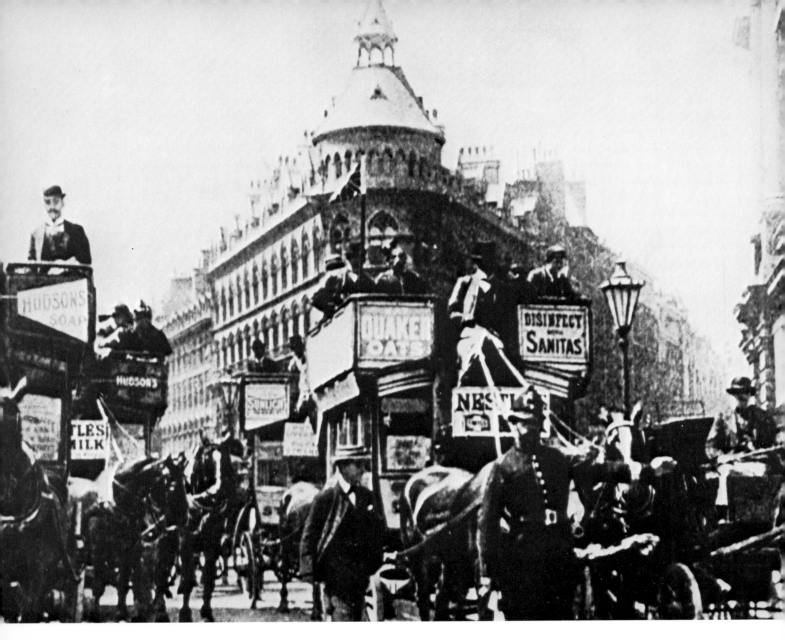

A nineteenth-century
streetscape: traffic choking the
city of London.

of the city in the nineteenth century—both
those of Europe and their like in North
America—the dark, angular shapes of the
houses, the chimneyed skylines, the roadways,
stone-curbed and choked with high-swaying
vehicles, in short, the cityscapes, severe in their
lines yet cluttered with discordancies of detail,
then these photographs of Beato stand in strong
contrast. The Japanese scenes express both
primitive earthiness and delicacy of form and
texture, a mixture alien in its sensibility to
nineteenth-century European life whether of
country or of town.

In the middle of Queen Victoria's reign these
visual fragments gathered abroad were coming
with increasing frequency before the eyes of
civilised Europe and America. An expedi-
tionary movement was under way only a very
few years after the announcement to the world,
in 1839, of Daguerre's process, as travelling
daguerreotypists moved through the Near East,
recording classical temples and Christian holy
places. With the triumph at mid-century of the
negative-positive process—an event we tend to
regard as the arrival of true photography—
fresh waves of expeditionary cameramen spread
out bearing the news and cumbrous wet-plate
equipment with them across the lands of
antiquity. The dusty sites possessed a new
allure now that they could be photographed and
transported away, as it were, on eight-by-ten-
inch plates to be reproduced in multiple copies
in London or Paris for the handsome album sets
kept by the well-to-do. Wealthy tourists were
finding their way to the Eastern Mediterranean
lands, if not in a flood at least in a steady stream

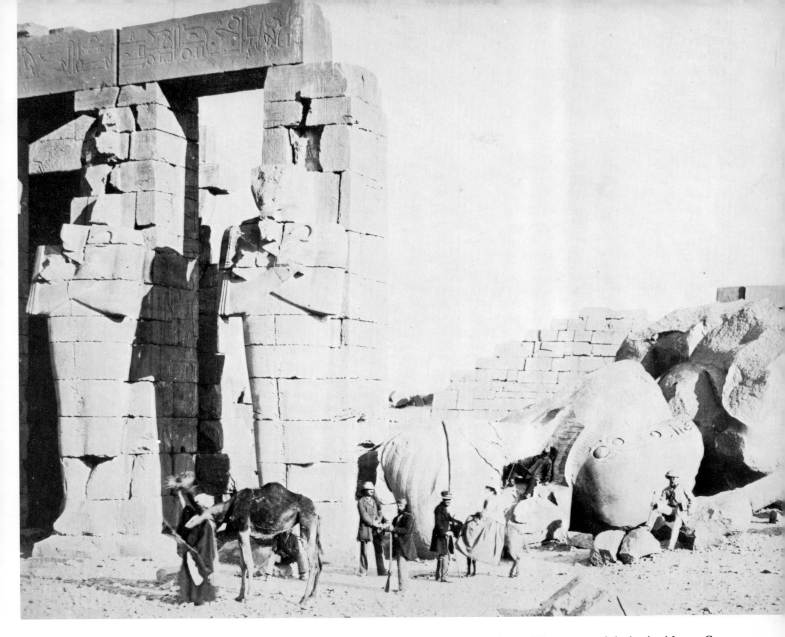

Victorian tourists pose amidst the ruins of Thebes, in Upper Egypt, for Francis Frith in the 1860s.

during this period, and such travellers, returned, naturally provided a market for photographic mementoes of an expensive journey.

Yet it was more than the stimulus of a luxury trade in views — this was before the days of mass tourism and the picture postcard, of course — which animated the expeditionary photographers. Many of them demonstrate the zeal and boldness of explorers, which, in a sense, they were, for the world lay before them unphotographed, its mysteries and challenges renewed. Theirs was a unique opportunity; they recognised the moment and, stretching for their place in history, overcame difficulties and braved numerous hazards. The journals of such men — Roger Fenton in the Crimea, Frith on the Upper Nile, Jackson, in a later generation, penetrating the mountainous defiles of the

American West — are rich in incident. Some episodes have the quality of high adventure, Frith's encounter with bandits in the Sinai Desert, for instance, but the prevailing theme is persistence in the face of difficulty. The equipment of a wet-plate photographer was not light — wooden folding cameras built to take plates as large as 20 × 24 inches, bottles of chemicals and other dark-room equipment, bulky cases of sheet-glass — and the stories of these expeditions bring out continually the problem of transporting this fragile equipment. We see it swung out of the holds of ships by boisterous labourers or packed on the backs of mules that sidle and kick. Always one has the sense of contrast between the rough crudities of transport and the fragility of the load, and this contrast may be extended to the photographer's

25

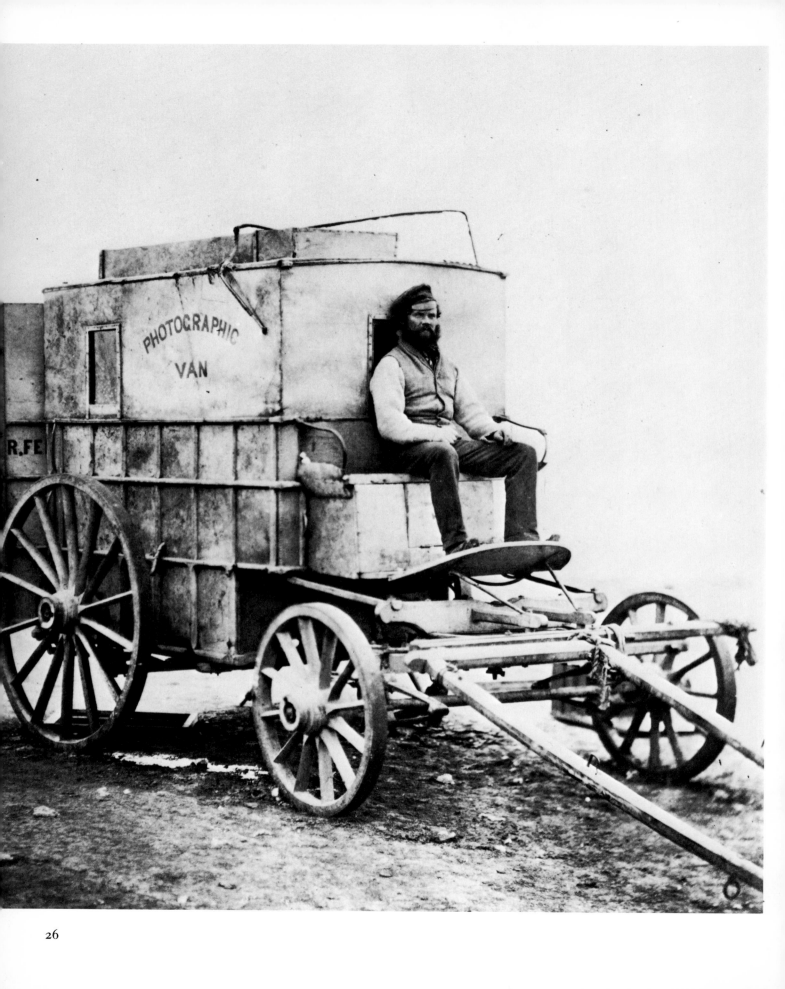

work—bringing from scenes of shift and heaped disorder precisely detailed, fixed images.

Such photographs were taken, for instance by Roger Fenton, of the port of Balaclava, where he had arrived anxious to record the expected fall of the Russian fortress of Sebastopol and the ensuing end of the Crimean War, only to find himself trapped with his equipment aboard a military transport in the harbour. Forced to evade regulations and ferry his photographic van ashore by private means, he explained to his publisher, who was footing the bill, 'I saw that if I could get none but official assistance Sebastopol would be taken by men and arms but not by photography.'[1] He added that if he had foreseen the difficulties of simple conveyance and provisioning he might never have gone. Fortunately he did and we have his views of the narrow, steep-walled inlet of Balaclava, tangled with the masts and rigging of shipping. Its shore is a chaos of supplies, lumber, provisioning baskets, and improvised

horse paddocks holding remounts for cavalry regiments. In their subject matter and tone Fenton's photographs, both of Balaclava and of scenes nearer the battlefields, are very different from the views of military life in the field presented by Victorian painters. There is very little dramatic incident even implied, and no appeal to a sense of heroics or of pathos. However, in their specificity and literalness Fenton's photographs must have been very interesting because they showed the actual makings of the settings of war. They may also have encouraged, in their flatness of tone, an awareness of the terrible ordinariness of war, a perception which appears to have been unfamiliar to the Victorian public but which gains widening expression as the photographic era proceeds.

The photographic van, in Fenton's case a mobile dark-room built on the frame of a wagon, was a necessary accessory for the expeditionary photographer. Some were simply used to carry materials, the photographer using

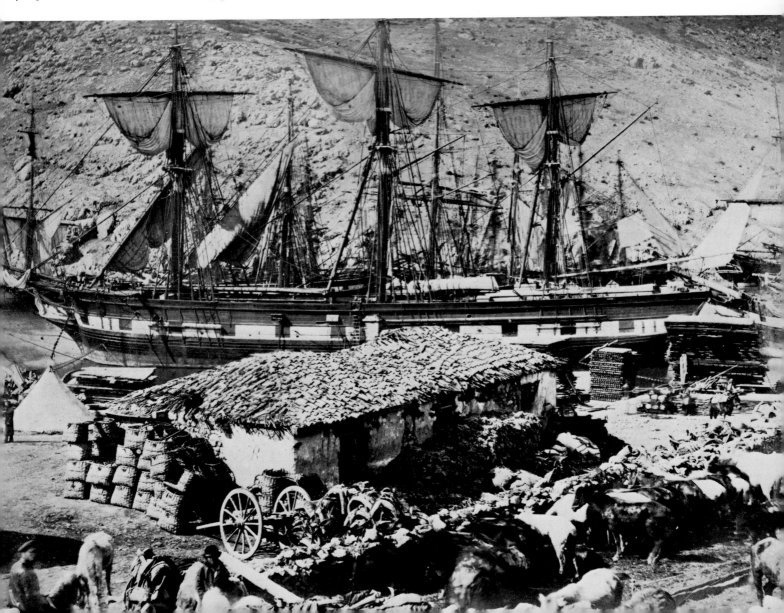

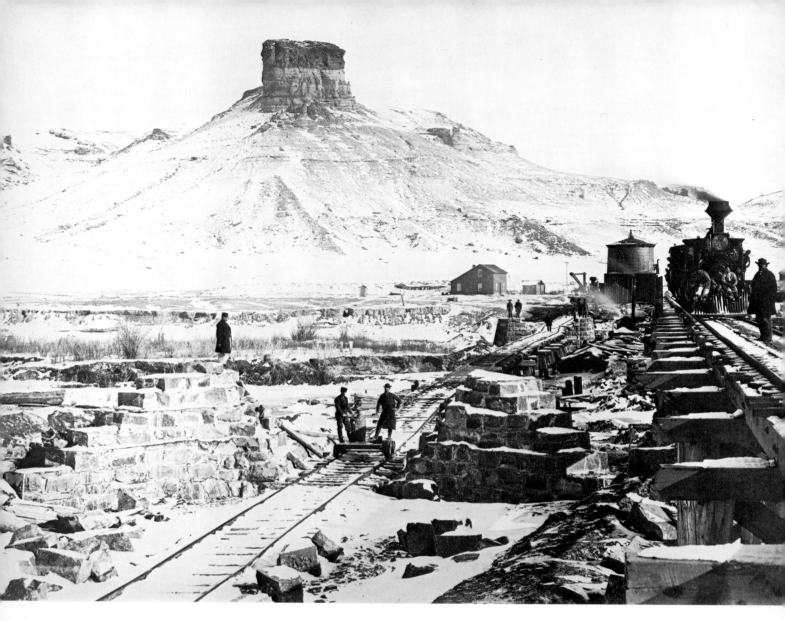

a portable dark tent or a developing box, but many were adapted vehicles with high, windowless bodies in which the sensitising and developing of glass plates could be carried on in a relatively stable and ordered working space — though one still hot, cramped and reeking with chemical odours. The appearance of these unusual vehicles often aroused comment. The converted buggy in which Mathew Brady followed the Union armies in the American Civil War was known among the troops as the 'What-Is-It wagon'; Timothy O'Sullivan travelled across the Nevada deserts in the late 1860s in a ponderous military field ambulance celebrated for its ugliness; Francis Frith, who used camels and pack-mules at various times and did not always enjoy the experience, finally had built a springy wicker-work carriage for travel in the Egyptian desert, its body tended over by

white sail-cloth; it was everywhere thought, he claims, to contain his travelling harem. Alexander Gardner used a buggy to follow the course of the Kansas Pacific Railroad as it crept with furious slowness across the Western grasslands. Later it became standard practice for railway companies to provide special cars for the photographer and his equipment engaged to make promotional pictures of the progress of construction and the visual delights of the route: the Denver and Rio Grande Railway Company, for instance, provided a special train with a flat-bed car to serve as a camera platform for W. H. Jackson, the famed Western landscape photographer. That sort of conveyance does not accord with the spirit of expeditionary photography and indeed, many of these promotional photographs possess a blandness also uncharacteristic of expeditionary photographs.

The opening of the American West to the railway seen in an official railway company photograph of Citadel Rock, Green River, Wyoming by A. J. Russell.

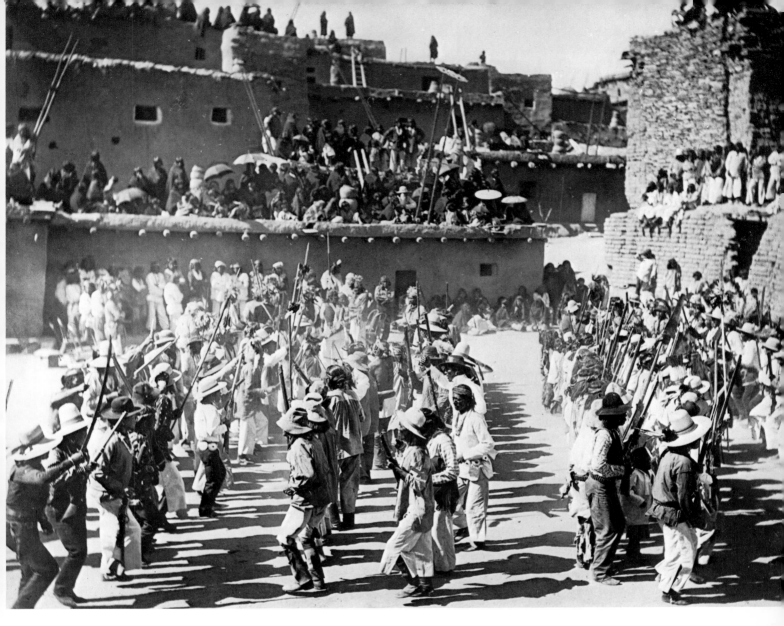

A war dance at the Zuni Pueblo,
New Mexico by W. H. Jackson.

Jackson himself had been a most persistent and
intrepid explorer in the mountains of the U.S.
West a decade or so earlier, travelling with his
material on mule-back into terrain inaccessible
to wheeled vehicles. Similarly, O'Sullivan
journeyed in hazard in his ascension of the
Colorado River with a survey party that lost in
upsettings and swampings of boats most of its
food and supplies; astonishingly, some of
O'Sullivan's glass-plate negatives survived.
While the most dangerous voyages with a
camera went where no wagon could go the
photographic van, rolling over empty deserts or
along rutted roads in the wake of armies, stands,
in its high, jaunty and self-sufficient shape as a
single clear image of the expeditionary spirit.

The photographers themselves possessed
remarkable qualities of personal force. They
travelled with a variety of backing—

government commissions, publishers' ven-
tures, their own inclinations—but whether
salaried employees, as W. H. Jackson was for
years, or photographer-entrepreneurs like Frith,
they shared an eye for opportunity and an ability
to seize it.

Some of these enterprising early expediti-
onary photographers travelled under a variety of
blessings: Roger Fenton, for instance, went to
the theatre of war in the Crimea in 1855
encouraged by Albert, the Prince Consort,
approved by the Secretary for War, the Duke of
Newcastle and financed by a Manchester
publisher, Thomas Agnew. This multiplicity of
patronage appears to have provided more
independence than a government commission
would have done. Two photographic parties of
serving officers and men were sent to the Crimea
directly by the War Office but either came to

29

grief or vanished subsequently into obscurity. Fenton, a thoroughly gentlemanly figure with no pronounced interest in photography as a business, managed both to survive and to justify the variety of expectations of those who backed him. Though he returned to England before the end of the campaign weak and emaciated by an attack of cholera that nearly killed him, he brought hundreds of photographs; of these 360 were published in handsome portfolios under the joint patronage of Queen Victoria, Albert and the French Emperor, Napoleon III. They are reported to have sold very well.

Of all the photographers who responded to the flickering glorious opportunities of the mid-century perhaps the most interesting in personal terms is Felice A. Beato, with whose photographs of Japan we began this discussion. Very little is known about Beato: he is said to have been born in Venice and to have been a naturalised British subject. These two ideas accommodate the known facts: his Italian name and his photographic career's recurring association with British military campaigns. He appeared in the Mediterranean in the early 1850s making views of cities and antiquities; in 1855 he was in the Crimea assisting James Robertson, another very colourful photographer, to record the capture of Sebastopol. From here Beato travelled with Robertson in the Levant and Egypt until, apparently having caught an enticing whiff of gunsmoke, the outbreak of the Sepoy Mutiny of 1857, the pair sailed for India and photographed the putting-down of the revolt. A couple of years later Beato, without Robertson now, accompanied an Anglo-French expedition that cannonaded and stormed the forts guarding Tientsin and forced Imperial China to open its opium trade to the West. Not long after that bloody episode—his photographs of the carnage inside Fort Taku, taken shortly after its capture, are testimony to the savagery of the struggle—Beato and camera are aboard a British naval squadron dropping anchor in Japanese waters. A fort or two is shelled, British interests are duly recognised, and Beato finds himself ashore in an exotic land which he immediately sets about photographing. A further outbreak of anti-foreign hostility lured him to China again in 1870. Through all of these adventures he appears to have travelled with his tongue as his passport, enjoying no special patronage beyond what his personality gained for him, finding his way into military camps and aboard naval ships, carrying his big field camera forward as soon as the guns fell silent. Beato the ubiquitous, with his nose for action and his talent for getting there appears the very type and prefiguration of today's news photographer. He was not an insensitive man—thoughtfulness and delicacy are implicit in the album of Japanese views—but military life appears to have offered him delight as well as financial reward. Late in his career the proverbial charger retired to pasture, but pricking his ears at a distant bugle, Felice Beato issued forth once more to accompany General Wolseley's hard-marching column in its attempt, in 1884–85, to relieve Khartoum.

A sense of mission often lies behind such adventures. War photographers, working to supply an ephemeral market in history as hot news, have at the same time created enduring records of human action. Mathew Brady, who dubbed the camera 'the eye of history' was unquestionably aware of this larger purpose when he rode off to direct photographic coverage of the American Civil War. The personal career of Brady, a leading studio photographer in Washington, demonstrated the difficulties involved in accommodating a high and serious vocation to the necessities of a daily retail trade in portraits and views. Brady received permission from Abraham Lincoln to follow the Union Armies but significantly, we are told, the President while applauding his aims could not offer a cent towards the expenses. Consequently the expedition—for Brady put as many as 22 photographs into the field at one time—were mounted as a private enterprise: stark images of war were sold to the public under the genteel imprint 'Brady's Album Gallery'. With the collapse of the Confederate States the market for war photographs dropped abruptly and Brady, over-extended, was obliged to sell his New York business. Years afterwards the U.S. government paid a token sum for his negatives which form a superlative visual record of the war.

In the history of expeditionary photography Brady's achievement serves as a bench-mark because of its vital statistics. Approximately 8,000 negatives were produced by dozens of photographers: the volume demonstrates the assured state of the art. From about 1860 onwards photographers took to the field with confidence in proven techniques and equipment: scarcely an expedition left for a frontier region without a cameraman or two. On the second Hayden Survey, of 1871, W. H. Jackson went as official photographer, and J. T. Hine of Chicago and J. Crissman, a Utah photographer, also accompanied the party: Crissman lost his camera over the edge of the Yellowstone

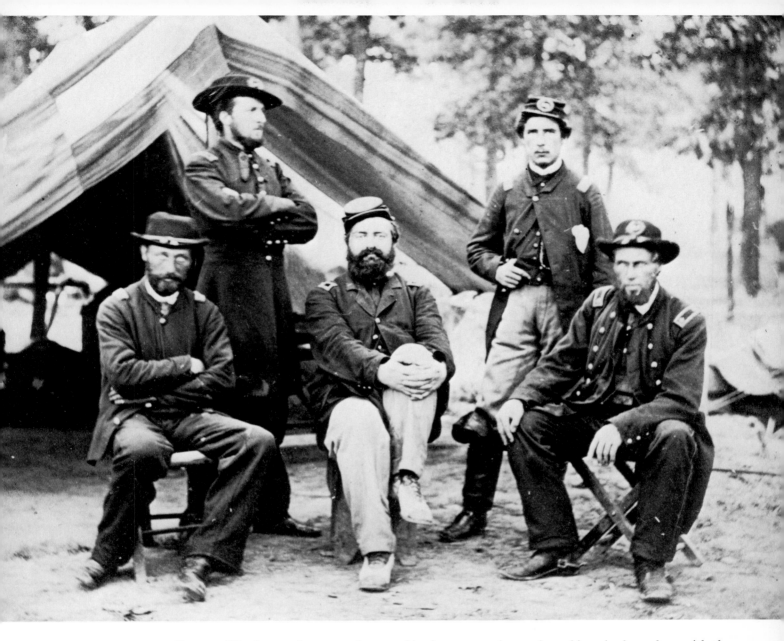

General Caldwell and his Union officers at their field-headquarters from Mathew Brady's 'Album Gallery', 1862.

Canyon, Hine's negatives were destroyed in the Chicago fire and only Jackson's work, including the first photographs of Mammoth Hot Springs, have come down to us. It was sensible to have a photographer in reserve. The small army of photographers who gained their experience in Brady's team found their way on to many of the scientific expeditions sent, after the war, into the American West. A growth in the practice of photography as a hobby increased the supply of able photographers.

The contribution of amateurs is a notable feature of British Army photography: it was a gentlemanly pursuit for officers stationed abroad with time on their hands. The British Boundary Commission, to give a small and particular instance, sailed for Old Oregon in 1858 with the prospect of several years' work in

surveying and marking the boundary with the United States west of the Rockies.[2] The party took no photographer as such on its strength; there was, however, a camera packed away among the theodolites. One of the engineering officers, Lt Charles Wilson, mentions in his journal of camp life that he had 'spent the afternoon at photography'—an admirable nonchalance is revealed by that terse phrase, for the processes of wet-plate photography were delicate, and staining and burning of the fingers were constant hazards from the silver iodide used to sensitise the plates and the pyrogallic acid used as a developing agent. The general nature of the photographs taken by the Boundary Commission bears out this sense of a casual employment of the camera to record camp life, with the exception of a body of

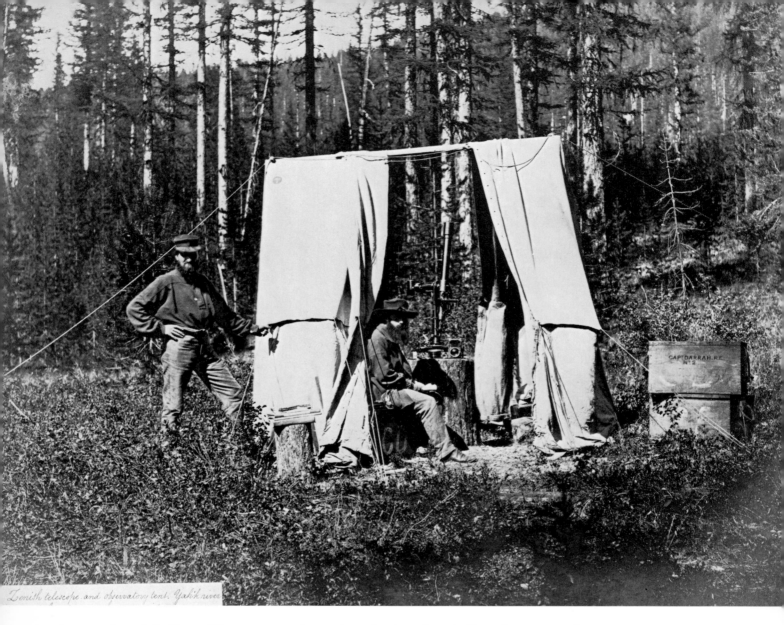

Zenith telescope and observatory tent. Yahk river

photographs of Indians. These are outdoor portraits which, in their number, repetition of pose and variety of subject, appear as a deliberately planned photographic survey of the little-known tribes of the region, including the Pendant Oreilles whose exotic name derived from their heavily-ornamented ear lobes.

Such photographs of native people, treated as curious, even wonderful, subjects to be gathered into a comprehensive visual taxonomy, reflect the European base of photography and the general association of the camera, a precision instrument, with scientific purposes. A general ethnographic intent, it is plain, guided the efforts of the many photographers who contributed to a remarkable collective work, *The Peoples of India*, published by the India Office in London in eight volumes between 1868 and 1875. According to the

introduction, these bulky volumes grew from a casual request by a retiring Governor-General of India, Lord Canning, and his wife for a collection of photographs which might 'recall to their memory the peculiarities of Indian life'. We should not be misled by the lightness of this remark or the subsequent apparently random planning of the project: 'officers of the Indian Services went forth and traversed the land in search of interesting subjects'. Hundreds of ethnic and cultural groups are covered in a comprehensive survey of the sub-continent; the treatment is uneven but the achievement is none the less monumental. More than 15 photographers contributed; some were professional, those from the Simla studio of Robertson and Shepherd for instance, but the majority were serving officers with a taste, as Lord Canning had himself, for dabbling in photography. Most

British officers with their surveying equipment establishing the boundary line across Old Oregon in 1858.

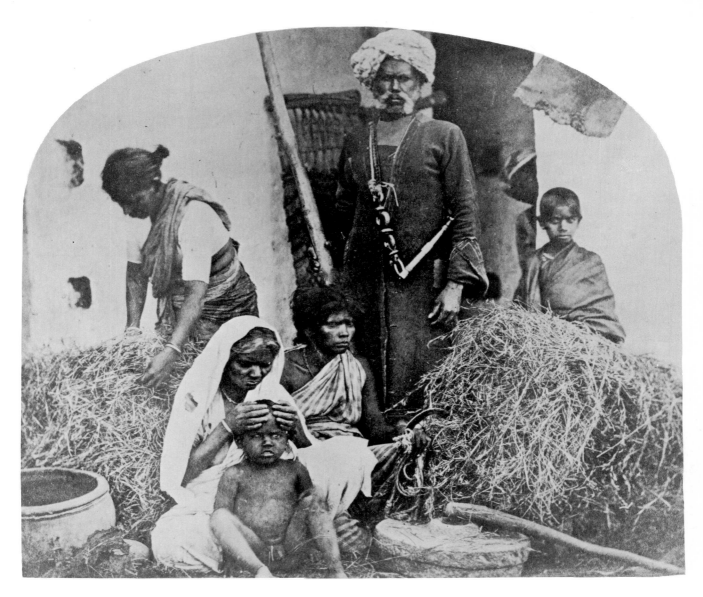

of the photographs are indoor portraits of types, Rajasthani princes, Tamil farmers and so on, comprising an often uneasy blend of geographic and social perspectives. But there are a significant number of outdoor scenes which escape from the inertness of portraiture and the weight of categorisation. Under the general ethnographic title *Hindus, Madras* are grouped a number of scenes rich in a sense of time and place: one splendidly candid scene, set behind a cavalry stables, shows women grass-cutters, a lordly head groom measuring their bundles of fodder, and a little boy squatting in the dust, naked. It establishes complete conviction: this must have been just how it was behind the stables of the cavalry in Madras.

Scenes from life of this kind offer a rich sense of revelation. Portraits, too, where the content is sufficiently exotic—the painted face of a Plains Indian—may convey to the European vision the sense of fragmentary glimpses of strange and imaginatively exciting worlds: the same power may be extended even to landscapes. This is notably true of the mountain and wilderness photography of the middle and latter half of the nineteenth century carried out by men in quite different parts of the world: the Bisson brothers, Louis and Auguste, in the Savoy Alps in 1860–61, Samuel Bourne in the Himalayas in the 1860s and, in the same decade, the school of San Francisco photographers, Watkins, Weed, and Muybridge, who made the remote Sierra Nevada and, in particular, the astonishingly beautiful Yosemite Valley, known to the world. They were photographing what had not been photographed before, and their constant difficulties—Auguste Bisson in making the first photographs from the summit of Mont

33

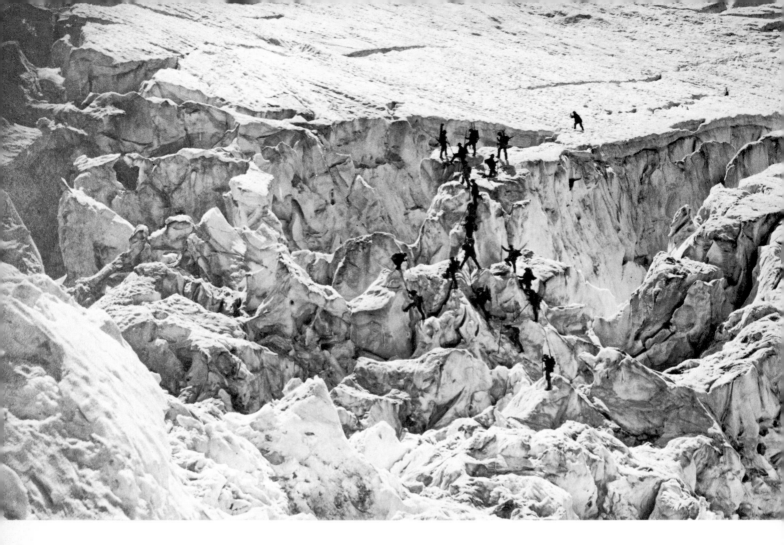

Blanc, Bourne in taking a camera through the high passes of the Himalayas—underline the historic nature of their achievements. But the simple novelty of first views of remote regions, which certainly gave these photographs immediate interest, does not explain the full nature of their appeal.

Wild scenery of the river valleys and mountains of the American West and Alpine views of cleanly-sculptured snowscapes possess in common the suggestion of an elemental, primitive nature, untrodden by man: photographs of such scenes appear to have been greeted with romantic enthusiasm by the civilised public of the 1860s. The work of the California photographers, for instance, appears to have fallen on the Europeans with the surprise of a thunderclap: their photographs were shown at the Paris International Exposition of 1867, were awarded a medal and elicited a warmly approving review by the *Illustrated London News*. The photographs are particularly commended, in this review, for revealing an unspoiled wilderness: 'In none of these pictures do we see the least

signs of man; not a log hut nor an axe-felled tree to indicate his presence: all seems wild, primitive nature, which gives the great charm to these excellent photographs'. An immediate consequence of this international recognition was the establishment by Carleton Watkins and Eadward Muybridge of their own studio imprints—the California photographs had been shown at Paris under the name of Thomas Houseworth, a San Francisco dealer. There was money to be made, it was clear, in views of striking natural scenery.[3]

While the Yosemite school, thus encouraged, approached the mountains as aesthetic subject matter, those photographers who came into the wilderness accompanying exhibitions from the East were charged, it appears, with the sterner mission of science. The precise nature of their scientific function has not been made clear in recent studies and it may not have been plain then. Generally, the photographers appear to have provided an auxiliary service: they rode alongside geologists and geographers and recorded special topographic features and, for

One of a series of photographs taken by the Bisson brothers during an ascent of Mont Blanc in 1860.

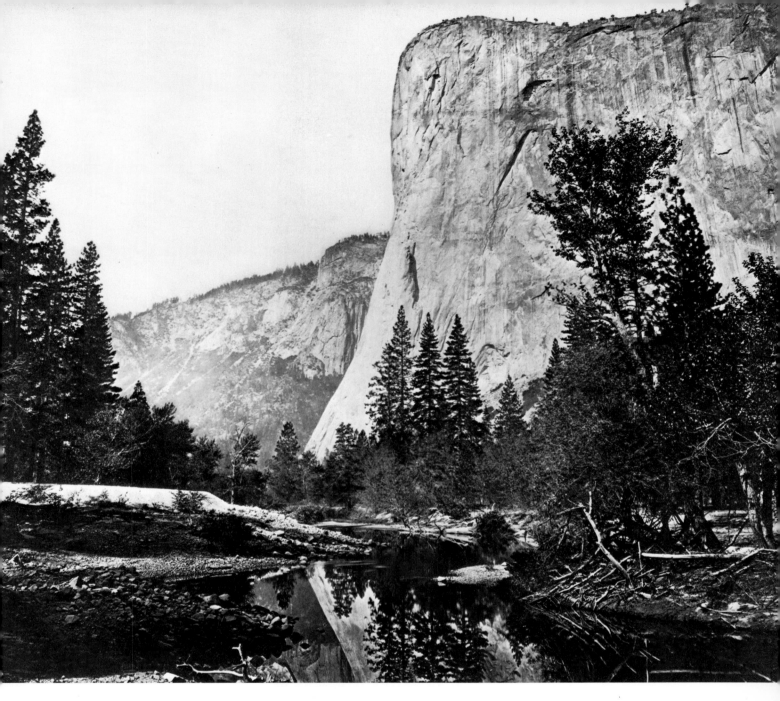

El Capitan, a striking rock formation in the Yosemite valley, California photographed by Eadward Muybridge in the 1860s.

the botanists, photographed specimens of plant life. One special function which appears to have been theirs alone was the ethnographic standby, documentation of the various native peoples of a region: W. H. Jackson was detached from the main body of the Hayden Survey in 1870 as it made its way back from the Western hills in order to photograph the Omaha and Pawnee villages of Nebraska; in his later work for the Survey he was allowed considerable independence for similar purposes, journeying into the South-West to record the life of the Pueblo people and the ruined cliff cities of earlier cultures. It is difficult not to feel that Jackson

created an added function for himself in these years; he became a species of publicist, an intermediary between science and the public, feeding the popular imagination with material that, unlike scientific data, revealed itself at a glance.

The plainest instance of this function occured in 1872 when Jackson's photographs of the Upper Yellowstone, made the previous summer, were instrumental in the establishment of the first US National Park in the region. The lobby for a parks policy was potently reinforced by the circulation to all congressmen of Jackson's prints, bound in an

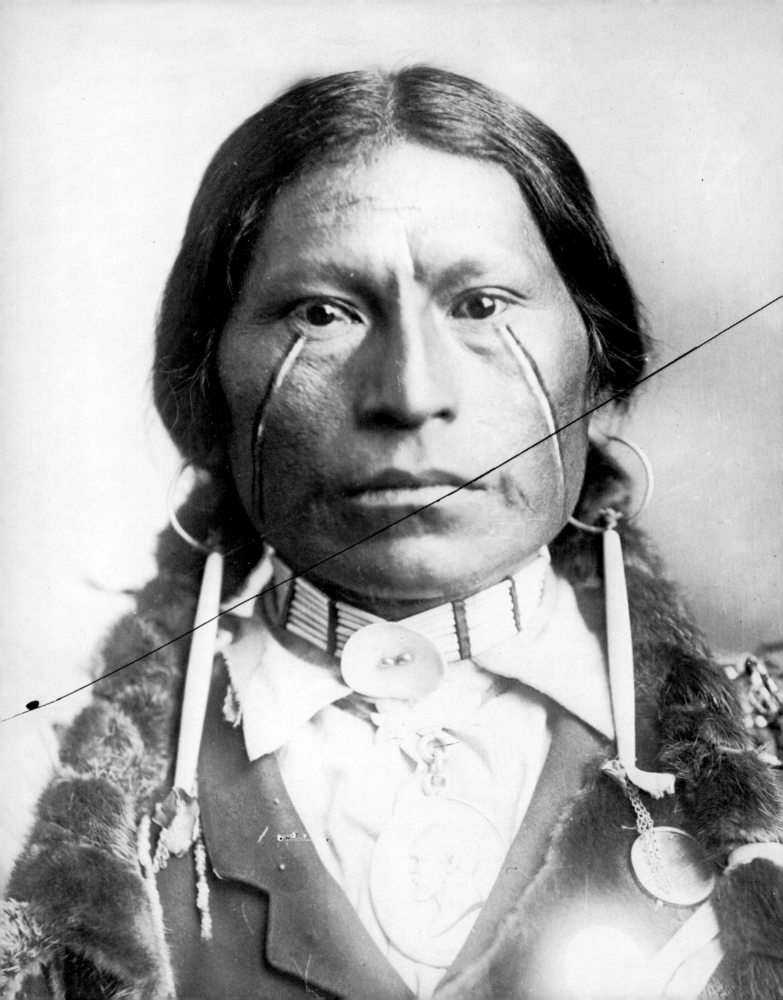

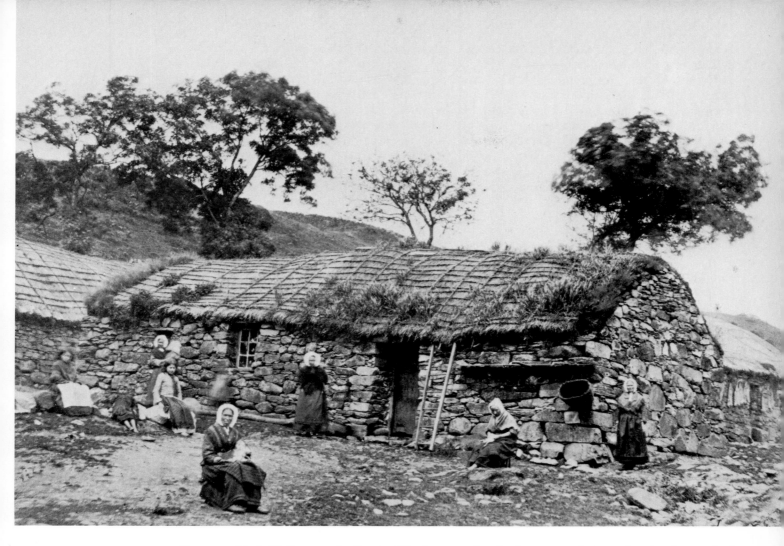

The primitive turf-roofed cottages of the village of Ardnacherra in the Scottish West Highlands, 1854.

Opposite
One of Jackson's many ethnographic studies of Indians of the American South West: Apache chief, James Garfield (the glass negative has been cracked).

album entitled *Yellowstone's Scenic Wonders*. The title suggests how readily photography could accommodate the discoveries of expeditionary science to forms familiar to the public. Again, Dr Hayden, the leader of the Survey, appears to have regarded the value of what he called his 'photographic corps' as lying mainly in its education of the public mind. In a report to the Secretary of the Interior in 1875 he writes:

> Twenty years ago hardly more than caricatures existed as a general rule of the leading features of overland exploration. Mountains were represented with angles of sixty degrees inclination, covered with great glaciers and modelled upon the type of any other than Rocky Mountains The truthful representations of photography render such careless work so apparent that it would not be tolerated at the present day.[4]

Apart from this general corrective function the only particular achievement to which Hayden refers is the accumulation of a visual record of Indian peoples, to which Jackson had devoted much time.

This and similar ethnographic work, whatever the scientific justification, arises from motives tinged with romance. A recognition of the transitory, doomed nature of the lives of peoples existing still in a primitive state under the threat of Western civilisation inhabits these photographs. They are important photographic subjects because they will speedily recede into the past, indeed are already to be seen, in the flow of time, as fragments of the past. That assumption, though equally valid, was rarely made about the Western world, and then only about rural folkways and practices, Morris dancing and other atavisms, which Sir Benjamin Stone, for instance, saw as the proper subject for record photography. Photographs of crofters made in Scotland in mid-century bear about them a sense of being records of primitive survivals. As the century proceeded, of course, it was necessary to travel further. In the Tyrell brothers' account of their journey of 1893

across the sub-arctic for the Canadian Geological Survey, an emotional peak is reached when, after weeks of travel, they come upon an Eskimo band near Baker Lake in the vast, empty land north-west of Hudson Bay. Second only to the pleasure of finding the Eskimos was that of photographing them. J. W. Tyrell narrates how, as soon as the opportunity offered, he set up his camera—and how his subjects co-operated in the strange ritual that followed on the treeless plain:

> I secured several good shots of the Eskimos. At first they were not prepared to be 'shot' by the camera but after explaining what I wished to do, they were pleased and amused to have their pictures taken and changed their positions when I asked them to.[5]

Unfortunately, in assigning 'positions' to his subjects, Tyrell worked against his best interests, creating a number of photographs as deadly wooden as if taken in a studio; far better, in its conviction of a real world, is a group photograph of a disorderly, giggling band who do appear to be facing a camera for the first time.

An essential quality of so many of these photographs of remote peoples is a sense of a privileged view. A scene is discovered in the sense that the camera's eye falls upon it for the first time, and this moment of discovery is repeated each time the photograph is taken up. The scene is also discovered in terms of style, that is, discovered in the abrupt manner reminiscent of the use of the word in Elizabethan revenge tragedies where a curtain is twitched back and all stands revealed.

The camera, possessed of this revelatory power, need not always be directed outwards towards geographic frontiers or backward in time to the edges of known history: hidden worlds, remote from normal experience, lay behind the familiar surrounds of nineteenth-century society, just as they do today. Former war and expeditionary photographers were among the relatively few to exploit this power. Some of Timothy O'Sullivan's photographs made at the Comstock Lode Mine while on a geological survey in Nevada have as little to do with geology as photographs of a modern car assembly line would have to do with the theory of the internal combustion engine. They are views of the hidden world of industry, an area seldom entered by the nineteenth-century camera. O'Sullivan's photograph of miners

A disorderly band of Eskimos face a camera for the first time. Photographed by J. W. Tyrell near Baker Lake in the Canadian North West Territories in 1893.

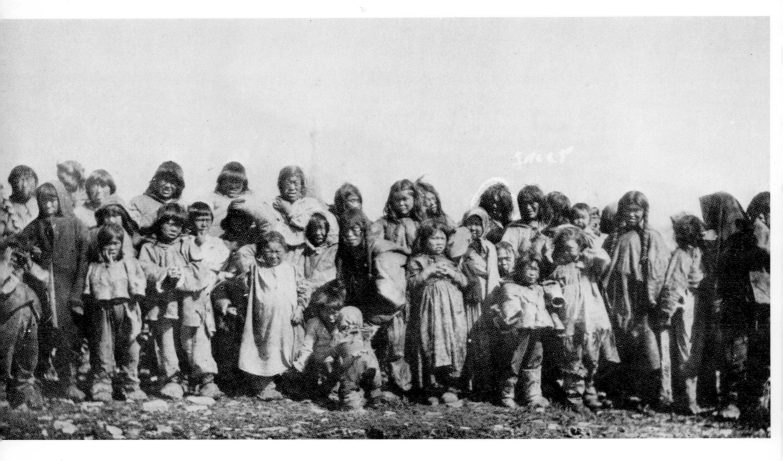

The hanging at Washington Arsenal by Alexander Gardner, 1865. (*Overleaf*)

Miners and ore-cars at the head of a shaft at the Comstock Lode silver mine, Nevada by Timothy O'Sullivan, 1868.

about to descend the Curtis Shaft reveals with instant clarity the essential formula of nineteenth-century industry: men and mechanical power equal wealth; labour, standing on one side of the hoist, is balanced by the car of silver ore rolling out, on the other side, from the depths. Another former war photographer, Alexander Gardner, demonstrates the effectiveness of simple discovery in his views of the execution of convicted conspirators following the assassination of President Lincoln. With a cool, wide gaze the camera registers the scene on the platform of the scaffold and the audience of lounging soldiers, fellow-witnesses, lining the top of the prison-yard wall.

Expeditionary photography, with its journeys under foreign skies to capture scenes expressive of a particular time or place, works no differently in its effects from the best photography of any kind. It creates compelling pictures. But in nineteenth-century practice, as we have seen, the expeditionaries were men of a special sort: not only were there unusual calls upon temperament and initiative involved; the

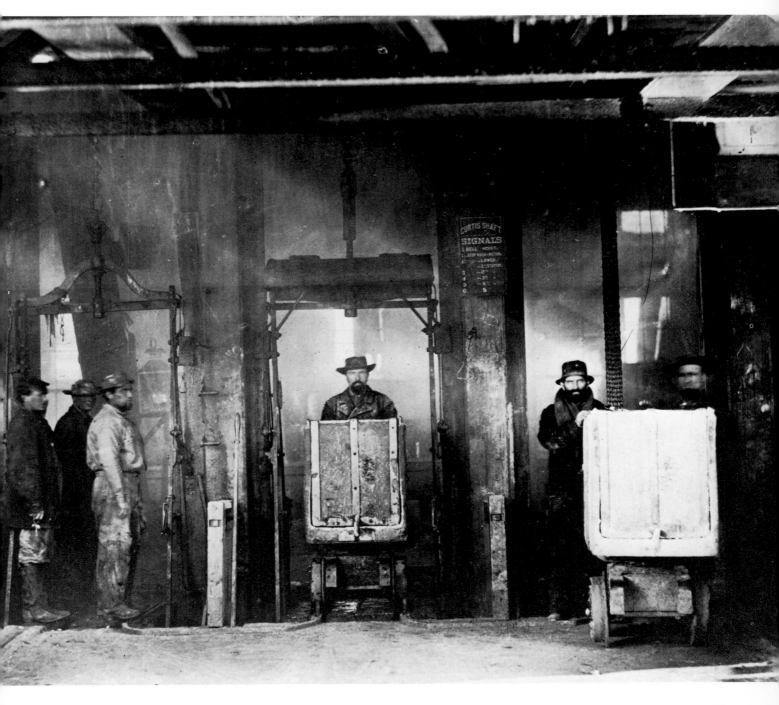

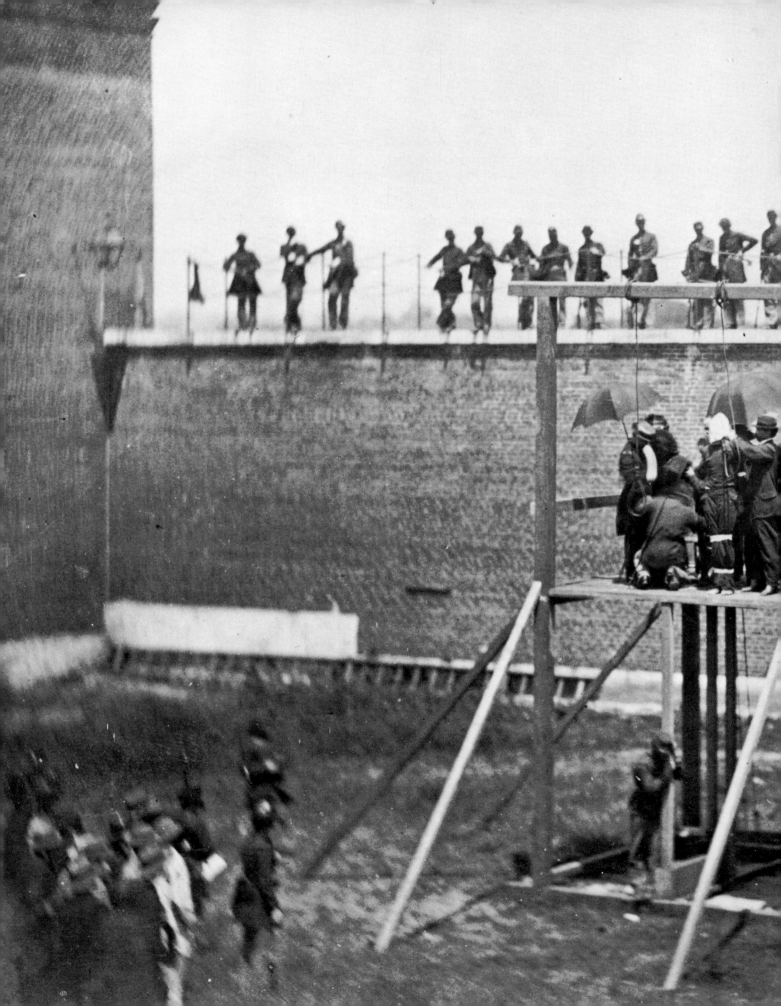

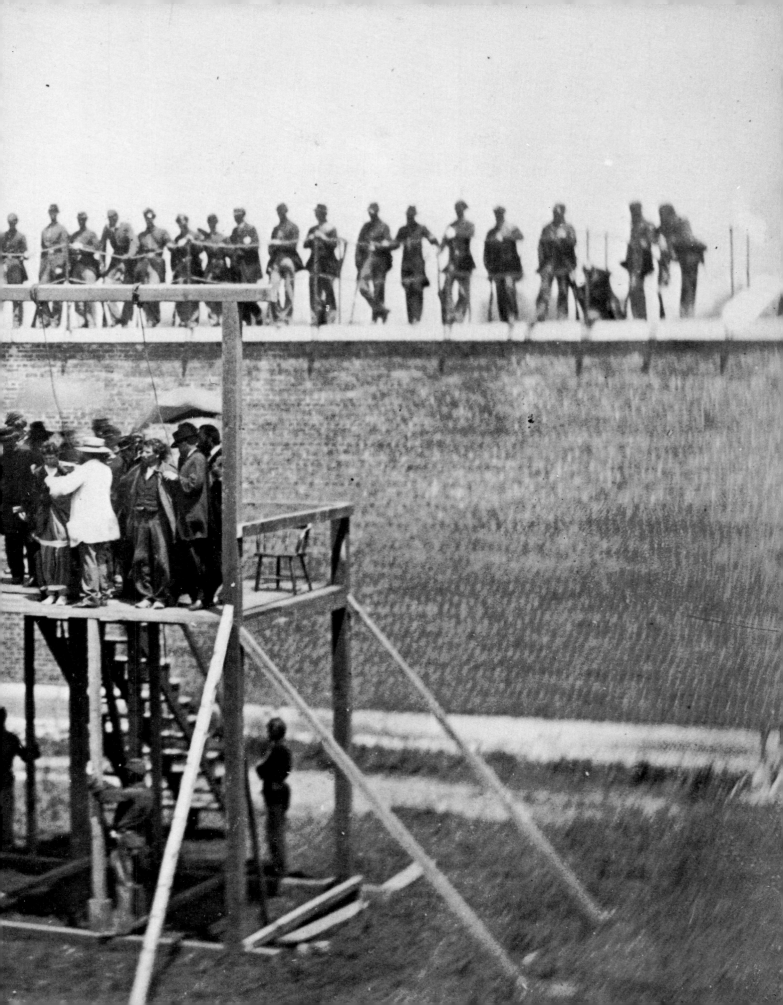

profession also required lengthy commitments of time which made the continuing practice of studio work almost impossible. Within the profession as a whole, expeditionary photography was evidently regarded as offering prestige, romance and artistic challenge: it was common practice for portraitists to mount miniature photographic expeditions, during their vacations, to the nearest wild stretch of coastline or range of hills in imitation of their better-known contemporaries. The careers of the most successful expeditionaries are not characterised by such compromises: Frith, Jackson, and O'Sullivan worked more or less continually over a stretch of several years at their special trade and retired from it with a clear sense of departure. This did not prevent them later returning to it, as did Jackson, or working at it in a modified form, as in Frith's case, as a travelling views photographer. A more fundamental difference lay in the degree of artistic aspiration: the general run of portrait-and-views men were obliged to answer the immediate public's needs and tastes; the expeditionaries, whether serving science, history, art or private reward, were also responding to a call for romantic idealism. Frith was moved to journey into the desert, he tells us, in 'a quest towards the romantic and perfected past'.[6] W. H. Jackson, a diarist of generally laconic manner, recalls in tones of boyish breathlessness how he and his party rode towards the Upper Yellowstone region as towards 'a wonderland ... of marvellous things' where he expected to do his 'first really serious work'. Contemplating these inner drives were the exterior pressures of testing experience arising from new terrain, a new range of purposes, and the simple difficulty of achieving a photograph. To face an arduous mountain climb on three days in succession, as Jackson did in photographing the mountain lake of San Cristobal, in Colorado, was to face anew each day artistic questions intensified by the previous struggle. Aspiration and challenge necessarily bred seriousness of purpose. In particular, it maintained within professional photography as it developed during the century the motive and ideal of discovery and revelation, the mark of serious work in many forms of art. This was an undeniably valuable function in a profession which often demonstrated that it could easily settle into an entertainment industry.

The expeditionary photographers, in their journeying outward, may be seen as representative figures of a restless age, for the attraction of a marvellous world was not confined to photographers. The market that existed for their work indicates a public hunger for colour, romance and new horizons, symptoms of a passion for experience which marks many nineteenth-century lives. In order to see something of the world, as the phrase had it, village lads and working-class boys from the cities of Victorian England took the Queen's Shilling and enlisted. Among the middle classes, so frequently characterised as smug and insular, it was regarded as normal to have a son abroad, either in the military or the colonial service. The pattern was repeated in every country with possessions overseas; the waters of the Mediterranean and the Indian Ocean were achurn with imperial engines. Much of the migration westward across the Atlantic was touched by the same spirit of expansive hope. Nor, when America was reached, did the restlessness cease. The new territories ever opening to the West were filled with Easterners on the move—Connecticut tradesmen to California, Ontario farmers to Manitoba, Montana ranchers to Alberta—as well as with migrants from overseas. These pictures made by the expeditionary photographers often register these movements and convey also, in the scenes they depict, the sense of an outer world which is strange but fast becoming familiar, opening and revealing itself at an exciting pace to the journeying eye.

THE FAMILY CHRONICLE

A Victorian family's photograph album can be personally and socially revealing to a degree at first little appreciated when the leather covers fall back to expose those distant reticent faces. As with graffiti scratched on ancient walls, the images frozen and preserved by the camera convey to the onlooker at first only a sense of fleeting vanities. But careful, repeated reading and the discovery of the facts of ownership (frequently a simple matter) transform the situation: the album becomes a living social document, richer in its appeal to the imagination than a casual initial on a wall, and unique in its concrete, visual record of worlds of past experience. If there has been any continuity of ownership, then a narrative will reveal itself: faces and scenes recur, familiar yet bearing the marks of change. From the selection and arrangement emerges a tone which suggests the personality of the album's owner (just as the personality of an author can be sensed behind a prose narrative), and because the images we see are actual, located in time, space and social class, a sense of that particular world—a social statement, in short—also emerges.

There is little doubt, for instance, that the Waterlow album[1] comes from the world of middle-class trade and commerce, though it is a family album, for the first portrait to greet us is that of Mr Waterlow senior, a Finsbury stationer, joined by his wife. At last (on page seven) the album reveals its owner, the former Anna Maria Hickson,[2] who a few years before the photographs shown on this page had married Sidney Hedley Waterlow. She looks out from a faded print, the frilled dress and ornamented jabot she wears emphasise the plain, thin-lipped cast of her features; evidently she does not photograph well. By contrast, her husband presents a firm, thrusting image of a rising City man. Below appears their first child, George, in frocks. The photographs are unusually early, and if we are to trust the dates which appear (1849 for the Waterlows, 1850 for George) they belong to the pioneer, pre-collodion period of the camera; certainly the clothing styles are early-Victorian.[3]

As child follows child the album develops in a predictable manner. Anna Maria, chronicler of the family history at this simple level, enters the names and dates and, further, reveals her satisfaction with the maternal role by cutting and pasting together two prints to make one group composition which shows her at the centre, surrounded by children: the heart of the family. Accompanying this numerical growth of the family, her husband is gathering honours. In a photograph dated 1863 we see him in court dress and a long fur-trimmed robe, cocked hat in one hand and scroll in the other. Evidently he has just become an alderman of the City of London. From this date evidences of a public life enter the album: in particular, we find pasted on the page a card of invitation to a reception for the Sultan of Turkey, Abdul Aziz Khan, to be held by the City of London; the name of Sidney Hedley Waterlow, Sheriff, is among those who extended the invitation. The elevation from the rank of Sheriff to Lord Mayor follows naturally, and it is no surprise to find, a few pages on, a view of a City coach, probably the mayoral coach, with its liveried attendants, standing outside the house on the heights of Highgate Hill occupied by the Waterlows.[4]

As a story of City success the album has now

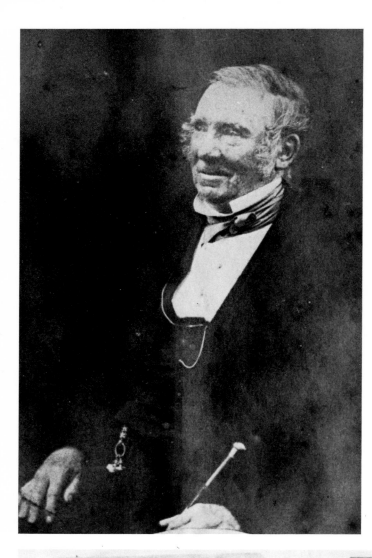

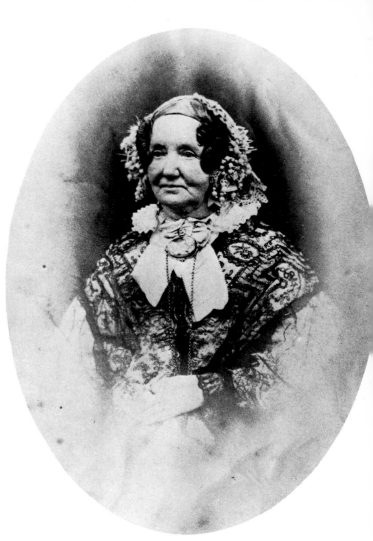

Old Mr Waterlow, the founder of the family and his wife.

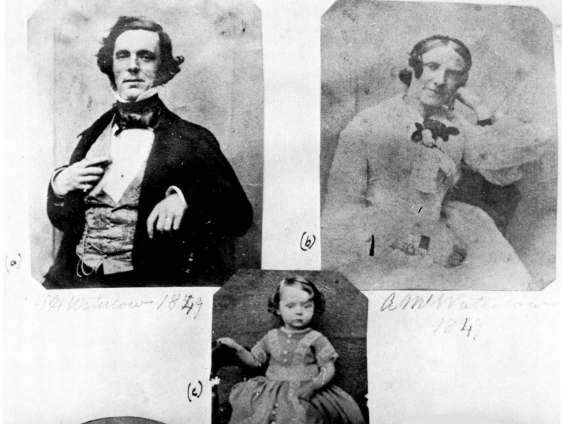

(a)

(b)

(c)

S H Waterlow 1849

A M Waterlow 1849

Sidney Hedley Waterlow, his wife Anna Maria and their first child George.

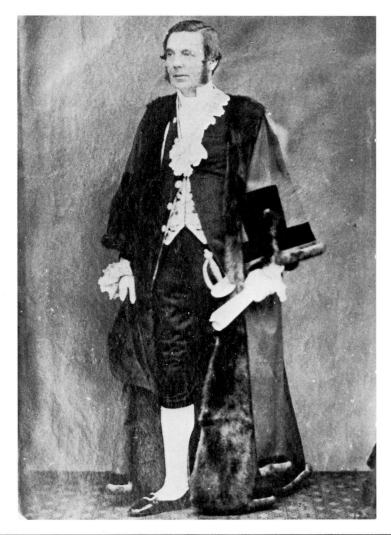

Sidney Waterlow as an alderman of the City of London.

Anna Maria amongst her children. The picture has been concocted from two photographs pasted together.

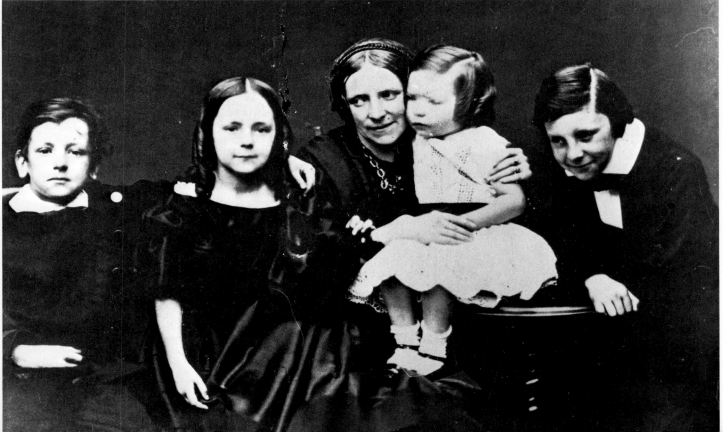

reached its peak and natural conclusion in this view of the coach which bore Sir Sidney through cheering multitudes to the Mansion House. Fortunately there is more to the Waterlow album. It is kept by Anna Maria, not Sir Sidney, and while public life has been forcing its way into the album, the pages are still largely devoted to domestic chronicles. These widen by a natural progression which sees portraits of individuals grow into family groups; beyond the immediate family groups are rows of further relations, and beyond them we see, in intermittent views, rows of yet further relations. There is a favourite uncle, thin-faced, who poses alongside a large, square-faced wife; between them they produce a round-faced girl who is obviously the beauty of the family and whose portrait is given a whole page; the children and their cousins grow and, at what seems an early age to judge by the young, barely moustachioed faces gathered about a new infant, they multiply; a page further we find old Mr Waterlow gazing across the generations at his grandchild.

These visual annals might hang, easily enough, as a domestic pendant from the public career of Sir Sidney but for one photograph which suggests otherwise. Public and domestic lives obviously can pull in different directions. A very strong indication of such tension appears in a photograph which is placed just after the mayoral coach. It shows Anna Maria in ball-gown, tiara and plumes; she is posed before a draped backcloth; she wears necklace, brooch and bracelet; her gown descends into a train of yards of brocaded silk; obviously this is a special occasion and, given the proximity of the civic coach, it seems likely that the portrait shows Anna Maria in the gown she had worn for some public function—possibly the costly reception for the Sultan of Turkey or the Mansion House banquet for the Khedive of Egypt which were Sir Sidney's responsibilities as Sheriff in 1867, or his lavish entertainment of the Shah of Persia at the Guildhall in June 1873 during his mayoralty. What ball or reception it might have been is immaterial. What we see in the photograph is an overdressed woman in her middle years enduring an uncomfortable moment before the camera. It is speculative, perhaps, but one is inclined to read into this one devastatingly unkind photograph a pattern of repeated experience: one imagines Anna Maria, uncomfortably aware of the contrast between her ball finery and her own plain self, gathering her courage—there is a quality of nervous fortitude about her expression in this photograph—and going forth to join her husband in meeting civic dignitaries and foreign potentates amidst the glitter of reception and ballrooms.

There is both internal and external evidence to support such an interpretation. From the album portraits it is clear that Anna Maria was not a fashionable woman: in the ballgown photograph, taken about 1870, she wears her hair in the same style as she wore it in 1860 and in 1850; more than anything, it is the girlish curls hanging alongside her cheek which emphasise her plain features and, latterly, the gathering years. She is in fact at her best in the album in a photograph which suggests the repose of home: Anna Maria sits tranquilly, with what might be crochet needles in hand, richly gowned in the silks and satins that betoken the security of a rich husband in the City. Photographs in which she appears with her children (including that one which she physically alters to place herself at the centre), as we have already suggested, support the view that she saw herself as happiest in the defined roles of wife and mother, especially the latter. Her husband's biography confirms, by implication, Anna Maria's diffident, withdrawn personality, and reluctant, forced accommodation to his public life. This work presents a public and adulatory view of Sir Sidney in a manner familiar in late-Victorian biography, listing achievements and honours and the distinguished personages he knew. It makes a brief—extraordinarily brief—reference to the hero's chosen spouse, mentioning Anna Maria in one sentence only as an 'amiable and gentle' person, the daughter of William Hickson of Wrotham, Kent, and the mother of Sir Sidney's six sons and three daughters.[5] Anna Maria— despite the children she bore him and the 35 years she shared with him (before her death in 1880)—is eclipsed in Sir Sidney's *Life* by the figure of his second wife, Margaret, an American half his age whom he met in California and with whom, after their marriage in 1884, he toured the world in a style suitable to an enormously rich English baronet. His latter years are in marked contrast to his years with Anna Maria (who appears never to have travelled abroad with him) and this contrast emphasises, as a consequence, the withdrawn, domestic quality of her album.

In making this contrast, the inquiring mind has been prompted to travel beyond the covers of the album; the stimulus itself may be a natural product of the historicity of the album, or, on the other hand, it may derive from the

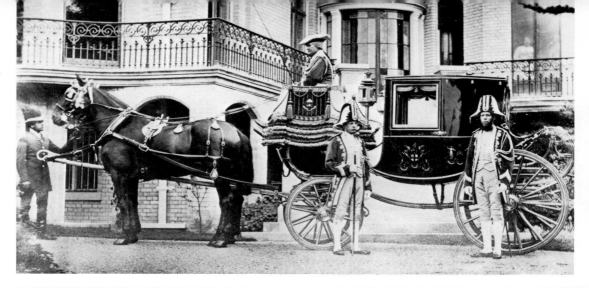

A City of London coach outside the Waterlow mansion in Highgate, North London, *c.* 1870.

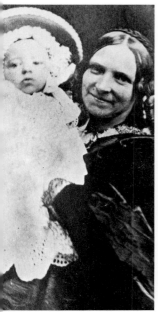

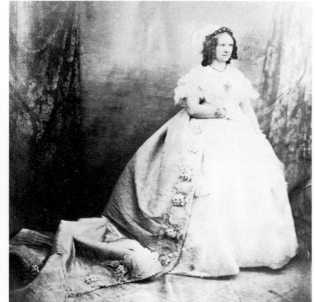

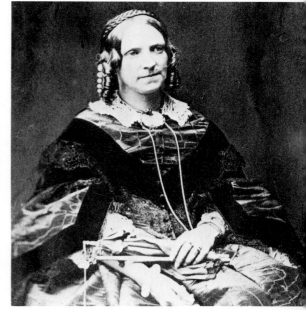

Above
Anna Maria and baby.

Centre
Anna Maria prepares to face public life in a formal ball gown.

Far right
Anna Maria in a relaxed domestic pose.

The arrival of a fourth generation of Waterlows.

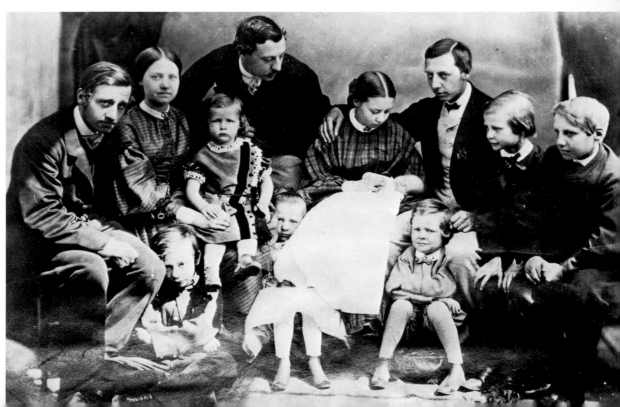

photographic aesthetic itself. In attempting to assess the importance and meaning of the Waterlow album we must keep in mind the inviting manner in which the beholding eye is led on to find out more. As an historical artifact, the product of early-Victorian technology and popular culture, this album is an estimable object and its value is enhanced by the visual record it provides of the richer kind of bourgeois family life. It is by no means a complete record, of course, nor is it by any means objective: it is the cooperative product of photographers and family engaged in presenting the Waterlows in the best light—in terms of social status, sentiment, and pictorial attractiveness. This celebratory function itself is fascinating because it reveals the poles on which the conventional Victorian success story revolves: public achievement (with its accompanying riches) and a numerous happy family. Again, on this level the album offers itself with an extraordinary vitality of attraction because it is a success story created with actual materials and arranged by one of the actual participants.

It may be that strong objections can be made to the distorting, falsifying aspects of Arrangement—if under this head can be placed all the self-glorifying and theatrical aspects of the photographic occasion and family participation: the dressing-up, the posing, and Anna Maria's selection and arrangement of the photographs. Yet there is an unassailable Actuality about the photograph which holds these objections in check. The faces are real, the clothes are real; in short, much real information is given to the inquiring eye, and, beyond this, the observed relationships are real; these are actual brothers and sisters looking, arms entwined about necks, into the camera (whatever their feelings for each other might be). It is this Actuality which creates fascination in the perusal of a success story as conventional in its conception as the Waterlow album; historical interest, that is, the attraction of a period remote from ours, naturally strengthens this appeal, but it does not seem to be of first importance. (If one knew that all the Waterlow figures were hired photographer's models, for instance, there would be a certain interest in the album as a photographic curiosity but the narrative would surely appear trivial.) The fascination of the actual, again assisted by curiosity about the remote, also encourages the eye to read closely in details of face and dress; such close reading can, at the least, produce historical information; it may lead to inferences about temperament and personality and, on

some occasions, assisted perhaps by a photographer's inadequacy or a sitter's wilfulness, it brings a gleam to the onlooking eye as awareness grows that Actuality is working against, even completely upsetting, Arrangement. Such of course, is the case with Anna Maria's ballgown photograph.

It was of precisely such an upset that George Bernard Shaw wrote when he termed photography—and he was referring to its late-Victorian practice—'too true'; as an iconoclast himself Shaw was not complaining about the medium; he was assessing its dangerous power of revelation.[6] This power is not to be viewed negatively; the perception of a gap between Actuality and Arrangement, or, in the terms of a theme familiar in the novel, between reality and appearance, feeds the imagination. It causes the mind to reappraise details and structure passed over earlier, and to gather into this re-examination facts from outside the album: to find and construct a story which explains everything. Here is the richest side of the Waterlow album, and of many other Victorian albums: it feeds the creative imagination; posed, literal and restricted it yet stimulates, with its detailed actuality, multi-dimensional glimpses of life.

Similarly when we take up the album of Emma Mary Hoyle,[7] of Hooton Levett Hall, we feel the presence of the social milieu of the landed gentry. There are indications of aristocratic title in other branches of the family but the Hoyles of Hooton Levett, West Riding do not appear to live in a grand style. Their existence appears to be defined by the Hall, or manor house, the Justice's bench, deferential villagers and tenant farmers, hunt balls, twice-yearly visits to fashionable resorts on the coast and occasional trips to London and abroad. Even in the mid-nineteenth century, when the manufacturing interest was powerful in northern counties, the landed gentry, by virtue of the broad acres they owned and the traditional place they occupied in local government, exerted a crucial influence in rural society. The question of how fitly they occupied this role bulks large in some Victorian novels of provincial life. A relatively slight piece of evidence such as Emma Hoyle's album cannot, of course, answer a question of such scope, but it can provide a flavour of the life of this class and, again tentatively, suggest something of its view of the world, the range of its vision.

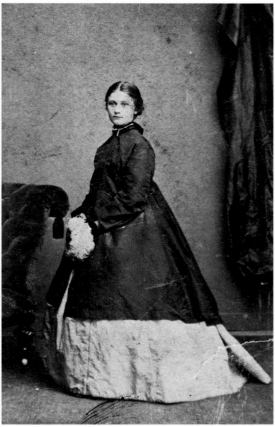

Emma Mary Hoyle at about 15, photographed by Sarony at the fashionable spa, Scarborough, about 1860.

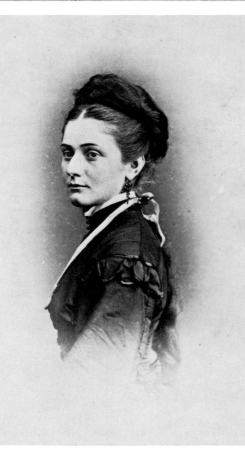

Emma at about 25, 1869.

One must not put too much weight upon the album, however, because it is self-absorbed in the manner of a girl's personal diary, and as it covers the years of her emergence into a larger social world than that offered by Hooton Levett, a hamlet of fewer than one hundred people, it is natural to expect self-consciousness to intensify this effect.[8] Not that Emma Mary Hoyle lacks self-possession. As one of the young ladies 'up at th' Hall' she occupies an assured social position. Both her youth (she looks about 15) and her poise are evident in the first view of herself which appears on page one of the album, below photographs of her grandparents. It is probably her first grown-up photograph, and, for all the simplicity of its line, the amplitude of the crinoline and walking coat she wears and the richness of her feather-trimmed hat impart a sense of dressed-up occasion. The date, to judge by the costume, appears to be about 1860 and the photographer is Oliver Sarony, a Canadian who settled in the fashionable resort of Scarborough in 1857, and made a fortune from the crowds of gentry who patronised his elegant studio as naturally as they took morning walks along the esplanade and attended band concerts at the pavilion.[9] For the young lady in the crinoline it must have been an enchanting place.

Against this first grown-up photograph we must place another. Again it is of Emma; yet she has changed, matured; her bearing is that of a poised, confident, full-bodied young woman. The face is fuller, the eye larger, and the hair, one long coil hanging to the waist, creates a fetching impression of soft luxuriance. In short, Emma now appears—the photograph is dated 1869—to have grown into a marriageable young woman. In the narrative told by this album this picture occupies a crucial position, for in showing Emma in full bloom it seems to ask a question. Where is the man to appreciate her?

One cannot help feeling that the question was in the forefront of Emma's mind. She did not lack gentlemen acquaintances, and their faces, row after row in the standard size and poses of the *carte-de-visite*, look out from the pages of her album. There are a few, a very few, foreign entries: a strong-faced young man from Milan, and another more dandified figure graced by a Parisian studio's imprint. The great mass—and this word is not so extreme since men's faces fill some five or six pages of the album—bear the marks of photographers of Yorkshire and the surrounding counties. There are also a significant minority from London and the South (gentlemen whom Emma probably met and

received photographs from during her 'coming-out' and subsequent Seasons in London). They are a various group: a pale curate from Sheffield, a smart young man from Leeds, an older, ruddy-faced man photographed at Scarborough (who one fancies has for a number of seasons haunted its esplanades and pavilions), one or two devastatingly formidable frock-coated young gentlemen, surely London barristers, and a young fellow in button-heavy livery who one feels has been either riding escort to the Queen's coach or has come from a costume ball. None of the photographs given by these young men to Emma—and one wonders if she exchanged with them portraits of herself—bears a message, other than a signature, with the notable exception of that from a wide-eyed young man named Algernon Ledjerde. Algernon—and one is inclined to call him Honest Algernon from the plainness of his features—stands before a picturesque back-cloth of lake and forest, wearing one of the standard outfits of the country gentry, hacking-jacket and breeches, and with bowler hat and riding crop in hand. He has an open, vulnerable face and this visible fact gives a certain poignance to the note on the back 'For dear Emma, with A's love'. It is a fragment from a young romance: the card is dated 1863, when Emma was 17 or 18; rapidly, and in numbers, other more debonair figures appear, over-mastering young Algernon with their suave, whiskered presences.

For the reader of the album the narrative has reached a point of tension; this probably, in truth, was the nature of Emma's experience also; the years between 1869, when she was the ripened beauty we have seen above, and about 1872, when the moment may have seemed to be slipping away, might well have been an anxious time. And then, quite casually, slipped in among the rows of Emma's gentlemen, we find a phlegmatic man in a frogged military jacket; a dark horse in the race. The *carte-de-visite* has been made by a Gibraltar photographer, which suggests that the sitter is serving in the garrison of the Rock; it is unsigned but the back has been inscribed, in pencil, 'Willie'. One cannot know how the acquaintance was made; perhaps it was the revival of an interest felt years earlier, before Willie was stationed abroad, and preserved by virtue of absence over the years. More likely it was a new meeting between two people who recognised the other's attraction and need, the girl passing beyond girlishness and anxious to assert herself as woman, the man, a stolid figure, normally, made hungry for society, and

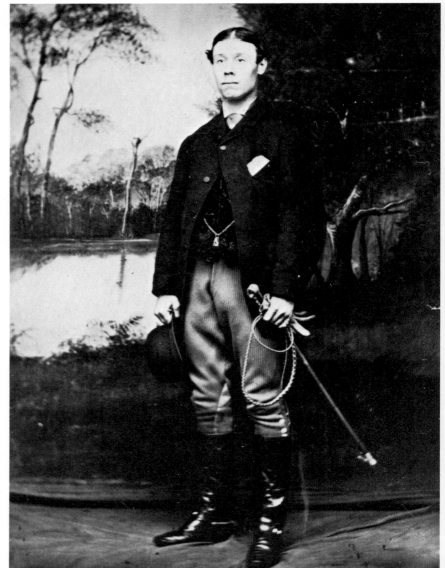

Algernon Ledjerde, one of Emma's admirers. The *carte*, suggesting an early romance, is signed 'For dear Emma, with A's love'.

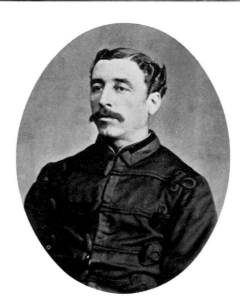

Willie's first appearance.

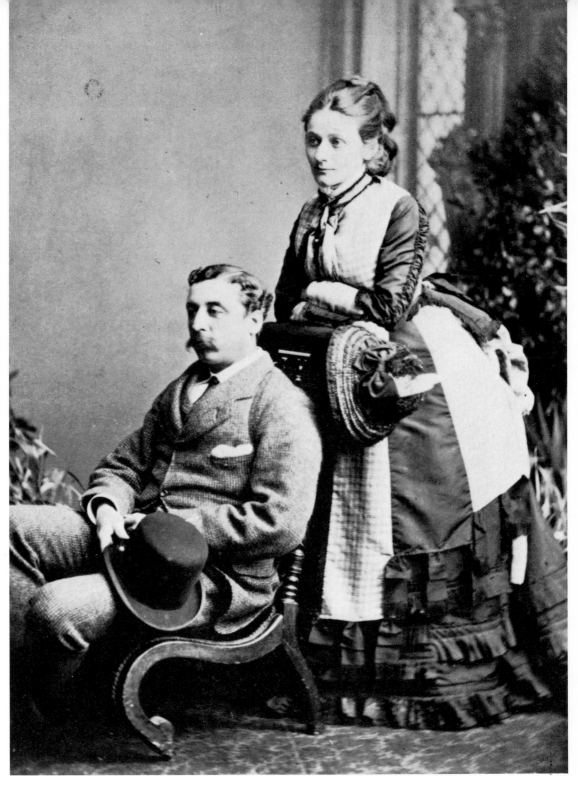

especially the company of women, by years abroad. Emma Hoyle and Captain William Salmond of the Royal Engineers were married at St James's, Piccadilly, on August 4th, 1874.

Emma married within her class. Her husband's father, also a military man, possessed two estates: one, the family seat, in Cumberland, the other in Lindsay, the huntin', fishin',

and shootin' part of Lincolnshire (about a hundred miles from Emma's home). The excitement of engagement, and the new social perspective this state creates, is expressed in photographs of Emma, appearing composed and softly happy, taking tea with Willie's sisters. From this point, the album tapers off. There are photographs of the young couple

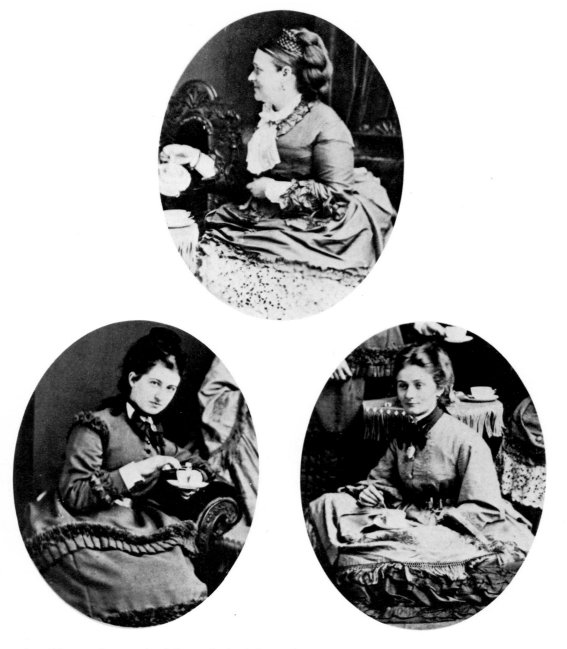

Emma, the young mother, surrounded by the family, Folkestone, 1877.

Emma takes tea with her sisters-in-law.

starting life together, and of the arrival of the first two babies. The last photograph, closing the album, shows a group taken in the conservatory of a house in Folkestone. Captain Salmond evidently is serving at the south-coast depot. The photographer has been called to record the visit of three ladies who appear to be relatives of Willie; Emma's sister is also of the party and holds the two-year-old eldest girl, Maizie, on her lap. Emma kneels, half-sitting and holding the baby's hand. She wears a checked-patterned house dress; her face has sharpened with years and maternal cares; she is no longer a girl.

Emma does not continue this album after the above photograph—dated 1877. She may, of course, have opened others; in closing this, however, at the point she does, she reveals a measure of shrewd perception. As it stands, the Emma Hoyle album possesses coherence and unity; it is the record of a young girl's emergence into the world, and carries with it a sense of the opportunities and freedom of that crucial stage in one's life when everything appears possible. Beginning with her first grown-up appearance before a camera, it concludes, equally naturally, with a view of Emma, transformed into a housewife, entering a new stage in her life.

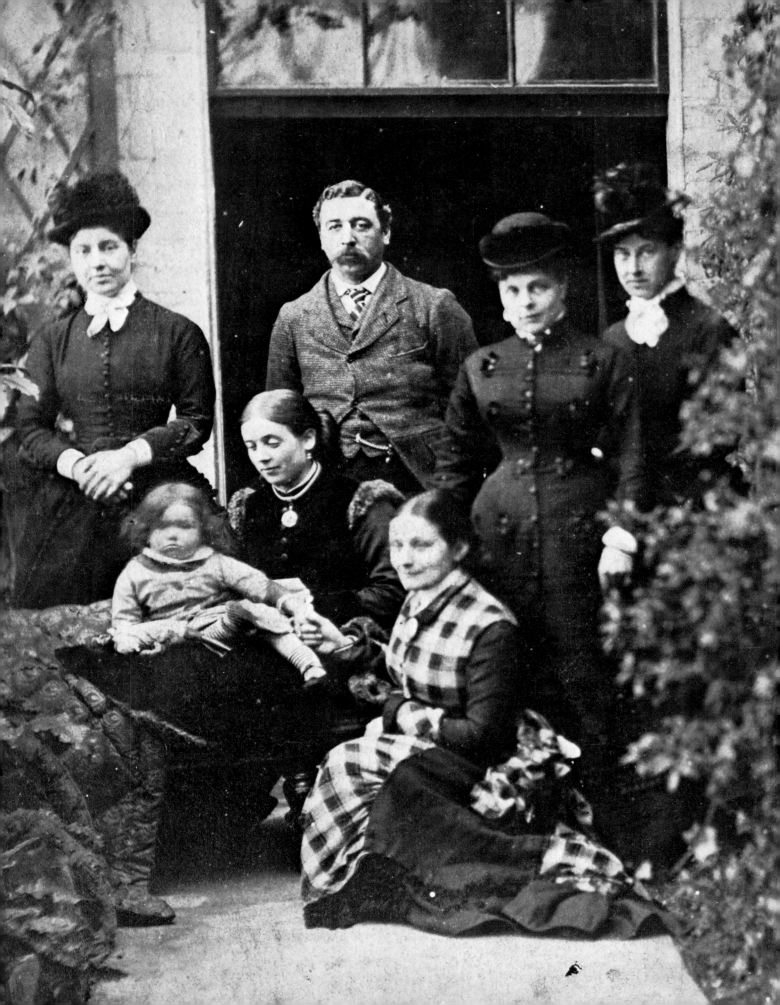

To move from the self-absorbed and re-
stricted vision of a young lady such as Emma
Hoyle to that of a woman rich in years and
position, the Countess of Hardwicke, is neces-
sarily to be carried into an ampler and more
varied world. The so-called Wimpole album
bears a gilt coronet on the cover and, this
turned, offers inside a full-plate view of the
aristocratic front of Wimpole Hall, an im-
posing residence in Cambridgeshire built in
the eighteenth century.[10] Despite this grand
introduction, the album does not proceed to
parade views of stately pomp; rather it presents
family portraits in arrangements that are
personally, and sometimes clumsily, created by
Lady Hardwicke; indeed, the album possesses a
strong flavour of art objects of the genteel,
parlour kind, like pressed flowers and water
colours of local views, popular in the nineteenth
century. This form of upper-class folk-art is
most evident in the family garland of photo-
graphs which Lady Hardwicke has arranged on
one page, a garland created from individual
portraits cut into the shape of leaves and joined
by a hand-painted stem and tendrils. The
garland is joined in a painted knot at the top; on
one side appears a photograph of the Earl of
Hardwicke, on the other side his lady; from this
emblematic union depends the rest of the
family. Elsewhere in the album photographs are
bordered with hand-painted lines, and the
group photographs are carefully captioned in
ink, with the children as well as the adults given
their titles. The exact and shiny images of the
photographs are in contrast to the hand-drawn
patterns and emphasise crudities and imperfec-
tions; at the same time the care implicit in these
adornments of the page lends extra meaning to
the photographs, an extra emotional dimension
of familial links and attachments.

All this is appealing in its openness and
display of common feeling; the photographs are
also captivating. A group portrait of the Earl
and Countess with some of their immediate
family reveals again an unassuming ordinari-
ness in their dress: the Earl, seated, appears as a
country solicitor might, in a comfortable,
baggy-kneed suit and thick-banded necktie; his
lady, in a plain, dark dress, similarly makes no
pretension at high fashion; their son, the Hon.
Joe Yorke, expresses a distinctly relaxed
attitude to life in his stance, hands in pockets,
hat tipped light-heartedly forward, jacket
unbuttoned. Far from being a swell, the
Honourable Joe maintains an outward casual
style that would make him at home, one feels, in
the billiards room of the local tavern, mixing

Lady Hardwicke's family garland.

Augustus Craven in a kilt, aged 6.

54

Lady Mary and her husband
William Craven with the infant,
Augustus.

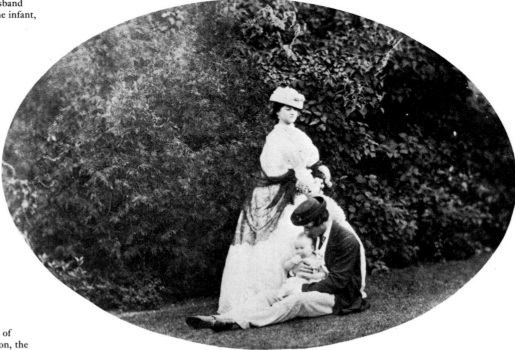

The Earl and Countess of
Hardwicke with their son, the
Hon. Joe Yorke and next to him
their daughter, Agneta and their
grandson Augustus Craven.

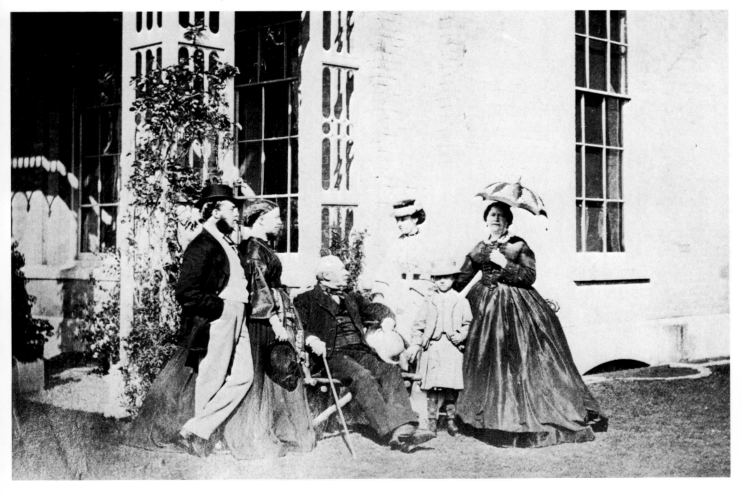

My Faithful Servants. Sydney Lodge 1863

Mary Syons. Aged 80. April 1867.
60 years service at Wimpole —

Joanna Butler. 52 y.ˢ faithful service
1875.

Mar.ᵗ Oswald. 38ᵗᵒʳ elevated service
1875 —

Rob.ᵗ Hinde. 14 y.ˢ faithful
valet to my dear Husband.

Eliz.ᵗʰ Robinson Aged 80. Oct.ᵗ 1867.
in Wimpole, Alms Houses.

W. Goulding. 24 y.ˢ faithful service
1875 —

with the sons of the lesser gentry and the villagers. His sister, Lady Agneta, appears to have made a less easy accommodation with life; a plain woman in a plain dress, she makes an unfavourable contrast with the stylish young woman behind her nephew Augustus.

Further on, by contrast with Lady Agneta and her mother, the plainer wing of the family, there stands the youngest daughter, Lady Mary, unquestionably a beauty and a lady of fashion. We see her, standing to do full justice to her crinoline, above her husband Mr William Craven, who cradles their infant son, Augustus, oblivious to the damage the lawns of Wimpole may be working on his light-coloured trousers.

The power of the Wimpole album lies in the variety of persons, styles and activities brought together within its covers. By contrast with the Waterlow and Hoyle albums there is virtually no narrative development. This is not to say that we cannot find stories within the album. We can trace young Augustus from his first appearance on the lawns of Wimpole in the summer of 1858 through subsequent portraits characterised by extraordinary precocity—at the age of six, photographed in high boots and a kilted suit, he presents the appearance of a worldly-wise Scottish laird (though curiously diminished)—to his appearance on his grandmother's family garland, a debonair somewhat languid youth of seventeen. One might predict from these early views that Augustus Craven—shrewd and worldly lad as he obviously was—would find nothing absolutely worth making an effort for in the world. In fact, Augustus appears to have lived a quiet and unexceptional life on the family estates in Cambridgeshire (his mother's side) and in Berkshire (his father was a nephew of the Earl of Craven who owned 20,000 acres in that county); he served briefly with the Royal Berkshires (Militia), married a general's daughter but had no children, and, after her early death, maintained a solitary, and no doubt gentlemanly, life until his own end (in 1929) at the age of seventy.

Moreover, such stories are to be found beyond the family circle, for the Countess, as lady of the great house, has special responsibility for the household, and a special sense of responsibility for those who serve it. She devotes a page to her 'Faithful Servants', as she terms them in the caption to a group portrait of the upper household staff at the smaller residence nearer London (Sydney Lodge, Hamble, Hants.), which the Hardwickes appear to have preferred to the stately pile at Wimpole. The page actually comprehends servants at both houses, and 'faithful' appears a just epithet when one considers the years of service they have devoted to the Hardwicke family. Two elderly women in frilled caps appear to have gone into service at the great house in girlhood and left only to spend a few remaining years in the Wimpole almshouse after 60 years of domestic work. Apart from these mob-capped veterans there are upper servants of as stately and respectable an appearance as their masters, housekeepers in rich gowns and capes who have been 40 and 50 years with the family, and a splendidly archetypal butler—a mere junior of 24 years' service—with a bald pate, upswept wings of hair, and a supremely confident air of respectable discretion. The inclusion of these portraits, fascinating as they are in themselves and in the sub-stories they suggest, serves a crucial function in the album as a whole. Here are men and women subject to the commanding assurance of the Hardwickes; their presence completes the views of the family: the precocious Augustus and his elegant mother, the easy-going Honourable Joe and his rather plain sister, Agneta; these varieties of confidently assumed attitudes depend upon the existence of the faithful bodies on the servants' page.

These albums run true to type: the conventional ideas associated with these three distinct social classes of the Victorian period emerge clearly and, one might almost write, predictably: aristocratic assurance, the narrow, rather unimaginative range of vision of the landed gentry, the drive of the rising bourgeois family. To what extent, one wonders, are the owners of these albums responding to a prevailing idea or image of themselves? It is virtually impossible to answer such a question. But obviously the family photograph album encourages self-perception and a certain degree of objectification of self and family; the figures in its pages play out, as it were, roles and stories to an audience of family and friends. Naturally it is possible for the owners to shape these stories, in conformity, of course, with the data, and guided by prevailing ideas of what the facts mean.

A nice example of this creative shaping can be found in an American album of the late-Victorian period.[11] All albums are cooperative works, involving photographer, sitter, and collector; the Shurman album appears to involve the joint work of two collectors, mother

Alice Schulthuss aged 18, the first keeper of the album.

Opposite
Alice and her schoolmates at finishing school in Germany. In keeping with the style of the Victorian scrap-book a cut-out portrait of one friend has been added on the right.

and daughter. The mother, Alice Schulthuss, appears to have been born in the United States of German parents in the 1850s. At the age of eighteen or so she was sent back to Europe to attend finishing school; it is at this point that the album opens, with a page devoted to German views, including portraits of the King and Queen of Würtemberg and their royal estate. A group photograph, holding the centre of the page, shows Alice Schulthuss and three of her schoolmates at their Stuttgart school. They appear to be extremely well-poised young ladies, dressed in the height of fashion of the early 1870s. A larger, close-up portrait of Alice, aged 18, shows a softer, rather dreamy girl, with flowers tucked into her much-curled coiffure. The girls have obviously come, from America and parts of Europe, to gain the appropriate accomplishments of well-to-do young ladies before marriage (in the group photograph one plays the pianoforte, another holds needles and wool).

Romance and marriage must have occupied the thoughts of these girls and, between the views of German castles, the album reveals these ideas taking concrete form. First, Alice Schulthuss goes to Baden-Baden as a bridesmaid for a schoolfriend; there, almost inevitably, one feels, she meets her own intended; and we find a large view of the Old Castle, Baden-Baden, its ruined walls overlooking a wide, sweeping valley. The photograph has been edged with evergreen of a small, Alpine variety, and it is annotated 'Where I accepted C. S. Schurmann'. We next see Alice in her wedding gown; the photograph is dated 1874 and someone has begun to alter the caption 'Alice Schulthuss' to read 'Mrs Alice S. Schurmann'. The obvious meaning of this photograph is confirmed by a stream of entries which follow, of views from many parts of Europe; Alice appears to have gone on a wedding trip down the Rhine, on to Hamburg and back, visiting Paris, Munich, Salzburg, and Vienna (for the Exposition of 1875).

At this point an interruption occurs in the keeping of the album. When it recommences a new hand appears to be placing the photographs, and 20 years, it appears, have passed by. The location is now Louisville, Kentucky, and the album is being kept by a new Alice, who appears to be about fourteen years of age, and whose name has been simplified to Shurman. We see this Alice, with her brothers Charles and Clifford leaning on bicycles, in front of the family house (a typical example of Victorian American house architecture) in Louisville; the

mother, Alice Schurmann, sits behind, on the steps. The photograph is delightfully evocative of turn-of-the-century America. But what has happened? Something sad or unspeakable lies in that unrecorded passage of time. There is one item of explanation: a note on the view of a large house in Baden-Baden reads: 'I became engaged to my first husband'. There are no photographs of C. S. Schurmann and no indication of how he departed from Alice Schurmann's life; nor are there any photographs of a successor, nor any of how and when Alice Schurmann returned to America.

It is these omissions which emphasise the hiatus in the story and create such a telling sense of mystery. There may be a simple, commonplace explanation for that gap, but these omissions suggest otherwise, and the sense of some profound psychic shock lying concealed in that emptiness is reinforced by the visual impact of the contrast between the early pages of the album—richly packed pages of views, on a tiny scale, of castles and palaces, surrounding the upright, becurled figure of Alice stepping hopefully into this romantic world—and the last pages. The strong, four-square American views challenge the scattered, miniaturised grandeurs of Europe like present reality dispelling past dreams. One cannot read the Shurman album without being conscious of the presence of ideas found in the novels of Henry James— novels being written between the time of Alice Schurmann's abandonment of her album and its revival by her daughter.[12] The theme of the promise of Europe—its appeal to the culture-hungry gentry of the New World, and the demands it places upon those who succumb to its promise—this theme appears to lurk in the unexplained gaps and contrasts of the Shurman album. The fact that the album's story is told first by the mother and then by the daughter suggests the vitality of this appeal which is passed down through the generations.

But the album does not need Henry James; rather, the boot is on the other foot. The Shurman narrative deals in experiences common enough, probably, towards the end of the nineteenth century, as immigrants who had made good in the New World sent their children back to Europe to be educated. The album belongs to the body of material—oral, written, and here pictorial—upon which James might have drawn. Of course pre-existent ideas and stories have played their part in its shaping—romantic Europe is itself such a story—but it is a particular, individual story which is recounted. The half-formed stories

Alice in her wedding gown in Europe, 1874.

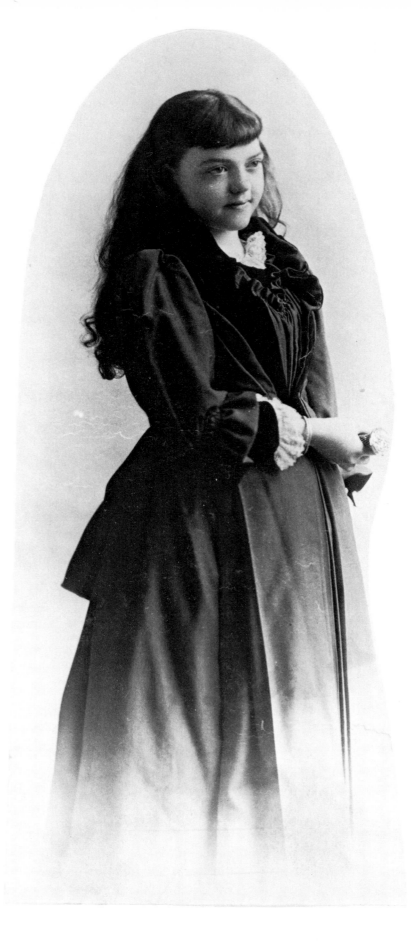

Alice's daughter, the new keeper of the album, aged 14.

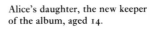

Opposite
Mother, daughter and sons on the steps of the new family home in Louisville, Kentucky.

which one finds in this and the other albums examined in this chapter appear to arise, in their parlour gestation, as creative attempts to order life into meaning; story is the simplest form of meaningful order. The literal details of the photographs are accommodated easily enough into the simple stories of the albums, and provide, in their particularity, a strong social and period colouring to the reading. It is no wonder that the modern reader examining these albums feels the hovering presence of Victorian novelists, for the fragmentary, half-seen actual histories they present are like the half-realised stories which those novelists perceived in the world about them; reading these albums is, indeed, like perusing a writer's notebook. As documents half-shaped into narrative Victorian photograph albums, they come down to us as objects halfway between the life and the literature of the age; in this they reflect again the median position which photography frequently occupies between actuality and art.

4

FASHIONABLE DISPLAY

Photography can bring one close to the famous Victorians. We can be especially grateful, in this regard, for the exceptional work of that independent lady Julia Margaret Cameron who, taking up photography at the age of 48, set about recording the faces of celebrated men. She found one most convenient subject in the poet laureate, Alfred Tennyson, who happened to live in a house near the Camerons on the Isle of Wight. Mrs Cameron's portrait of Tennyson, reproduced here, is an excellent example of the large head studies which were her forte: it was made in 1869 and, in terms of camera style, is far in advance of its time and quite different from the general run of commercial portrait photographs.[1] This difference lies chiefly in the candour achieved by close positioning and focus upon the face (Mrs Cameron did no enlarging). We feel, perhaps with a certain degree of shock, that this is indeed what Tennyson looked like at the age of sixty. Carlyle's comment, after a visit to Farringford, that Tennyson had the figure and head of a Guardsman, but that the features were 'spoiled' by poetry, becomes understandable in this study of a man of manifestly sensitive and introspective nature.

Mrs Cameron's portrait is, in fact, a photograph taken for the purpose of revealing character through the face, a comparatively rare use of the Victorian portrait camera. If we look at the full-figure photograph of Gladstone taken in 1861 by J. E. Mayall we see a far more typical example of portraiture from the middle of Victoria's reign. Leaning against a Corinthian column and balustrade, a gentleman stands, top-hat casually in hand. The pose, the dress and the background are common to a

thousand portraits of Victorian gentlemen but the striking, hawklike features of Gladstone, immediately recognisable, convert the portrait into a social document of more particular meaning. This was taken at a moment when Gladstone was coming to public attention as a formidable political figure (he had just put through Parliament the country's first Finance Bill, against the will of the Opposition, led by Disraeli, and the disapproval of the Queen, the Lords, *The Times, Punch* and his own Prime Minister, Palmerston). Mayall's *carte-de-visite* photograph, made for mass sale, is itself evidence that the Chancellor of the Exchequer had become a celebrity; his fierce eyes would henceforth glare from the display racks of photographers' shops and from thousands of private photograph albums.

Is there more to the photograph? The arrangement of the figure and the studio properties is pleasantly asymmetrical (though the negligently crossed legs appear curiously dislocated), but there is nothing more than journeyman competence in the composition and conventional *carte-de-visite* pose. Rather than close with those bold features and draw from them a dramatic expression of the powers within, Mayall has contented himself with placing his subject in pleasing relationship with the fragments of a fashionable drawing-room, constructed from wood and plaster, which are elements of a photographic code reading 'Here Stands a Gentleman'. There is no news in this: the public did not need such instruction or reassurance concerning the social status of Mr Gladstone (educated at Eton and Oxford and, through patronage, hard work and a fortunate marriage, the owner of a substantial estate in

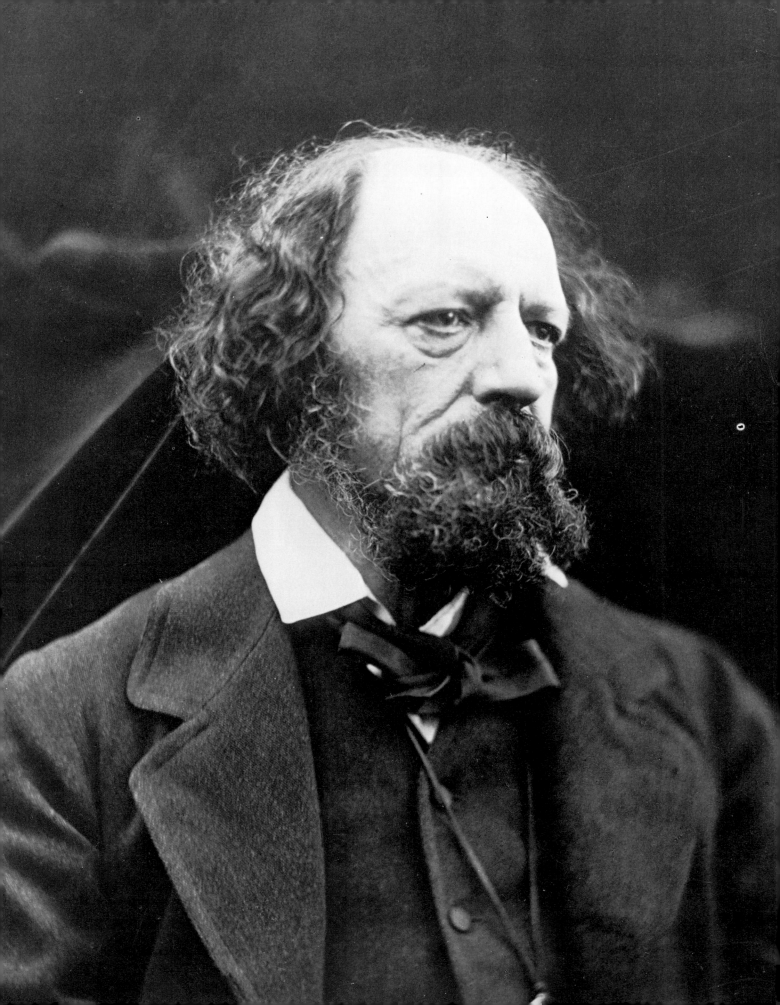

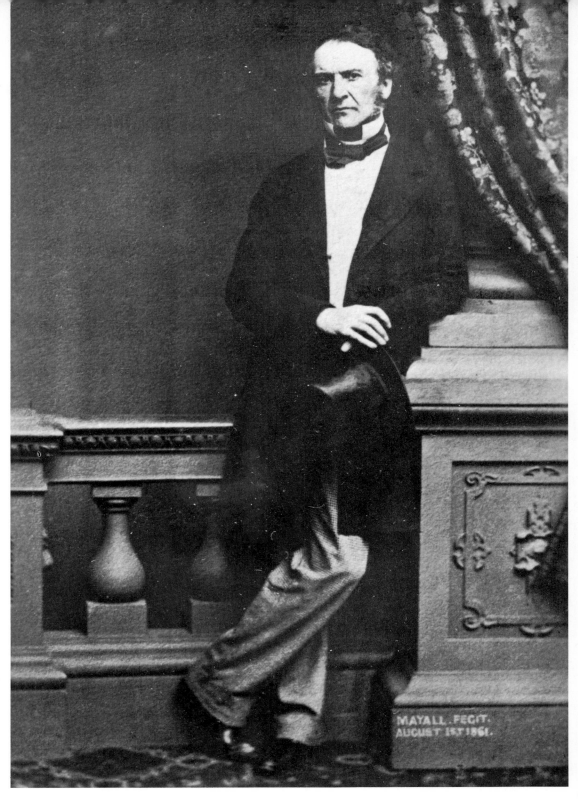

Alfred Tennyson by Julia
Margaret Cameron, 1869.

Opposite
Gladstone by J. E. Mayall, 1861.

Wales). Yet the energy, capacity and time of the photographer and sitter have been put into a display of convention which is as empty of purpose as the carrying of gloves on a summer's day.

Such displays of conventional decorum, blending the dictates of society and the studio, are among the characteristic marks of Victorian portrait photography. Preparation is everywhere manifest: we see rooms and figures, arranged and dressed. A panoramic over-view of this host of images, if it were possible in an instant, would show a society on parade, faces at attention, Waiting for the Photographer. This

general impression is unquestionably of value, for it provides the basic context, yet it also leaves the Victorians exactly where they want to be, framed in distant, conventional poses which deflect the examining eye. It is necessary to press closer, to superimpose other contexts and disrupt the considered terms on which these sitters meet the public; once this is done a complexity of meanings begins to emerge, linking the relatively narrow field of portraiture with broad social attitudes, refining our perceptions, and, one would like to think, making the photographs more interesting.

A drawing-room background, as in Mr Gladstone's portrait, was the most widely used studio set of the 1860s—the period of the *carte-de-visite* (about which more will be said) and the general expansion of portrait photography. To that date it had been an amusing affair for amateurs and an uncertain business for professionals; the decade of the 1860s saw it broadening into a lucrative and widespread trade with diversification into a luxury market, supplied by the fashionable studios of London, principal cities and smart watering places, a second-class trade driven by photographers located in unfashionable suburbs and industrial towns, and a more general trade served by the photographers' shops that stood in the High

Street of many small country towns. For all these levels of custom—encompassing high society, the gentry, merchants, farmers and work people—the drawing-room set the standard; differences in the figures, social and physical, only bring out variations in the essential meaning of the set, which expresses fashionable respectability.

Camille de Silvy, whose portrait of the Prince of Wales, full-length, top-hat in hand, appears here, was one of the most fashionable of West End photographers. He has been described, in contemporary photo-history, as imaginative in his use of studio backgrounds, and is credited with introducing (with J. E. Mayall) the *carte-de-visite* into England.[2] Yet in this photograph his handling of stock studio properties reveals adept use of tricks of the trade rather than artistry. The essential elements of the composition are social and occasional: the identifying symbol—the Prince of Wales's three-plumed crest—embossed on the base from which the upper cornice and the column have been removed (revealing, under the Prince's hand, the flimsy nature of its construction); the fall of black cloth which replaces the column and runs along the floor behind the Prince; the figure of the Prince, his sombre frock-coat, waistcoat and cravat matching the drapery of

A typical commercial photographer's shop, Taunt's of Oxford. The window on the left displays a range of 'Shilling Views' of the Upper Thames; on the right a number of *carte-de-visite* portraits are shown under the Christmas cards.

Opposite
The Prince of Wales in mourning for his father, by Camille de Silvy, 1862.

68

C. Silvy

mourning and his shortness disguised by the lowered height of the base against which he leans in the standard, nonchalant pose of the gentleman at ease. Evidently the photograph was made in early 1862, after the death of Albert, the Prince Consort (in December 1861), and stands as a formal record of an historical episode — part of the Royal Family's official history, so to speak. We can be sure that this photograph was 'published', that is, reproduced many times, and the prints distributed throughout the country for sale. Certainly the elements we have noticed, the crest, the drapery, the dress, would have struck in the Victorian public the acceptable and sonorous note of funereal decorum and no doubt produced sighs, and head-shaking over the young Prince, left fatherless. Within the context of these fashionable and decorous expectations the photograph conveyed a firm meaning; to later viewers, conscious of the stresses of the Prince's upbringing, under the eye of his severe parents, extra dimensions of meaning are added, enriched by images from later photographs, of the Prince at 45, portly and self-indulgent, or at 60, as King Edward, bearded, heavy-lidded and over-wise.

The young Prince, a slim and boyish figure in his slightly baggy, over-large clothes, tall and ugly hat in hand, might serve as an emblematic image of the young upper-class Victorian obliged by family, class and social expectation to don the formal garb of the Victorian gentleman at an age before experience and a sense of self had filled out his substance. The Prince was, in fact, suffering the pressures of a forced maturation at this time. Although his parents were disappointed in him — and told him so — he was sent off alone on a State visit to Canada and the United States in 1860; the trip gave him a glimpse of freedom. Away from stern parental watch the Prince enjoyed himself as any high-spirited youth might, and charmed his hosts, particularly the Americans, who appear to have expected a stiff and condescending young prig, by attending all the parties and balls he could and dancing into the early hours of the morning with many of the rich and fashionable heiresses of eastern North America. Returned to England in the summer of 1861, he attempted to assert himself by asking, again, to be allowed to go into the army; as a compromise, he was allowed to attend summer training camp at The Curragh in Ireland, and there he met Nellie Clifden. This young actress was thrust upon the Prince — some say conveyed secretly into his bed — by brother officers

amused by his sheltered and innocent state.[3] The consequences were terrible for the poor youth, for, being unwise enough to allow Nellie Clifden to follow him to England, he brought the affair himself to the point where it was reported to his parents. Their reproaches were unrestrained and crushing and, on the Queen's part, were redoubled after the death of Prince Albert from a condition brought on, she charged, by grief and disappointment; the Prince remained into middle age fearful and uncertain in the presence of his mother, while making up, in a libertine and opulent private life, for what he must have regarded as the wasted years of his adolescence. In this light the portrait appears charged with a poignancy deeper than that arising from a single death: the life-killing drapery of respectability makes its weight felt.

A portrait of Adelaide Neilson, the American actress, should be considered in this wider context, for, while not capable of bearing a comparative weight of meaning, it reveals respectability implicitly countering impropriety. Photographically, the picture is a curiosity. Taken by Napoleon Sarony, who later became known as a specialist in theatrical photography, it comes from the period just before the wider Cabinet size and head-and-shoulders form became usual for theatrical portraits. While employing the stock properties of column, balustrade and curtain, and the full-length figure of the *carte-de-visite*, Sarony portrays his subject in theatrical costume — 'in character' as it was termed — in the long robe she wore as Juliet in a Broadway production of *Romeo and Juliet*: yet any suggestion of abandon, of that Bohemianism and unconventionality of behaviour associated with costumes, dressing-rooms, and the life of the stage in general, is checked by the rectitude of that stiff drawing-room set. The photograph stands in strong contrast to a class of *carte-de-visite* which came, commonly, from Paris and showed entertainers, notably ballet girls, in poses displaying their legs; it expresses the respectable and well-bred tone which marked the American theatre, and which European visitors commented upon, a decade or so before that quality became dominant also in the London theatre.

These questions of propriety appear trivial, however, when one considers that of class. Social respectability, having a position in life, being above the anonymous mass, becomes the claim asserted by the drawing-room background when working-class people are mus-

tered before it. The fake panelling, columns and curtains, a bland or perhaps ironic frame for members of the upper classes, become potent indeed in meaning when they are the only re-semblances to a fashionable drawing-room the subjects are ever likely to know. Such is surely the case in the photograph of the Alexanders, a Birmingham artisan's family, photographed in the mid-sixties. The studio they are patronising is evidently of the second-class, for the imit-ation moulding and wall reveals a crack— nevertheless this print is not likely to have cost less than five shillings, a sizeable outlay. The girl at the back, marked with a cross, is Caroline Alexander; she started work at the Cadbury's chocolate factory, in the centre of Birmingham, at the age of ten, in 1860. It was common prac-tice for the children of the respectable working class to go early to factory or shop work, particu-larly when there were many mouths to feed. But if factory labour, in genteel eyes, meant social ignominy there is no sign of it in this photo-graph: husband and wife sit four-square and solid, the twin pillars of the family, with the children arranged in respectful poses about them. All bespeaks virtuous and hard-won respectability: great care has evidently been taken with the boys' collars and hair; a book, evidently a testament or missal, lies at mother's hand as a sign of the presence of moral guidance; the whole family wears dark, sober dress. Homogeneity of dress characterised the Victorian middle classes and the wearing of the same respectable styles extended downwards to the working class (unlike the situation in Continental Europe, where, for instance, the artisan's blouse and beret marked the French workman).[4] Here only the meagreness of adorn-

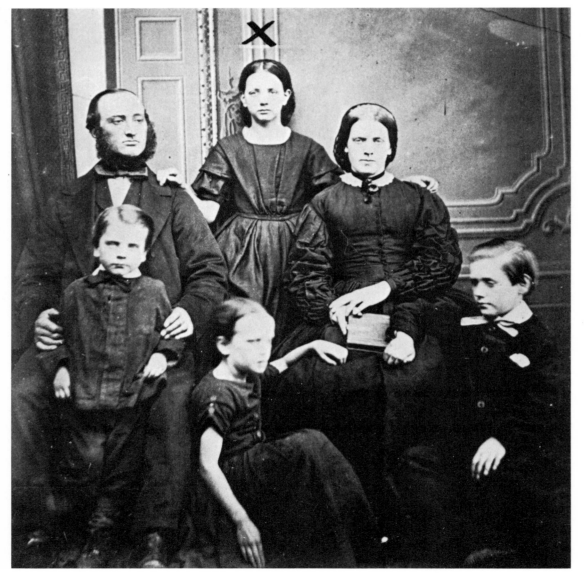

Caroline Alexander, a Birmingham factory girl and her family in the 1860s. Despite the meagreness of their clothes, all bespeaks virtuous and hard-won respectability.

Right
A burlesque *carte-de-visite* from an English album of the 1870s.

Far right
A living doll from a Victorian family album. The photograph provides a striking image of the upper-class cult of the nursery and a detailed visual account of the care with which its darlings were dressed.

ment and the poor quality of the children's clothes indicate the less than comfortable financial circumstances of the Alexanders, which for this photograph they have clearly made a mighty effort to transcend.

While there is some stiffness in this photograph, the plain seriousness and honesty of the effort made at social assertion overcomes the risibility lying in the exaggerated thrust of a side-whiskered jaw and the uncomfortable piety of a child posed at mother's knee. But with its social display settled into mannered poses Victorian portrait photography obviously lay continually in peril of subversion through its own incongruities. Photographers were aware of this: in the 1870s a vogue existed for comic portraits which overturned convention; they show gentlemen confronting the camera with newspapers drawn across their faces, or in a theatrically dishevelled and drunken state. This is the same spirit of fun—a gently satiric pleasure in topsy-turveydom—which inhabits much Victorian light journalism, *Punch*, for instance, after the mid-century, and Gilbert and Sullivan's comic operas. (Photographically, this tradition rises again in comic postcards at the end of the century.) This burlesque tradition fed naturally upon conventions such as the drawing-room set, which, in its standard use for all figures, sometimes takes a quite charming turn: a very small girl, for instance, stands against a grand background of column and balustrade. In a social sense the figure and setting are of one piece—short crinolines and bootees were high children's fashion in the 1860s—but the formidable bastions behind, in their scale, reduce the child to the figure of a doll. The photograph comes from a family

album and there is no reason to regard it as deliberately comic in conception; it provides a striking emblem of the upper-class cult of the nursery and a detailed visual account of the care with which its darlings were dressed.

Another photograph, from the 1890s, and from another continent, reveals social display transferred from the studio to the outdoors: two young ladies, dressed in the height of fashion, engage in parlour occupations, reading and sewing, on a rock outcrop in the woods of upper New York State. Again, the photograph succeeds, and is completely charming, because of the assurance of the sitters and the candidness of the composition: it depicts the two girls in a fashionable light, while being thoroughly honest about the photographic occasion.

Not all outdoor portraits accommodate incongruities with such grace. Actuality of background introduces a documentary element which may make the deliberately arranged poses of studio portraiture appear disconcertingly contrived. A group photograph of Prince Arthur, later Duke of Connaught, with his party in Canada in 1870 reveals awkwardnesses caused by the further complication of rank and occasion. One of the most common outdoor motifs employed by Victorian photographers is the lawn party, for tea or croquet; as an organising principle it is equivalent to the fake column against which gentlemen lean. In his recording of the Prince and his party at the summer home of the Canadian shipping magnate Hugh Allen, at Memphramagog, Quebec, the photographer has adopted the croquet-party form in order to create a natural and relaxed group. But the form has been overborne by the sense of royal occasion. The ladies and gentlemen of the party have been arranged in rather obvious alternation, and the group is unified in a pyramid shape, with Mr Allen and Lord Lisgar, the Governor-General of Canada (in dark frock-coat), serving as the twin peaks of ascending lines. The Prince has been seated at a table off-centre; unfortunately, the casual effect created by this displacement is frustrated by the stiffly attentive pose—one might say guardianship—affected by Lord Lisgar, at the elbow of the young prince, and by Lady Lisgar, who directs a fixed stare across the table at their royal charge. Perhaps the only figure to appear genuinely relaxed is that of Hugh Allen, who stands like a loyal retainer at the rear, hat in hand (he was rewarded for his services with a knighthood the following year). A companion photograph, showing the servants of the party at the rear of the house, reveals a more cheerful freedom on the part of both photographer and subjects—but the striking of individual poses is again noticeable.

Opposite
Prince Arthur's royal party visiting Canada in 1870. The croquet-party form was supposed to create a natural and relaxed group but this has been destroyed by the sense of royal occasion.

The servants of the royal party in a more cheerful mood.

Fashionable young ladies from New York State in the 1890s.

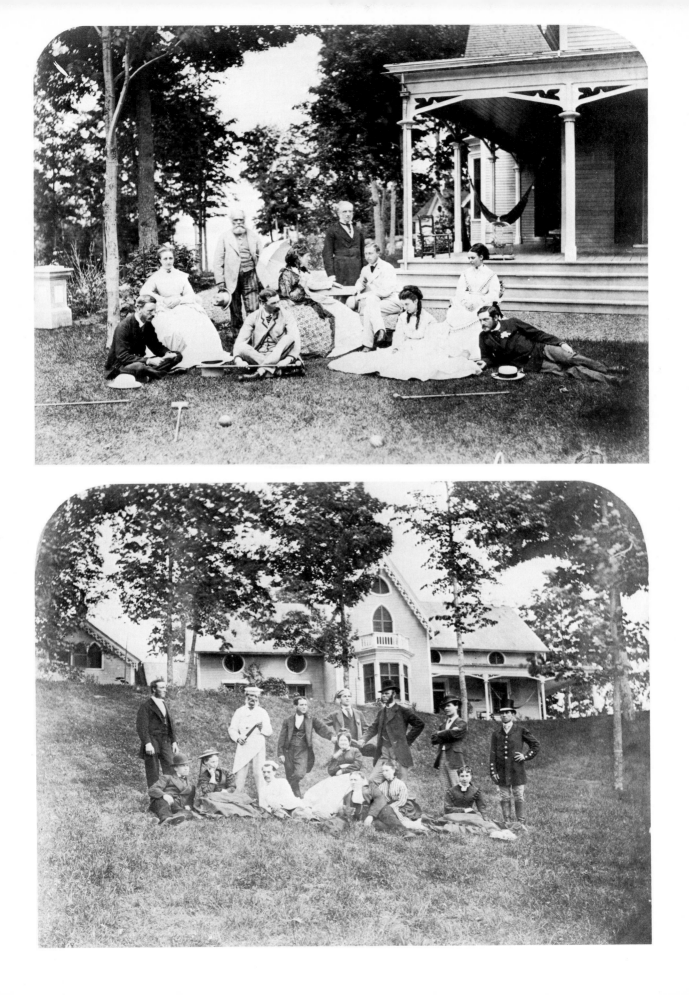

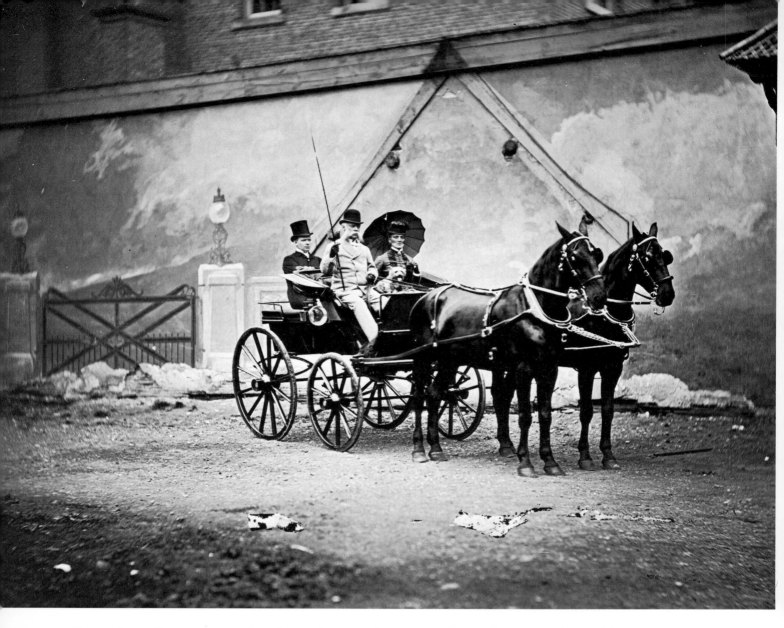

Social display in fashionable
Montreal: Colonel Stanislaus
David against a crumbling
painted landscape (William
Notman).

Pomposity suffers, as ever, when it stands revealed, and this a widened camera vision may do. In a photograph by William Notman (of Montreal) made of Colonel Stanislaus David and his carriage and pair, we see the pictorial fiction of the background — the wall and gates of a palatial estate — visibly undermined by the crumbling plasterwork at the foot (and the exposed building behind the wall on which the scene is painted). The carriage is very smart indeed — one of the principal amusements of fashionable Montreal in the age of the horse was the 'show' drive around Mount Royal — and all is in its place: the Colonel sits erect on the driving seat with his lady and her parasol and Yorkshire terrier; the groom sits behind, arms folded until he is required to hold the horses' heads and assist the 'quality' to descend. The actuality of the grit-strewn and peeling sur-round counters the studio centre-piece with sufficient dramatic force to make this an amusing view of smart society preening itself — amusing and rather repellent. Indeed, with Colonel David's carriage in mind it is difficult to accept more modest displays of pride and affluence. Tactful and natural grouping makes a pleasant and interesting photograph of a family of well-to-do Scots Canadians returned from a long holiday trip to Scotland and other parts of Europe; yet one cannot but be aware of the calculation which has brought Mr James Croil and his family, armed still with the walking sticks and staves used on their Alpine tour, before a fashionable studio set at Notman's — trunks and cases arranged label foremost as evidence of the travels.

The opinion of Thorstein Veblen comes to mind; that delightful iconoclast of the late-

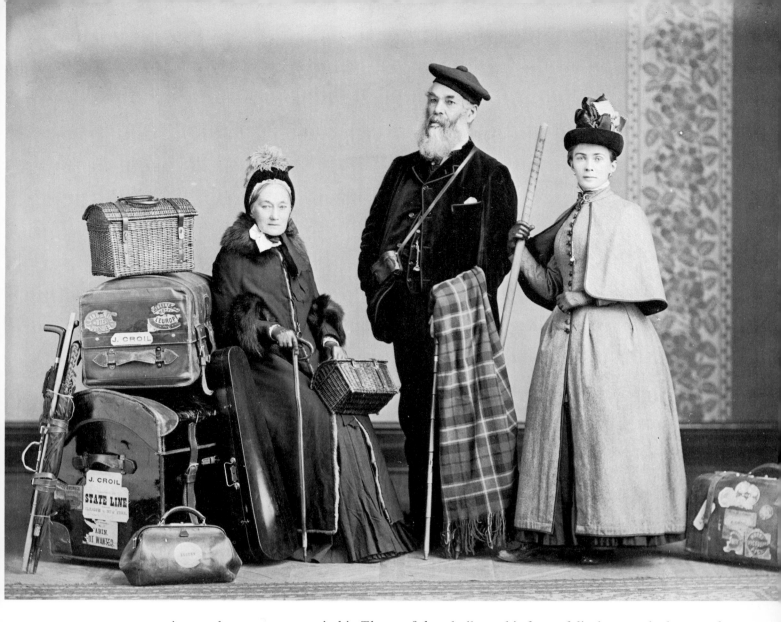

Mr James Croil and his ladies recently returned to Montreal from a European tour with their luggage appropriately presented (William Notman).

nineteenth century argues, in his *Theory of the Leisure Class* (1899), that the motive behind the vigorous economic activity of the West in his lifetime lay not in self-interest or in social improvement but in the cultivation of an expensive and non-productive appearance, richer than one's neighbour, and demonstrably at leisure. To a certain extent the Victorian portrait camera bears him out: the self-made men of engineering, industry and commerce might be willing to be visually associated with their work—Isambard Kingdom Brunel before the anchor chains of the *Great Eastern* stands as a splendid example—but their children, and many eminent Victorians besides, evidently found that good form required that they be photographed in drawing-rooms or upon lawns of great houses, living, conspicuously, at leisure. The spread downwards of conventions

built on this form of display reveals the spread through all classes of acceptance of—or at least deference to—affluent leisure as the good life. While the camera appears to be the perfect Veblen instrument for making a fashionable appearance, hindsight allows us to note that photographic portraiture has not developed in the service of social flattery—its direction has been towards the revelation of truths. We can see an example of this in a photograph from the 1890s; it is a portrait of a navvy foreman and his wife that might at first seem to confirm Veblen, for there is a chokingly claustrophobic presence of conventional social display. Husband and wife stand at the family portal (a wooden hutment beside the railway line), their possessions at hand—a bicycle and a terrier dog; their dress bears a vestigial resemblance to fashionable wear. Yet the photograph is not the

Social display in a railway yard: a British navvy foreman and his lady from the 1890s.

social travesty (of Colonel David's carriage, say) that it might be, for a sense of personality is conveyed with such direct force that dress, dog, hut and bike become only details subsidiary to the whole human message. The intent, of course, has not been to flatter; this is not a commissioned studio portrait; but once the capacity of mind and technique to work in wider fashions than serve narrow social purposes is demonstrated then the validity of sweeping explanations, such as Veblen's, becomes suspect.

In justice, it must be said, however, that a great deal of social make-believe inhabited the world of portrait photography and was deliberately fostered by commercial photographers. The fashionable studio set was a part, at the better houses, of premises equipped like West End clubs with lobbies and reception rooms. Some of the establishments were large and imposing: the Sarony Gallery, in Scarborough, was one of the sights of the town, a building designed in a 'Grecian style', we are told by a contemporary, with its entrance flanked by stone lions. Receptionists of genteel appearance attended to the customers, whom assistants in the back never saw except as darkroom images. Ladies and gentlemen were to feel at home in these *salons*—according to H. Baden Pritchard, a photographic journalist of the 1870s, well-to-do women did spend leisurely afternoons at the photographer's,[5] but the group most likely to be excited by the fashionable tone of these studios would be the classes below the drawing-room level, office clerks, shop assistants, milliners and so on, who valued a respectable appearance and who, stepping inside the photographer's premises, might feel themselves engaged in an activity which joined them, however briefly, with the Upper Ten Thousand.

In a sense, the photographers came by this fashionable tone honestly, since the carriage trade was their support during the days of the daguerreotype and the calotype, when a portrait cost a guinea or more. But there is no question that they strived consciously to make fashionableness part of their stock-in-trade as costs dropped and the lower middle classes swept in. It could be overdone. Baden Pritchard, in fact, warns against creating a studio fit for Belgravia where a Belgravia clientele does not exist, and driving custom away by an expensive appearance. The more general trade of the country-town photographer allowed a down-to-earth, comfortable aspect; Henry Taunt's studio in Oxford's Cornmarket, with its rows of frame patterns hung in the window, looked like any other shop in the High Street, and up the

Opposite
Miss Bompas being served tea in a studio set at Notman's Montreal studio, 1888. The photographer has taken obvious care to arrange every detail including the placing of the cakes on the plate and the folds of the white shawl against the black dress.

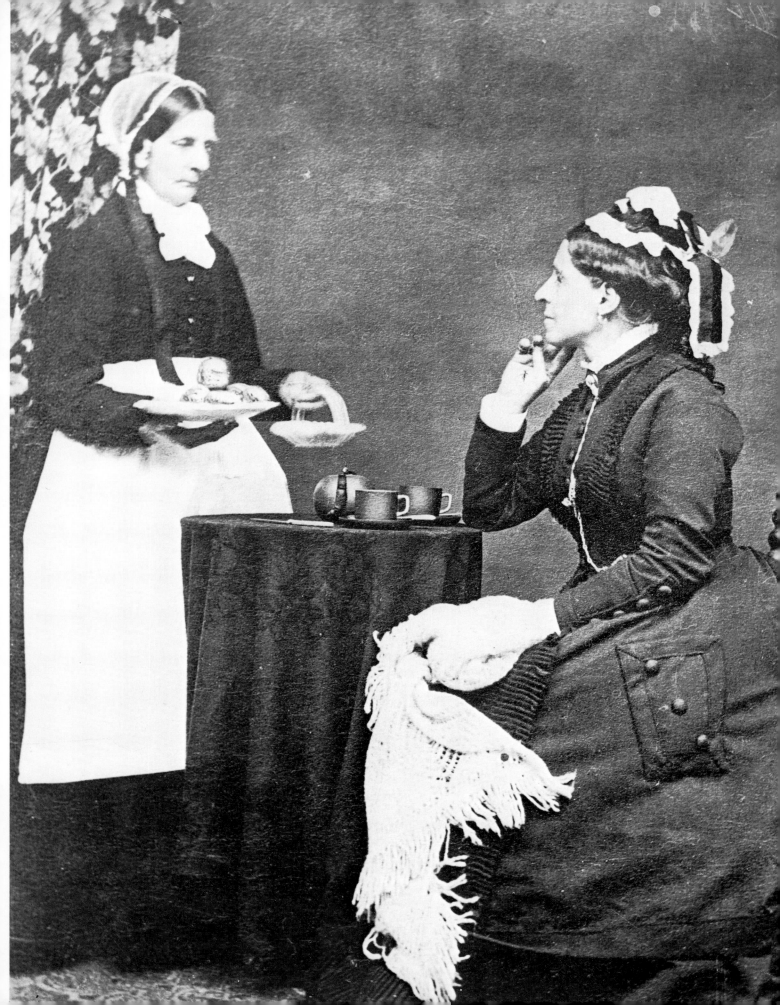

stairs to his sky-lighted studio clattered towns-people, local gentry, and dons and under-graduates from the university.

Socially, the majority of Victorian portrait photographers appear to have been drawn from the ranks of the lower-middle class and—although often possessing artistic talent—reveal a strongly commercial attitude in a field that (in the 1850s) was expanding rapidly; commercial aptitude was necessary for survival. The success stories of this generation do not involve technical invention; they celebrate rags-to-riches achievements. Edward Thomas, who established the Cambrian Gallery in Liverpool and became a prolific producer of series of Welsh views, was the son of an illiterate hill shepherd; Henry Taunt, the eldest son of a plumber and glazier, amused himself with water-colour paints while working as a shop junior at a draper's; taken on as an assistant in a photographer's shop, he became an operator at 16 and opened his own business at 22. (Disderi, the king of photographers in France in the 1850s and 1860s, also began his working life as a draper's assistant.) William Notman, the son of a designer at the Paisley silk mills, emigrated to Canada and, while working as a clerk in a dry-goods importers in Montreal, profited by the slack winter season to start a photographic business; the firm was a success, with branches in Boston, Toronto and other principal cities.

In their advertising, photographers appear to have been neither more nor less obsequious than other forms of Victorian trade, which in mid-century addressed its customers as Ladies and Gentlemen, the Favour of whose Custom was Respectfully Begged; such expressions of respect were dropped when a more aggressive style of advertising developed. Because of daily contact with the public one can see that the studio could be an arena of conflict. Mastery of the new technology, with its esoteric chemical terms, conferred authority on the photographer in a manner expressed in Lewis Carroll's burlesque 'Hiawatha Photographing', as sitters came under the command of he who:

Stretched his hands, enforcing silence—
Said 'Be motionless, I beg you!'
Mystic, awful was the process.
 All the family in order
Sat before him for their pictures

But this is written from a deliberately naive viewpoint and, anyway, reflects the willingness of a genteel family group to be intimidated, and amused, by the visit of a scientifically enthused

and eccentric friend. There is no question that the authority of the portrait photographer was frequently contested by patrons who regarded all tradespeople as servants and were un-impressed by science. In memoirs and other literature addressed to a general public the note of complaint is sounded by photographers who recount their experiences with difficult sub-jects, and interrupt their narrative to deliver advice on basic visual principles ('Long, longitudinal stripes in a lady's dress cause her to appear taller . . . one row of flounces make her appear shorter in stature, and continues to decrease in apparent height, as the flounces or ruffles are added upwards on the dress'[6]). J. E. Mayall, who, as we have seen, was one of the best-known portraitists in the British Isles, found it necessary to assert authority in his Brighton studio with a tactful sign reading: 'Sitters for portraits are requested to place themselves as much as possible in the hands of the artist.'

One serious consequence, for a professional photographer, of conflict in the studio was non-payment—he would be left with wet and unwanted prints on his hands. We are told that at Notman's studio 'a courteous insistence on pleasing' was the rule but a legend in the firm recalls a dispute in which a dissatisfied cus-tomer tore up his prints in the photographer's face, and threw them on the floor. William Notman, in reply, snatched up and sent to the ground in shreds the $20 account he had been about to present. The tradesman could not win in matching such displays of high-tempered pride. Baden Pritchard, in his article for photographers, counsels them on 'Business Tact' and, even more to the point, on 'People who do not like their portraits'.[7] At W. and D. Downey's discreetly fashionable studio in Belgravia it was assumed, we are told, that payment would be made as a matter of course before the sitting; other photographers disp-layed cards making that assumption explicit; some charged for a sitting, no matter what the results (and children under eight, being parti-cularly troublesome, one assumes, were char-ged for at an extra half-guinea rate by Elliot and Fry of Baker Street).

To be technically master of the situation and hold, in one's shutter release, the initiative, yet to be subject to caprice and social conde-scension must have been trying for all but the toughest commercial spirits. Stock poses and standard backgrounds which both create and satisfy a predictable expectation of what a portrait should be (and allow rapid mass

The gnome-like secretive features of Prime Minister Benjamin Disraeli photographed by the Downeys at Balmoral Castle in Scotland.

builder, who sportingly undertook to transport the house to Windsor and erect it by 10 o'clock next morning. As a studio, it was a splendid success; the couple made excellent subjects, and Mayall gained financially and in reputation with the publication of album sets of the wedding photos.

Another legendary story of the trade again begins with a summons from Queen Victoria: on this occasion she was at Balmoral Castle, her retreat in the Scottish Highlands, and wished photographs to be made of the party. A message was sent to W. and D. Downey, then a firm of quiet but reputable photographers in New-castle, 200 miles to the south, as the crow flies. The brothers immediately set off on the journey, by train and pony cart (the Queen, preferring seclusion, had opposed the laying of railway track up the valley of the Dee towards the Castle). When they reached Balmoral they found themselves lodged, by an unsympathetic steward, at a labourer's cottage on the estate (but were amply supplied with food and drink, they reported, by special command of the Prince of Wales, who rode over to see them). They worked diligently, produced good prints, and satisfied their patrons; their trip to Bal-moral became an annual affair. One year they completed their work and set off on a holiday tour of the Highlands; but a messenger came after them: Benjamin Disraeli, the leader of the Conservative Party, had arrived at Balmoral as a late guest, and the Queen had let it be known she wanted his portrait taken. The Downeys returned to find their special subject to be an awkward customer; on two successive days sittings produced unsatisfactory portraits, once because the dandiacal Disraeli, fearing rain would spoil the velvet jacket he wore, would not sit still under the threat of dark skies. Gathering their courage, the Downeys approached Dis-raeli yet again, through a lady in waiting, for a third sitting. He agreed to five minutes only and, in the words of the brothers, sat 'again in the velvet jacket and in very bad humour'. The single portrait they achieved was an enormous success, it sold in thousands during the years of Disraeli's second Prime Ministership (1874–1880) and was as good, reported Baden Pritchard, 'as an annuity' to the Downeys, who subsequently established their fashionable studio in London. [9] The portrait allows a remarkably clear and close view of the gnome-like, secretive features of the Conservative leader who, in Lytton Strachey's words, charmed the Queen 'with his rococo allure-ments'.[10]

production) must have provided a solution for uneasy moments in the studio.

Particularly interesting in their revelation of social and psychological pressures are those articles in the photographic press (by Baden Pritchard and others) which recount the exploits of notable photographers; they form the mythology of the trade. Frequently these adventures are placed within the frame of a particularly testing demand imposed by the 'quality'. One such episode features Mayall, who had attracted royal attention—actually the eye of the Prince Consort—with portraits made at the Great Exhibition of 1851.[8] A dozen years later, when the Prince of Wales was about to be married to Princess Alexandra of Denmark, a summons came to Mayall from Windsor. He was required to photograph the royal pair, and the wedding guests, in the 48 hours that remained before the ceremony. A canvas marquee, a most unsuitable studio, was assigned him for the task. Mayall, in some distress of mind, was gathering his equipment when, travelling by cab along the Euston Road, he saw a sign on a small glass house, a conservatory: 'For Sale—Will Erect Anywhere'. Mayall disclosed his plight to the owner, a professional

Queen Victoria's attachment to photography was one of the legacies of her husband's interest; but the nature of her patronage was markedly different. The Prince Consort, a consciously modern man, installed a darkroom at Windsor and encouraged photographers as a matter of duty towards the arts and sciences (Roger Fenton was particularly favoured, and allowed to record, for instance, quite intimate scenes of the Royal Family engaged in the pastime of staging *tableaux vivants*). Queen Victoria's interest was less enlightened: possessed of a strongly literal cast of mind she appears to have employed the new medium as a means of grasping hold of the material world; she collected *cartes-de-visite* of celebrities, just as her subjects did (and allowed her own portrait to be published as an article of trade); her collection of members of European royal families was especially large and comprehensive. During the Crimean War she collected albums, carefully annotated, of men who distinguished themselves (officers and other ranks being arranged in separate albums). After the Prince Consort's death she used the camera as a means of holding fast not only to his memory—Albert's bedroom was preserved as in life—but also to the appearance of things as they had been in his lifetime. Rooms in the royal residences were photographed, at her instructions, as a visual guide against alteration by the household staff. Jabez Hughes, a photographer distinguished only by the chance of being located near Osborne House, the royal residence on the Isle of Wight, was one of those engaged in the task of resisting change, and kept stored on his premises at Ryde rows of glass negatives he had made, packed in brown envelopes and marked with the names of the rooms at Osborne: by right of this function he called himself 'Photographer to Her Majesty'.[11]

The patronage of the fashionable and great must have provided for the portrait photographers that element of distinction implied in their view of themselves as artists working in a new and highly technical medium, yet denied in their daily experience: they were caught up in trade, like a bootmaker, turning out portraits by the dozen for an uncomprehending public. Yet commercial success, however demeaning, was absolutely essential: in the pattern of their mythology, as we have seen, satisfying financial rewards await those who persevere in loyal (and ingenious) spirit in service to the mighty. Noticeably absent from these stories of legendary *coups* is any reference to artistry (beyond plain technical competence). We can see this

again in the repetitive upturns and downturns of business which characterise the trade in the 1860s and 1870s, and which reflect the waves of vogue generated by what, essentially, were new packaging ideas. The *carte-de-visite*, established in France in the late 1850s and introduced into England about 1860, was the first, and it established the pattern. It consisted of the simple notion of modifying the camera to allow twelve separate images to be exposed on adjoining areas of a whole plate—in other words, twelve pictures for the cost of one. The images were small, it is true, but in their size and cheapness the *cartes-de-visite* (roughly the size of a calling card) possessed a number of amusing properties. An individual could be photographed in a dozen different poses (for the previous cost of one); one's portrait could be handed out, in casual fashion, to a dozen friends and, in exchange, portraits of others accepted and gathered in an album; finally, the portraits of celebrities could be collected and kept in an album providing further pleasant hours in the parlour, arranging images and turning pages.

The sale of celebrities developed into an international trade—hundreds of thousands of prints being passed through the wholesale houses of Europe and America—and gave the vogue the dimensions of a mass craze (of a kind which links our age to that of the Victorians). The celebrity trade depended upon the indulgence of the great—who could give or withhold permission to publish. Helmut Gernsheim has noted its political advantages in his account of the first deliberate use of the form by an international figure. Napoleon III, leading his troops out of Paris on their way to the Italian campaign of 1857, climbed from his horse and clattered, in full military dress, into the studio of Disderi.[12] Soon after, Queen Victoria gave her blessing to the *carte-de-visite* fashion through Mayall, and the Royal Family occupied a conspicuous position in the ranks of British celebrity photographs. This trade developed outwards through institutionalised figures of reverence—royalty, statesmen, bishops, and so on—to include writers, artists, society beauties and people who were, quite simply, the talk of the day. P. T. Barnum's protégés figured in this curiosity trade, as did Major-General Custer after the events at the Little Big Horn. It is clear that some professional celebrities sought to profit financially from publication of their *cartes*: Sarah Bernhardt is said to have charged Napoleon Sarony several hundred dollars for the right to publish her photograph (during her visit to New York

Major-General George Armstrong Custer, his long hair revealed, photographed by Alexander Gardner in Washington before the fatal Sioux Campaign of 1876. The photograph is taken from an English *carte-de-visite* album.

Custer, Maj. Gen. Geo. Armstrong
(1839 — 1876)

in the late 1870s); Baden Pritchard reported that in Paris at that time a standard percentage was paid by photographers, like a royalty, to the subject, and such practices were talked about in the English trade. Certainly large sums were to be made from 'sure cards', and a prudent photographer, planning a *coup*, timed his release carefully, distributing stocks of the print secretly, in order to frustrate pirates, and arranging simultaneous publication over a wide area to make the maximum effect.

Obviously the *carte-de-visite* celebrity craze reinforced the attachment — one might say dependency — linking the photographer and fashionable society, and tended to vitiate his role as independent artist. Background studio scenes, standardised and mass-produced, went through trade-wide changes of fashion: the drawing-room set was varied by the Alpine vista; later changes brought in the country-stile, the punt (or gondola) and the bicycle. Artistic change was of the shallowest sort and generally associated with changes in size, for, as the *carte-de-visite* had been revolutionary in size, so new stimulation of the trade was sought in those terms. After cartomania withered in the late 1860s — an understandable development when one considers its standard and unrevealing form — the Cabinet size was devised. This larger, broader format made the head-and-shoulders portrait the 'modern' style for the 1870s; vignetting, in which the head is isolated within a gradually fading surrounding, returned to fashion (it had been used in daguerreotypes) with the Cabinet. Later, the Promenade portrait, a still larger size, was introduced to stimulate the market (it was 'the favourite picture of the season' at the Sarony Gallery in 1881). By the mid-1880s photographers were looking about again for a means to give impetus to trade. Baden Pritchard quotes M. Lafosse, who practised 'higher class' photography at Manchester, on the subject:

We do not want merely a variation in the cutting and mounting of photographs but some modification of the photograph itself. A real cameo, or bas-relief portrait, in which the face stands out from a dark background would make an attractive picture, for example, if we could only produce such things.[13]

M. Lafosse's remark, for all its apparent boldness, expresses the characteristic reliance of his trade on novelty in the decades following the introduction of the *carte-de-visite*.

If portrait photographers appear to have been creatures of Society, what can one say of the hunger for celebrities shown by the upper-class and middle-class public? Leafing through English *carte* albums and finding, after the Royal Family and a Prime Minister or two, the images of Abraham Lincoln, Napoleon III, Ludwig II of Bavaria (patron of Wagner) and Garibaldi, one might observe that the world was clearly becoming a smaller place. One could also say it was more commonplace. Variety presents itself, in these albums, tamed by the photographic occasion. German counts, Turkish army officers, American statesmen — despite minor eccentricities of costume — confront the world in uniform poses and settings; like exotic fruits packaged and ranged on the supermarket shelf they strike the observer as both interesting and safely domesticated. These two elements, the ordinary and the exotic, appear to comprehend the contradictory impulses of celebrity collecting. A middle-class citizen leading his life among fellows like him in appearance and tastes, found there a pastime that brought the world's notables into a common purview: the homogeneity of a society of shared history and values was reinforced. A middle-class individual of different temperament, taking up his album, found the lions of the day within reach of his imagination and was able to step out of the quotidian round and enter a world populated by figures of beauty, fashion and high public distinction.

A *carte* album in the Victoria and Albert Museum bears, on the flyleaf, the name of Lord Napier of Magdala; within one finds a more or less standard range of drawing-room celebrities of the early 1870s; there is a very generous proportion of poets and novelists — Tennyson, Trollope, Longfellow, Wilkie Collins (but not Dickens), Elizabeth Browning, Swinburne — a few painters and musicians (including Hallé, the founder of the Manchester orchestra, and Lady Hallé), the religious celebrity, Father Ignatius, a measure of social thinkers — Thomas Carlyle and Herbert Spencer (and the Public School apologist Thomas Hughes) — one statesman, Lord John Russell, two scientists, T. H. Huxley and Charles Darwin, and a pair of fashionable ladies, the beautiful Duchess of Manchester (mistress of Lord Hartington) and Viscountess Castlereagh; some cartes-de-visite of friends follow. There are no military men in the album at all; one might think it the property of a society lady with literary tastes rather than that of a fighting British general.[14] How was this collection gathered? Since virtually all of

Anthony Trollope, the Victorian novelist, from *Men of Mark* produced by Window and Lock of London in the 1870s.

the photographs come from the studio of Elliot and Fry of Portman Square, it seems likely they were garnered in one swift campaign; probably the general, in retirement, marched stoutly upon Portman Square one day, swept his cane indiscriminately over the racks of celebrities, and demanded a couple of dozen of those fellows. The heavy, brass-clasped album in which they are kept would stand at hand, ready to be drawn upon in the pause of a slow drawing-room visit, to point an anecdote or start a new one.

In this manner the *carte-de-visite* album fitted with the superficial general conversation and polite decorum of the drawing-room. Such a role was not necessarily linked to the collecting mania. In the 1870s, when the intaglio printing process, Woodburytype, made book reproduction possible, the Regent Street photographers, Window and Lock, published an annual collection of portraits, with attached brief biographies, under the title, *Men of Mark*. This costly set of volumes, the Victorian ancestor of the lavish 'coffee-table' book of today, contains a fine range of head-and shoulders portraits composed in the formal, public manner of the *carte-de-visite*: the generals wear their medals, the bishops their surplices; the camera, creating a glossy parade of fashionable images, serves drawing-room culture.

The argument for a more subterranean appeal must remain speculative, yet it is supported by the general hero-worshipping temper of the age in Western Europe and America. Implicit in the public's admiration for Great Men, strong in will and character, lies a hunger for the irresistible energy of the natural life force which, it was felt, these men had tapped.

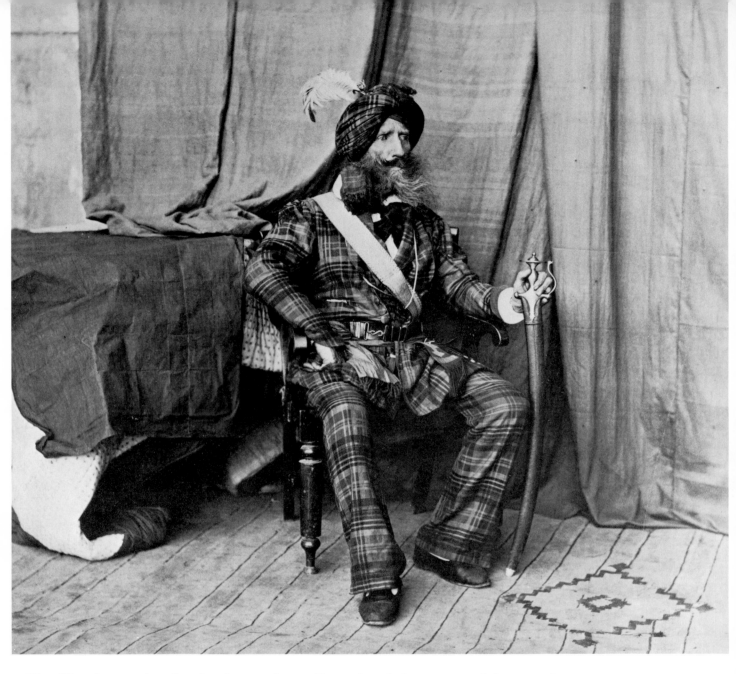

The Victorian passion for dressing up is further evidence of romantic escapism. Costume balls and home theatricals of many kinds—plays, charades and *tableaux vivants*—were extremely popular among the upper classes and provided the occasion for many photographs. Some puritan elements expressed disapproval, it is true, and Queen Victoria, anxious over the possible indelicacy revealed in Prince Albert's direction of their children in portrayals of The Seasons, destroyed Fenton's photographs decades after they were made.

There was also a good deal of costuming which arose from theatrical exploitation of the possibilities offered by the British Empire: one is not thinking here so much of soldiers in uniform, though these are certainly a part, but of the odd figures whom events turned up, engaged ostensibly in exploration, missionary work, or administration, but whose career hinged upon the adoption and simulation of the language and appearance of Arab, Turk or Hindu. In America the expansion of portrait photography coincided with the years of the Civil War; its dreadful occurrence at least provided men with an escape into a choice of self-image—one, the tall, elegant drawing-room soldier and the other, its opposite, the shaggy, flop-hatted, devil-may-care romantic figure frequently chosen by officers in the field and modelled on the Scout, independent, hard-riding and knowledgeable.

Colonel Gardiner, a character of British India, photographed by Bourne and Shepherd at Simla, India.

Opposite
A drawing-room soldier of the American Civil War by Mathew Brady.

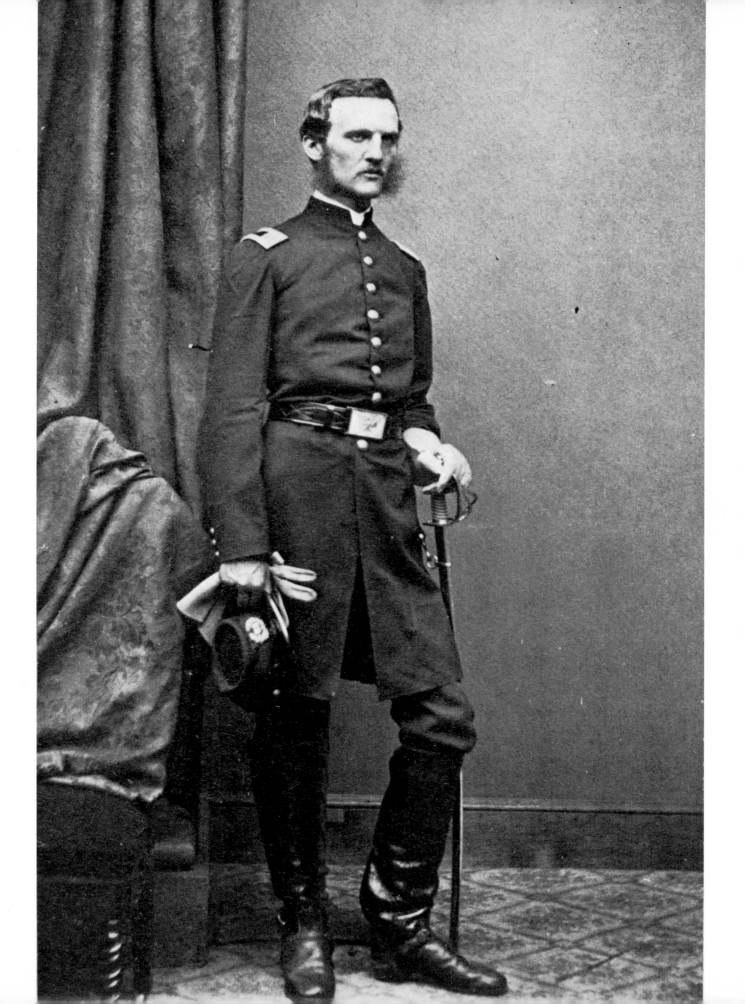

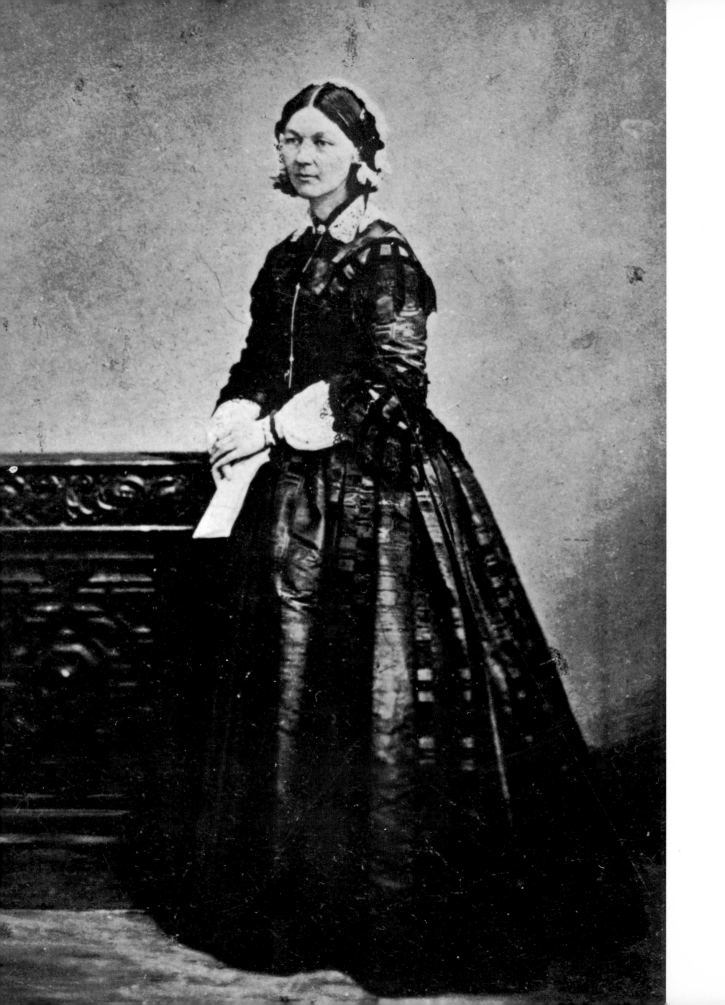

Romantic escapism may be so permanent a human condition that it lies beyond historical explanation, yet it is difficult to avoid pointing the finger at pressures in Victorian society which must have, at the least, aggravated the tendency. The pressure of confinement arose from the cult of the family, the forced propinquity of the drawing-room, class exclusiveness and the web of proprieties which, in particular, circumscribed the life of young ladies. Imagine a young upper-class girl, sensitive and self-conscious in the acute form known as adolescence, seeking escape from the tension and boredom of the drawing-room behind the covers of the photograph album of celebrities. One of those she encounters might be Florence Nightingale, wooden of face and heavy in crinolines, like any other *carte-de-visite* fashionable lady. Yet the context of the photograph would be known: here was a young lady who had surprised her respectable family by her interest in the indelicate practice of nursing and astonished the British Army by arriving in their rear, during the Crimea campaign, and instituting a system of hospital care which gave some chance to the wounded. Established as a national celebrity, blessed by soldiers as the Lady with the Lamp, the girl of good family whose image now rested in the lap of the escapee on the drawing-room sofa had completed a circle. Her own girlhood had been oppressed by genteel confinement, of which she complained later, in exclamation marks:

Oh, weary days! Oh., evenings that never seem to end—for how many years have I watched that drawing-room clock and thought it would never reach ten! And for twenty, thirty years more to do this!...I have known a good deal of convents and everyone has talked of the petty grinding tyrannies supposed to be exercised there, but I know of nothing like the petty, grinding tyranny of a good English family.[15]

The photograph album widened the range of indoor occupations which developed in the Victorian period (novel-reading was the most important, and was regarded by its enemies as the death of good conversation). These pastimes gave privacy and nourishment of the inner spirit to individuals hard-pressed by family care.

To the obvious influences of social and professional demands that of escapism may be added as an element of hidden dimension which contributes to the strange mixture of picquancy and exoticism in wooden, standard forms which gives much of portrait photography in this period a distinctive flavour. It would be wrong to emphasise these unstated forces at the expense of obvious purposes and obvious success in using the camera's special capacities to handle contemporary material. One is thinking here of Lady Hawarden's work, and approaching, probably with too heavy a tread, photographs which are unpretentious, delicate and direct. From them one can see that the Viscountess Hawarden, another upper-class lady who took up the new medium, delighted in the photographic possibilities of feminine dress. She was fortunate in possessing five beautiful daughters of dark Spanish looks (which they took from their grandmother, Catalina Paulina Allessandro) and an elegant Kensington terrace house, with real stone balustrades and high-ceilinged drawing-rooms. In this setting her daughters, in crinolines, walking dress, ball dress and 'Bohemian' costume, posed for their mother.

The photographs are beautiful compositions and, in addition, exceptionally useful in conveying to later generations, quick to mock, the Victorian idea of high fashion in the early 1860s. Veblen, with sardonic eye, gazed at the practice of tight-waisting and wrote 'the corset impairs the personal attractions of the wearer but the loss suffered on that score is off-set by the reputability which comes of her visibly increased expensiveness and infirmity'; a nice line, but is it true? Or rather, doesn't it deliberately miss the point that tight waists can be attractive and, as Lady Hawarden's photographs reveal, are consistent with an aesthetic which prizes delicacy and balances complication and concealment against simplicity and revelation? A study of one of her daughters reveals the complication of design of a ball dress: the crinoline overskirt, pulled up by ribbons, reveals the layered tulle beneath; a half-skirt, a train of patterned silk, tumbles and exaggerates the mushroom swell of the skirts; above, the striped bodice suggests neatness, while trailing out to falls of lace at the wrists. This rich elaboration of form and material emphasises the smooth texture of the girl's bare throat and arms, left unadorned, and the simply rolled hair, held with a pearl circlet around the torsade. The Victorian crinoline does not look ridiculous in this beautifully composed picture; the dress must certainly have been expensive, but rather than suggesting infirmity of body, as Veblen suggests, it conveys a subtle—and

Florence Nightingale, the Victorian heroine of Crimea in a *carte-de-visite*.

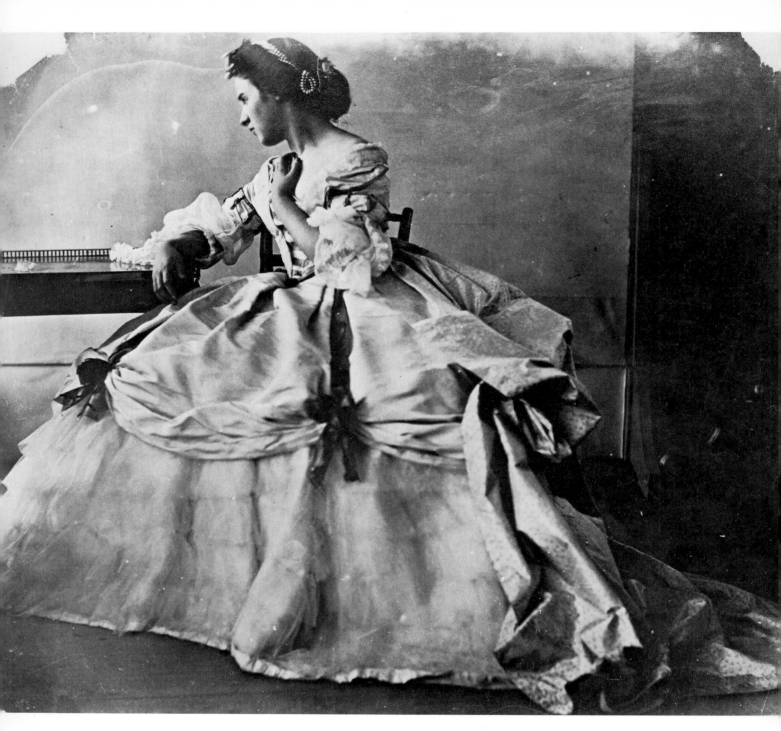

thoroughly sensual—appreciation of the human body and the art of adornment. Another picture by Lady Hawarden, 'Two Bohemian Girls', shows a style created in absolute contrast with orthodox fashion. Henri Murger's novel *La Vie de Bohème* popularised the term Bohemian. The *midinettes* and seamstresses of Paris, who people that novel, prize, above all things, a silk dress for themselves: by the grace of the Hawarden fortune the girls here appear as the very type of well-appointed Bohemian. The

Spanish-gipsy style in which their silks are cut, a popular Bohemianism associated with the artists and their models of the Paris *ateliers*, suits their strong looks. Again there is subtle appreciation of textures and materials, but in this style everything hangs down—hair, sashes, long dresses—naturally from the body by contrast with the carefully contrived swells and falls of the crinoline.

Lady Hawarden's limited body work (she died in 1865 at the age of 43) defines her as,

The Victorian crinoline conveying a subtle and thoroughly sensual appreciation of the human body and the art of adornment. One of Lady Hawarden's daughters photographed by her mother.

Opposite
Two of Lady Hawarden's daughters as Bohemians.

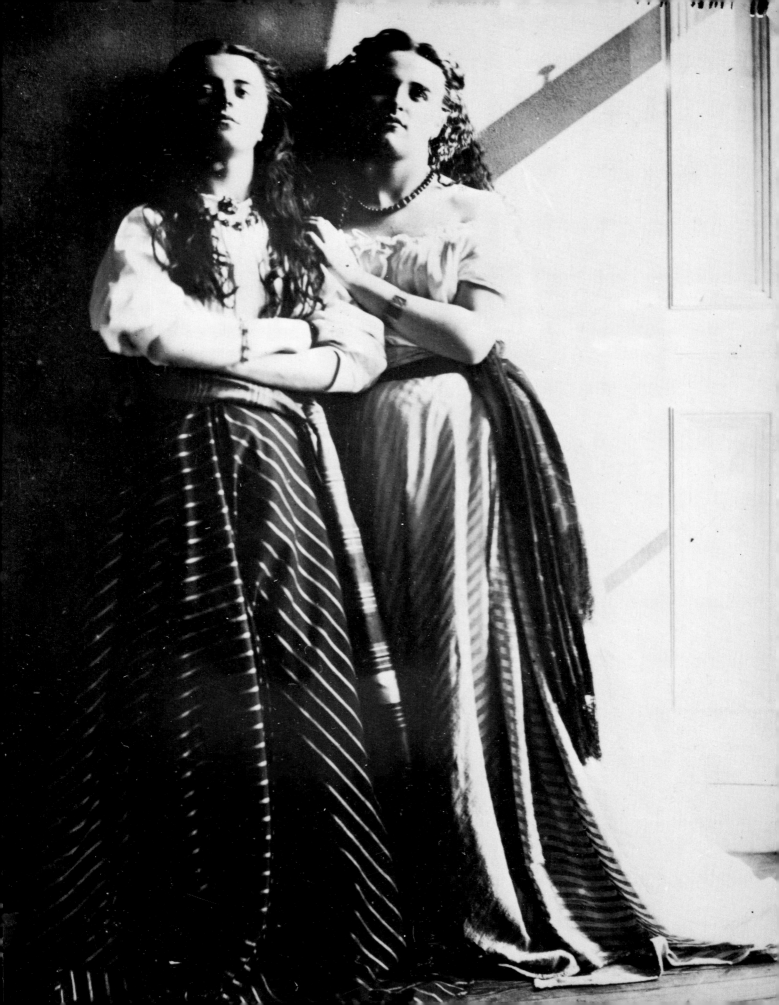

essentially, a dress photographer. Roger
Fenton's work is much more various but in, for
instance, his portrait of the Queen and Prince
Consort, he uses the texture of material with the
sensitivity of a fashion photographer to express
his fundamental purpose, to suggest the re-
lationship between the Queen and her husband.
Although not placed centrally, Queen Victoria,
in her light summer dress, occupies the centre
of attention. The command given to her by
tonal contrast—her light figure against a
sombre background—and her unencumbered
posture, is reinforced by Fenton's handling of
the Prince Consort: his turn of body, gaze, and
scroll of paper are all directed towards the
Queen. The complexities of the institutional
and personal relationship between Victoria and
Albert may be read here: she the pinnacle and
he the support, she the gracious and he the firm
(and intellectual). In addition to this emble-
matic pattern of complementary figures we may
read a more local and particular content in the
photograph: the Prince wears the patterned,
contrasting waistcoat of the Early Victorians
(notable extroverts by contrast with their

successors) and the Queen, in flounced muslin,
a French cap far back on her head and trailing
ribbons, reveals the dominance of Paris fash-
ions.

A sense of fashion and its social dignity
pervades much of Victorian portrait photo-
graphy. A simple journeyman photograph of a
wedding group, taken at the small village of
Christable, in Somerset, in the 1880s, reveals
for instance, the taste for 'something dressy'
even in remote agricultural communities.[16]
This is not a moneyed group: the bride, a
withdrawn young lady by contrast with her
assertive husband, wears a sensible dark dress
(purples and dark browns were common for this
occasion) which could serve as best wear in the
future. Some of the men's clothes look back to
the 1860s in style; some of the ladies simply
wear their Sunday best. On the other hand
there is a very distinct attempt to be smart: all
the men wear white gloves and the younger
ladies make a dash at high fashion with
feathered hats tipped forward. In this photo-
graph we feel close to the ordinary yet self-
respecting rural communities.

Yet as we draw close to the end of this chapter it becomes clear that this kind of photograph, and this kind of reading, is straying over into documentary. The portrait photographer crossed this boundary increasingly as he moved outside the studio. Portraiture, strangely enough, has more to do with the expression of general ideas than particulars. Concrete detail is important in the photography of Lady Hawarden but again that is work that might more accurately be classed as fashion photography.

Mrs Cameron, with whom we began this chapter, certainly had a rare talent for candid portraiture. Yet there is also a strong streak of the obvious in her approach. One is not thinking here of the absolute disasters of her career: her attempt, for instance, to illustrate, photographically, Tennyson's *Morte d'Arthur*. Her successes are a case of obvious, yet very bold handling as in her powerful *Pomona* where a young girl with apple blossom in her hair is placed against a wall of leaves and blossoms. The

Pomona, the Roman goddess of tree fruits, by Julia Margaret Cameron. The model is Alice Liddell, the inspiration of Lewis Carroll's *Alice in Wonderland*.

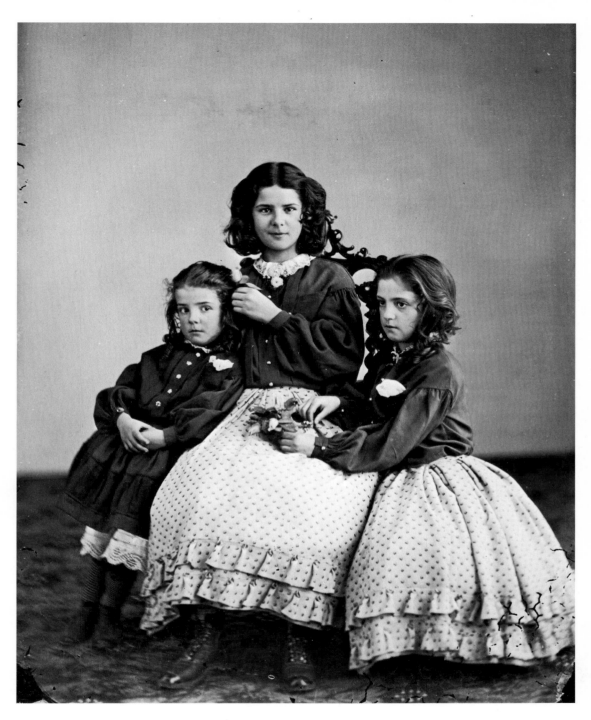

The Brehan sisters from Montreal by Notman in 1863.

directness with which the camera approaches the subject brings out a vigorous boldness in her even-eyed countenance and the jaunty self-possession of her hands.[17]

Quite different from Mrs Cameron's bravado of handling, yet equally obvious in its conception, is William Notman's group of three Montreal sisters gathered in a geometrical pose. The matching skirts and the angle of the youngest's body give a vigorous precision to the portrait.

The reflective mood in association with the tender hopes and expectations of girlhood is common to many photographic studies of the mid-century. It might be objected that these photographs, and those of Mrs Cameron, which exploit Victorian sentiment, are not really portraits. Although under the broad definitions of Victorian photographic exhibitions which for decades knew only two categories—'Portraits' and 'Other'—they would be so listed, it is true that in spirit these studies are closer to the *genre*

95

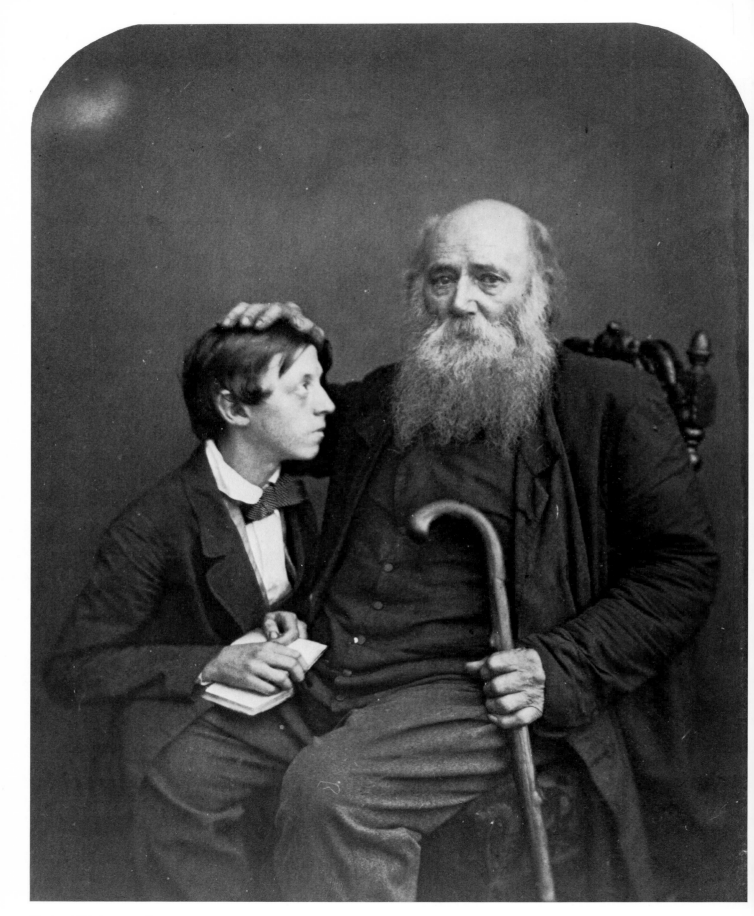

Youth and Old Age, an excellent
example of Victorian moral
sentiment by Fallon Horne.

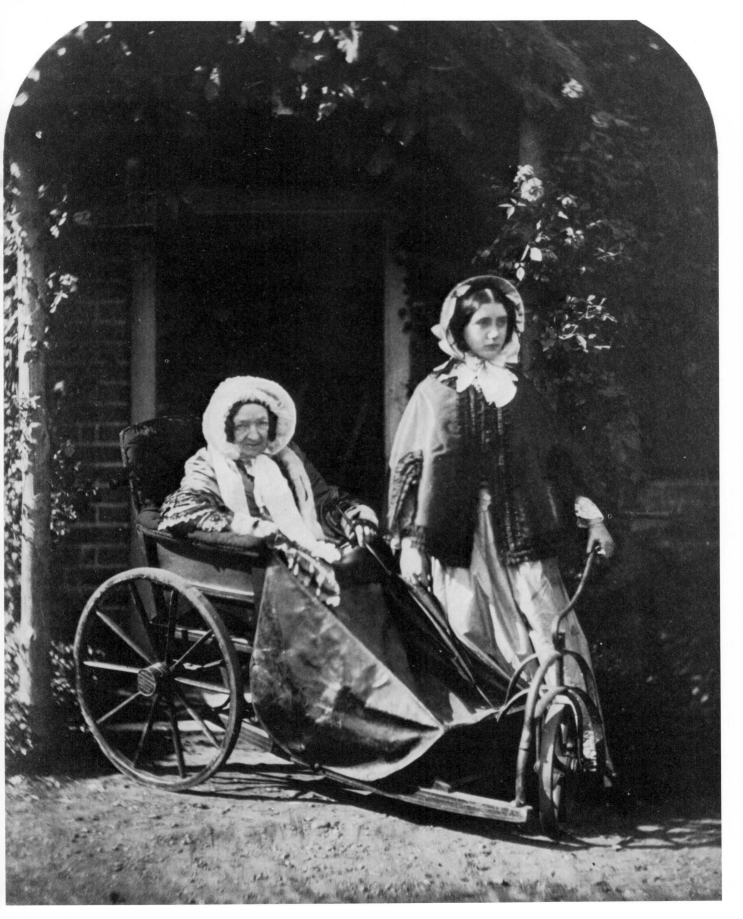

The Garden Chair: a sentimental
theme by Henry White, 1854.

mode of painting than portraiture. Heavily sentimental, *genre* painting presents intimate glimpses of ordinary life (Mrs Cameron, with her allegoric tendency, cannot always be included here). Although not, in a strict sense, portraits, these anecdotal photographs influenced the large, journeyman world of photography in terms of tone and composition. Family groups, as we have seen, commonly bear a message of harmony; clusters of girls are arranged to convey the idea of tenderness and delicacy.

One of the commonest sentimental themes, shared by art study and portrait, is that of the relationship of youth and old age. Fallon Horne's study, under precisely that title, may be compared with many commercial portraits which express the harmony of complementary roles: the old and experienced instruct, the young learn. Fallon Horne's studio piece, with its use of models from a poorer class, broadens the sentimental appeal of the relationship. The old man with the crook-handled walking-stick and worried eyes lays his hand upon the adolescent boy and gives his blessing with anxious foreboding about the future. Death will separate them, and the boy, who gazes at his mentor with tender regard, will have only the book, open in his hands, as his guide through life. The theme is repeated in Henry White's *The Garden Chair*, a photograph which is pictorially more interesting, as well as being more delicate in its handling. White's work was published in a compendium of photographs by members of the Photographic Society in 1855.[18] The soft and insistent pressure of sentiment, as if not sufficiently present in the photograph, is poured out in an accompanying poem by Dinah Maria Mulock,[19] who lectures the reader on 'this pleasant picture, full of meanings deep' which concerns itself with:

Old Age, calm sitting in the July sun
[With] . . . eyes now so near
Unto their mortal closing, that we
 deem
They needs must pierce through life's thick
 maze
As eyes immortal do . . .

and the contrasting figure of

. . . Youth. She stands
Under the rose; with elastic foot
Poised to step forward, eager-eyed, half-
 grave
Under the mystery of the unknown To-
 come
Yet longing for its coming.

This portrait, taken in the 1850s, provides yet another example of the dominance of convention. Social assertion, decorum, fashion, romance, sentiment and moral sententiousness: a complex group of ideas and attitudes governs the content and forms of Victorian portrait photography. Its products vividly reveal the stamp of these preconceptions. The possibility of art is not annulled by predetermination in accordance with a system of ideas, but such governance implies a formal and hieratic art. Roger Fenton's photographs of the Queen and Prince Consort, taken in mid-century, demonstrate that Victorian society possessed a set of accepted social and ethical ideas sufficient to provide a basis for such art. But these beginnings are as shoots that do not grow and thicken. Perhaps mass society taking over the portrait camera and diverting it to the ends of amusement made the practice of a popular, fine art impossible; perhaps Victorian culture was too shallow in its ideas to provide nourishment. Certainly timidity is everywhere present—a corollary of convention—and we have seen how the social position of the portrait photographer, in trade, placed him awkwardly for pressing his customers into the advance of art. Late in the century the portrait camera was used more boldly and effectively. But the vast number of Victorian portrait photographers are best read as social documents; again and again it is not the portraitist's art but the cultural meaning which, along with historical detail, gives interest to the photograph.

PLAYERS AND BEAUTIES

No professional group of the nineteenth century has been more extensively photographed than the men and women of its stage: theatre archives in London and New York bulge with the evidence.[1] There are simple explanations for this volume of material and perhaps the first is the natural invitation offered to the camera by the subject: men and women of commanding presence and beauty prepared with care for public appearance. This natural appeal was supported by an awareness, which developed rapidly after the mid-century, on the part of both photographers and stage professionals, of the uses of theatrical portraits for publicity and commerce. The stage was a splendidly willing source of supply for those photographers who drove a trade in celebrity portraits; for the actor and actress it was a means of claiming attention, both public and professional. A new role and a new costume led one naturally to the studio.[2]

Essentially, theatrical photography meant portraiture. Casts assembled in costume before studio sets for group photographs: it was not until the late 1880s that the camera began to be taken to the theatre and photo-calls became a stage custom. But the ensemble photograph, on or off the scene, never challenges in volume at any time in the period the mass of individual portraits being taken. In this the archives accurately reflect the nature of the nineteenth-century theatre. It was the age of the great player and the great beauty. The star system flourished amidst an intense glamourisation of the world of the theatre. Girls of the middle class yearned to go before the lights and sometimes shocked their families by actually doing so; young men abandoned promising careers in safer fields. A profession which

previously drew its members from old trouping families became invaded by newcomers. One can sense this crowding of the marketplace and the consequent jostling for attention in the shoals of photographs of little-known actors and actresses, their countenances bright with smiles or folded in heavy stage winks or frowns.

Amidst this visual clamour only the most beautiful or the most talented could command attention. We can see from her photographs that Mary Anderson was certainly of the former class. This clear-browed beauty, after a brief early career in America, arrived in London in the early 1880s and was given the part of the girl-in-the-statue in W. S. Gilbert's *Pygmalion and Galatea*. Before the play opened, we are told, photographs of her were sold all over town; given this assistance the production was a popular success. One leading critic, Clement Scott, obviously taken with her looks, warmly commended Miss Anderson's performance while implying, with muffled qualifications, that she was as wooden as an actress as she was statuesque as a beauty.[3] Miss Anderson was, however, established, and her beautiful image appeared—in a wood engraving copied from a photograph—on the front cover of the *Illustrated London News*.[4] This particular episode, a small but significant, and strikingly modern instance of the exploitation of good looks, may have fed the resentment of Mrs Madge Kendal, a distinguished leading lady, who astonished the theatrical world with a denunciation of the publicity 'mania' growing in her profession in an address to social scientists.[5] Mrs Kendal, known in England as the Matron of the Drama—she frequently acted with her husband in husband-and-wife roles—had created

the part of Galatea in Gilbert's play years before and she may well have been scornful of the nature of Mary Anderson's subsequent success. At any rate she referred specifically to photography as one of the degrading means of gaining public attention being resorted to by her colleagues: being so conspicuously married and respectable, in art and in life, and the descendant of generations of actors, Mrs Kendal evidently regarded herself as the natural champion of the profession's dignity.

Equally chosen by nature and circumstance to demonstrate a mastery of publicity and its devices was Sarah Bernhardt who, in the same year as Mrs Kendal's speech, 1884, in a typical stunt designed to feed a sensation-hungry public, lay down in her satin-lined coffin, surrounded by love-notes and other mementoes, and had herself photographed ('I thought it better to have the photographs taken while I was still alive and my face was still agreeable', she said, disarmingly). In her flamboyant cultivation of a public image Sarah Bernhardt was all that Mrs Kendal found disreputable in the contemporary theatre. She created for the public the attractive figure of a wilful and outrageously unconventional *artiste*: it is clear that she knew how to exploit this appeal. Before going to England for the first time, in 1879, she prepared the ground by sending a consignment of her paintings and sculptures for exhibition and making available photographs of herself, looking extremely elegant, in her sculpting costume (white satin jacket and white cotton trousers). It was this outfit which was the cause of the titillating whisper 'She wears men's clothes'. England, well prepared, greeted this Bohemian figure with intense interest. Despite some bad performances with the *Comédie Française* on this tour Sarah Bernhardt became the rage of fashionable London: she made private appearances for a fee, at West End houses, in a little drama in which she chatted with her maid as she carried out her *toilette*, donned her sculpting costume, and preparing to address a bust. While in England she added a cheetah and a wolfhound to her menagerie and appeared at a charity bazaar where stocks of photographs of her sold out quickly. After London, she sailed for New York and a Parisian critic wrote, as she set off:

> She is too American not to succeed in America. The people who have brought the arts and graces of publicity to the highest development will recognize a kindred spirit in a figure so admirably adapted for conspicuity.[6]

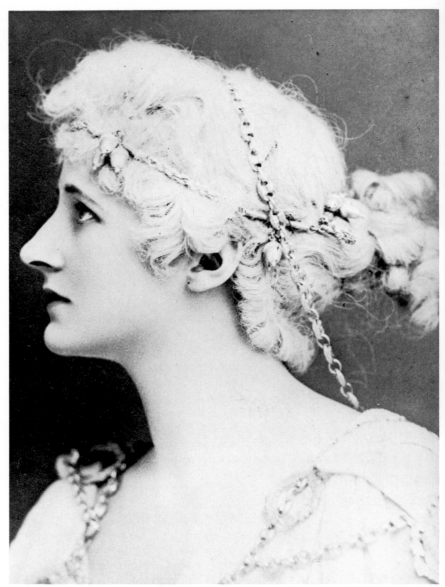

This message directs our attention to Sarah Bernhardt's conspicuous figure and suggests one of the principal values to us of the nineteenth-century theatrical photograph. In its time there seems little question that it served as an auxiliary to good looks and assertiveness. Today, it offers the power of recovery of faces and gestures which are not half so well recalled in words. Of Sarah Bernhardt, for instance, her friend and biographer Maurice Baring has written that it is only in photographs from early in her career that one can gather any sense of her impact upon nineteenth-century audiences.[7] The full-face portrait of her in character for *Theodora* conveys the force and excitement customarily associated with her performances: her acting was apparently based on attack and broad effects—Ellen Terry termed it 'symbolic

Mary Anderson, an American star who captured London of the 1880s with her beauty.

Opposite
Sarah Bernhardt caused a sensation in London and New York with her publicity stunts like this satin and cotton sculpting costume, 1879.

Tippy Cooke in a classical stance
from the Victorian melodrama of
the 1850s.

and decorative'—but in the portraits one also sees revealed what Baring called that 'poignant facial expression' which insinuated itself more subtly on audiences. Her extreme thinness enabled her to wear the most heavily adorned costume and yet appear elegantly slender; conversely, she could wear the small, silver-lace diadem specified in Hugo's *Ruy Blas*—in effect, a toy crown—on the top of her head and not appear ridiculous. To remarkable degree these photographs support a legend of extraordinary vitality and allure.

In other periods of the century, and on other levels, we find the history of the theatre illustrated with the same persuasive force and conviction. From the 1850s, for instance, comes a photograph of Tippy Cooke (from his initials, T.P.), one of the most swaggering leading men of the nautical melodrama. His photograph in character, sword between teeth, bell-bottomed legs astride, offers a magnificent and emblematic image of the dash and vigour of melodrama and explains its appeal to the audiences of the popular theatres. For all the negative connotations now borne by the term, melodrama was a strongly theatrical, one might say basically theatrical, use of the stage. The form underwent many transformations during the century, including a social journey from back-street theatres to the West End. The elements which delighted the costermonger on his Saturday night out—broad characterisation, pitched battles between good and evil, alternations of mood between rousing good humour and deep pathos: displays of intense feeling generated within a loose structure of ethically-defined action—continued to be the mark of Victorian drama in the various forms developed from the melodrama.

A group photograph of the cast of one of these subsequent varieties of play, *Dearer Than Life*, a so-called domestic drama, shows how visible to the eye is the stock characterisation taken over from the melodrama.[8] Prominent among the group is the first old man, with pipe, whose role, typically, is sententious utterance, given a heavy comic emphasis, and a display of age's virtues by contrast with the second old man, shown tilting a bottle, who bears age's vices with equal comic exaggeration. Occupying the first part is the most distinguished low comedian of the Victorian stage, J. L. Toole; his partner is Lionel Brough. Behind Brough sits a dark young man dressed in a rather caddish manner and sporting waxed moustachios and cane—obviously the villain, played here by young Henry Irving, making his first

impression on London audiences. Wearing the grey beard of a heavy—a part calling for expressions of deep feeling—is Charles Wyndham, and laying her hand on his sleeve, feelingly, is the emotional actress, as his daughter; she sounds the sombre notes on the female side while, by contrast, the young lady in the spotted dress, the soubrette, is the vehicle for bringing vivacity and sparkle to the play; she is assisted by the light comedian, wearing dark eye-brows and white-powdered hair, a common make-up for curates and other eager, silly-young-fool roles.

Where standardised characters and standardised plots were the rule it was necessary for actors to develop and expand their techniques of playing to give life and individuality to their parts. The capacity to invent new business was essential. J. L. Toole, recalling the occasion when the photograph of the *Dearer Than Life* cast was taken, demonstrates in an anecdote the kind of professional readiness of invention that lay behind his performances.[9] Arriving, with Lionel Brough, at the photographer's studio in a fashionable West End square, they were obliged to wait, and went for a stroll in their costume—the images of old men down on their luck. On their walk, struck by the contrast between their dress and their surroundings, they went up the steps of what they discovered to be the town house of a peer of the realm, and fashioned a drama on the threshold, imploring the footman to let them enter; they were cousins of his lordship, they said, and needed a helping hand to rescue them from the workhouse. They were driven off with threats of the police.

The most celebrated of the great English actors of the high-Victorian period was Henry Irving: an actor of formidable stage presence, as we can learn from his photographs, and a highly mannered style. His power was not expressed in thundering heroics of the kind associated with many of his predecessors but in closely studied and detailed representations. Irving, believing that he did not possess natural gifts as an actor, substituted single-minded care and worked out and executed his parts with extraordinary concentration. It may have been this deliberation of manner which made his performances admired, even in trashy melodramas like *The Bells*, for the depths of feeling they touched; evidently the audience sensed an inner dynamic, powerful feelings powerfully restrained, which gave life to the parts he took on. A powerful remark went about at the time of performances of his Mephistopheles in *Faust*

Henry Irving as Mephistopheles in *Faust*, 1885. A fine portrait of his strong challenging face which thrilled the London theatre.

An array of stock characters from the domestic drama, *Dearer Than Life*. Henry Irving on the far right was making his first appearance on the London stage.

(Lyceum Theatre, 1885) that Irving needed no make-up for this one. From his photographs in different characters we can see, however, that Irving always made use of the same physical characteristics. The long face, with its heavy eyebrows, appears poised like a hatchet, for generally there is a stoop about the shoulders and neck which contains an implied forward movement, restrained yet threatening; the small eyes, snakelike, glitter with alert intent, alongside the strong line of the nose. In each character, no matter what the costume, we see this strong, challenging face.[10]

Irving's success in *The Bells* (1871) and, in the following year as Charles I in the play of that name, established him as leading man at the Lyceum Theatre where, as actor-manager, he staged some celebrated revivals of Shakespeare. Idolatry of Shakespeare was the salient feature of the serious theatre of the period, and photography bears naturally upon the aspect of spectacle, notably of costume. The camera first

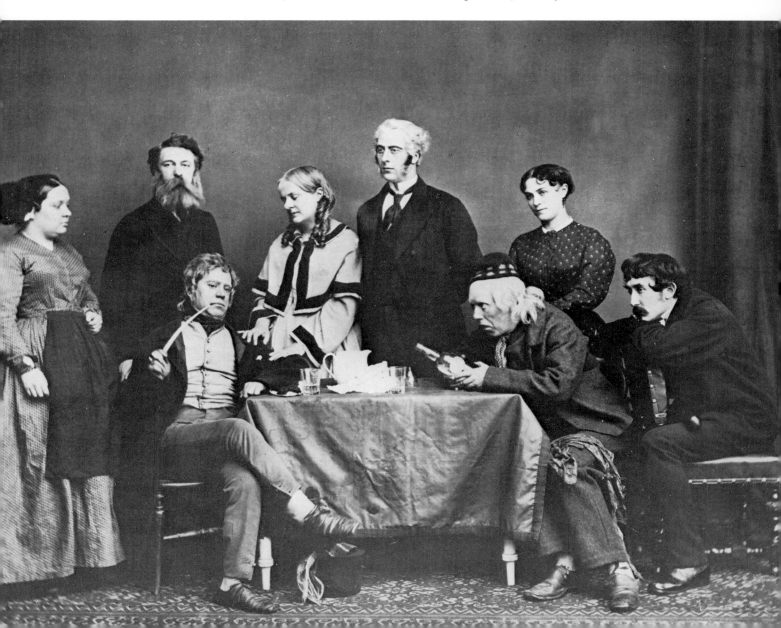

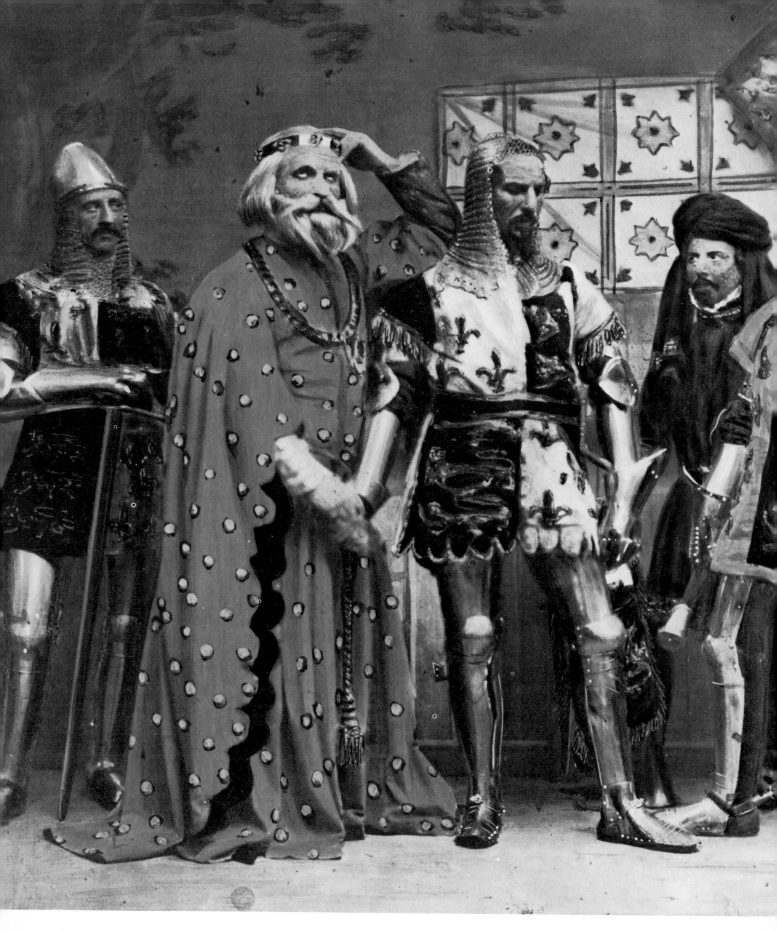

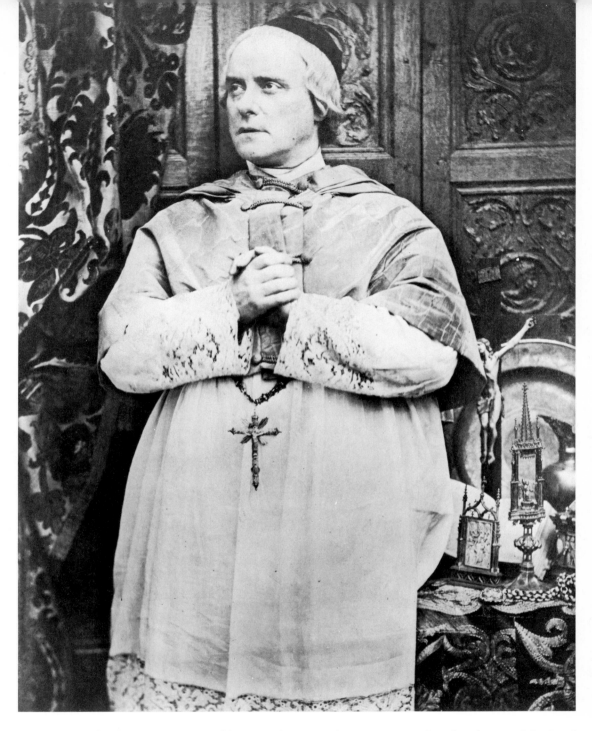

Charles Kean as Wolsey in *Henry VIII*, 1855.

encountered Shakespeare on a significant scale in the 1850s with the regular photographing by Sylvester Laroche of the series of plays mounted by Charles Kean and his wife. At Laroche's studio, neighbouring the Princess's Theatre on Oxford Street where the Keans were lessees for most of the decade, the Plantagenet and Tudor monarchs and their peers and knights assembled in cardboard armour: Kean was particularly fond of the history plays and brought a quite pendantic care to designing them with antiquarian exactitude. He was also willing to spend money, mounting the plays as rich visual spectacles, with large crowd scenes, and a splendid pageantry of costume, including the use on stage of caparisoned chargers.[11]

Laroche's photographs, a series of portraits and groups in costume, appear to have first been made for public sale with the sumptuous production of *King Henry VIII* in 1855, a great triumph (Kean played Cardinal Wolsey). Laroche appears to have caught the spirit of the Princess's revivals in more ways than one: he colour-tinted the studio scenes—hand-tinting

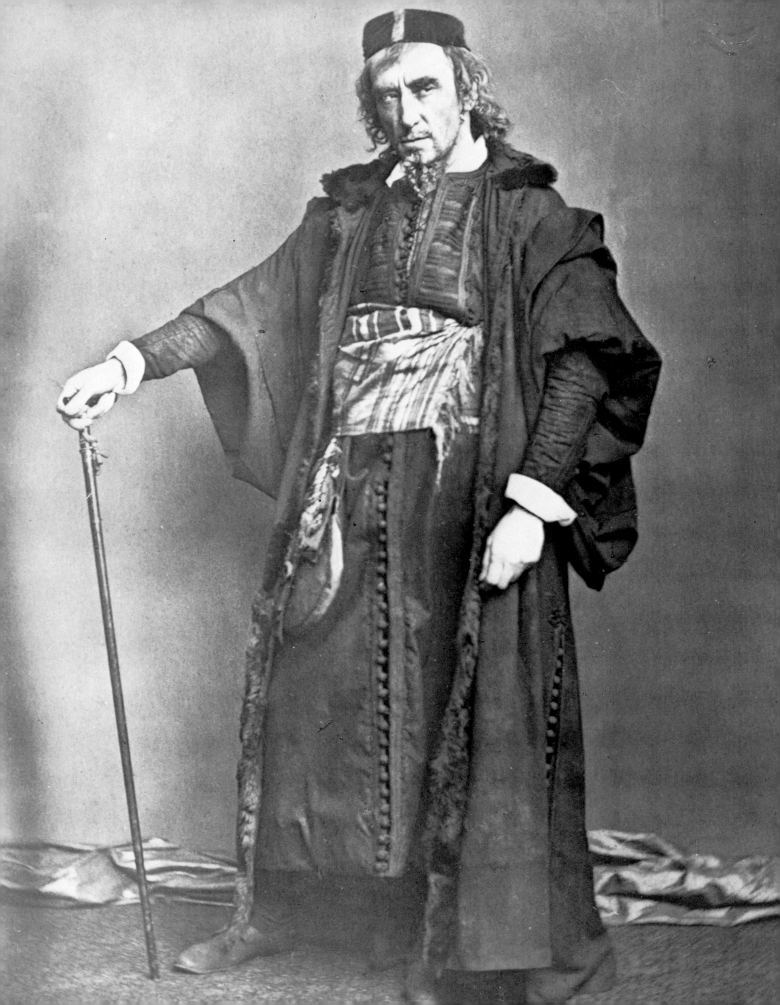

was common in portraiture at the time—to do justice to the richly coloured costumes, hung banners for backdrops and, in the instance at least of his portrait of Kean as the Cardinal, provided studio properties, Renaissance *objets d'art*, of authentic appearance. This photograph also allows a good look at Charles Kean's short stature and unprepossessing features, disabilities which he overcame to bring continued theatrical glory to the family name (during his tenure at the Princess's he was also obliged to cope with false dentures attached by suction, which rendered his diction unclear). According to contemporaries Kean's best acting was not in the great tragic roles, which his father had filled memorably, but in comic parts, playing opposite his wife, in which he put to good use a range of deft techniques of gesture, learned over the years, and what a critic called 'almost ferocious vivacity' of facial expression.[12]

At the Lyceum Theatre in the 1870s and 1880s Henry Irving continued the tradition of the richly-dressed production. Celebrated artists were called upon for set and costume designs: the ragged gaberdine worn by Irving in his photograph in character as Shylock came from the distinguished hand of Sir John Gilbert; it was never permitted to be cleaned during the run of the play for fear its delicately ragged condition should suffer.[13] This production of *The Merchant of Venice*, in 1879, was one of the triumphs of Irving's reign, though it is clear that the great actor, by introducing extra scenes and, when on stage by controlling the pace and tone, invested the character of Shylock with such moving dignity and pathos that the balance of the play was dangerously tilted. The Lyceum's leading lady, Ellen Terry, was hard put to it, as Portia, to wrest success in the Trial scene from a Shylock who had, as a critic put it, the aspect of 'a heroic aristocratic martyr'.[14]

Ellen Terry, Irving's partner in many triumphs and the queen of the Lyceum for two decades, was born into an acting family and started her professional career as a child in Kean's productions of Shakespeare. This means that her acting history can be followed in photographs virtually from the beginning.

Evident contradictions emerge: first, the natural gravity of her expression appears to belie her reputation as a comedienne. She was not beautiful but her features have a handsome regularity and it is these level, shrewd lines of brow, eyes, and mouth which convey a sense of thoughtful composure. Of course most of these photographs taken in the studio show her face in repose and it is only, perhaps, from one view

of her, at the age of 14, playing a boy in a one-act comedy *Home for the Holidays* that we draw an impression of mobility of features that might accord with G. B. Shaw's judgement that her success rested on a 'most curious naughty-child charm'.[15] It is also clear from photographs that Ellen Terry possessed a tall, long-limbed figure. As an adolescent she felt herself ungraceful and ugly—'How long and gaunt I am' she notes at the time—and was conscious of having big hands. She kept this figure into maturity, as is clear from her little daughter's comment on a sensational moment in a costume drama, *Masks and Faces*, in 1875: 'You did look long and thin . . . when you fainted I thought you was going to fall into the orchestra you was so long'.

In many of her stage photographs Ellen Terry wears long dresses of clinging material which emphasise her height. She was an 'aesthetic' dresser before that look became fashionable: in 1875, for instance, going to a meeting with Mrs Bancroft, the manager of the Prince of Wales Theatre and a fashionable little woman who dressed in smooth-textured outfits with bustled skirts, Ellen Terry wore:

a dress of some deep yellow woollen material which my little daughter used to call the 'frog' dress because it was speckled with brown like a frog's skin. It was cut like a Viollet-le-Duc tabard and had not a trace of the fashion of the time.[16]

In addition to challenging the fashions of the drawing-room Ellen Terry introduced these original dresses to the stage; we find her garbed in one variant or another of the 'frog' dress in most of her photographs. As Lady Macbeth, at the Lyceum in 1887, she made a highly aesthetic figure in a long, deep-sleeved dress of entwined green-blue strands of colour, embroidered with what she called 'beetles'. In this costume she was painted by Sargent as well as being photographed: with her grave, tilted face rising from the long body, hung with braids, and trailing folds and sleeves, she makes an impressive figure.

With this height was combined lightfootedness. Those who saw her on stage remarked on her grace; she herself came to realise, as she modestly puts it, that she possessed 'the gift of being rapid in movement'. The significance of the contradictions between her face and figure and her style of acting begins to emerge. When critics wrote of 'the youth and freshness of her performance' or 'the undiminished brightness

Henry Irving as Shylock, 1879. His costume was never cleaned in case its ragged condition should suffer.

and buoyancy of her style' it seems likely that they were responding to the unexpectedness in her combination of qualities: a tall, grave woman charged with lightness and verve. Her most acclaimed roles were as Portia, Olivia in *The Vicar of Wakefield* and other quick-minded and youthful parts: she recognised her strengths well enough to seek the role of Rosalind, the boyish and spirited girl of *As You Like It*, but never played in it at the Lyceum. The photographers reveal how well her robust sweetness and pert gravity would have served in that ambiguous part.

The great days of the Lyceum, where strong acting and richness of design reigned, making it a place of resort for the fashionable and witty, dwindled with Irving's illness and financial troubles in the middle of the last decade of the century. Photographs of Johnston Forbes-Robertson's revival of *Romeo and Juliet* there in 1895 show that the Lyceum's sense of style continued after Irving. Apart from the purity of profile and androgynous large-eyed look of both Forbes-Robertson and his leading lady, Mrs Patrick Campbell, the aesthetic style is evident in the embroidered velvet and gem-studded brocade of their costumes. Everything about the production, one gathers from these photo-

Ellen Terry at the age of 14 in *Home for the Holidays* playing alongside her older sister, Kate.

Opposite
Ellen Terry as Lady Macbeth in 1887 in one of her typical aesthetic costumes.

An 1890s production of *Romeo and Juliet* with Johnston Forbes-Robertson and his leading lady, Mrs Patrick Campbell.

Opposite
Squire Bancroft as Captain Hawtree, a typical gentleman dandy, 1867.

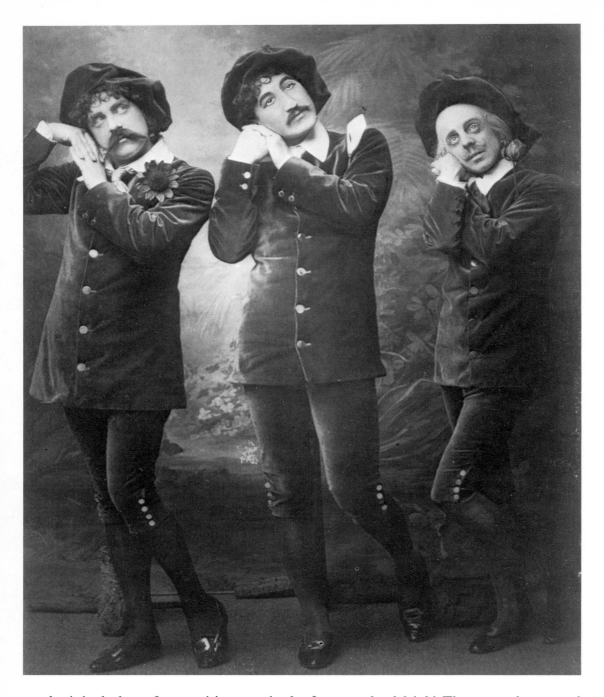

graphs, is in the best of an exquisite, restrained taste. One can understand the justice of Shaw's sardonic remark that Juliet on her bier, as Romeo gazes intently upon her, 'reflects the utmost credit on the undertaker'.[17]

Nevertheless, the aestheticism of the Lyceum was not a majority taste. Photographs of the casts of Prince of Wales comedies reveal a style much nearer to middle-class appearances and manners; these photographs also trace the development of native English comedy of contemporary life. This story began in 1865 when Marie Wilton, a favourite for years in

farces at the Adelphi Theatre, took over and renovated a small popular theatre on Tottenham Court Road which she named the Prince of Wales. There she gave Tom Robertson, brother of Mrs Kendal mentioned above, and an unsuccessful playwright, an opportunity by providing a London stage for his domestic comedy *Society*. It was an historic event, for the play was more than successful, it opened a new era in Victorian drama. Clement Scott recalled later that *Society* 'brought a marvellous sense of life and freshness into the theatre on the day'.[18] A stream of plays issued from Robertson. In his

Three would-be aesthetes from the Savoy opera *Patience*. Gilbert and Sullivan delighted the middle-class audience with the satire and high spirits of their musicals.

Opposite
'She's going to smoke!'—a crucial scene from a society drama of the 1890s.

hands the domestic melodrama, with its stock characters, was brought into some relationship with the normalities of Victorian life, both in its representation of appearances and behaviour and its subject matter, contemporary social ideas.

Many traditional types populate Robertson's plays: tyrannical marchionesses, town fops, drunken artisans, but they have a contemporary, nineteenth-century air about them. In the foppish Captain Hawtree, of *Caste* (1867) for instance, Robertson created a new model of the gentleman dandy suited to Victorian tastes. A critic's recollections illustrate the warmth of the public's response:

> The drawling speech and apparent affectation, the stolid sensibility relieved by a subtly suggested shrewdness, the 'good form' of the man with it all, his slight soupcon of horsiness, the whole tone of the creation was irresistible.

Squire Bancroft, who conquered the Prince of Wales audience with his smooth poise, and married Marie Wilton, disturbed tradition by playing Hawtree in dark hair—fops usually wore blond wigs—but this was nothing to his successful realisation of the combination of worldliness and a decent, good heart which Robertson had created and of which the Victorian middle class so approved.

The Bancrofts, John Hare the comedian, the Kendals and Charles Wyndham in turn continued the presentation of the new 'cup-and-saucer' drama, so called from its characteristic scenes of domestic life around the dining table (other epithets applied were 'the milk-and-water' and 'the bread-and-butter drama'). The study of manners—mainly upper-class manners—which was a preoccupation of this drama required a style of acting founded more on the drawing-room than on stage conventions. As we have noted earlier, a flood of amateur ladies and gentlemen swept on to the stage in the 1880s, though most were swept off soon after and professionals were left to develop the techniques for conveying refinement of gesture, speech and manner. The stage itself drew back a step or two from the audience; the Bancrofts, who took over the Haymarket Theatre in 1880, cut off the apron stage and the action was now confined within the frame of the proscenium arch, like a picture.[19] The 'low' part of the theatre audience had long departed for the music-halls; for the middle classes who liked a song and a dance, the Savoy operas had miraculously come into existence. For those who found continued fascination in the 'parish of St. James', Pinero and Jones, late-century successors to Robertson, wrote plays in which the fashionable drawing-room was the essential locale.

It is with the society drama that one senses the theatre and photography finding common ground. There is a more profound relationship here than in the operation of commercial publicity expressed by the racks of theatre performers' photographs hung outside studios. It is true that the conventions of the photographer of fashionable portraits and the conventions of the stage meet on these racks during this decade: those beautiful people dressed in the height of fashion cannot be players in costume—they must be ladies and gentlemen of the stage! This union of fashion is, however, only a token of shared assumptions on a deeper level. By the 1890s naturalism was the prevailing mode in Victorian society drama; its content was not of that challenging kind associated with Ibsen but in style it was essentially naturalistic. In this theatre players were not put upon a stage: rather, in that brilliantly-lit room framed by the proscenium arch, ladies and gentlemen were seen going about their lives, holding dinner parties, playing cards, listening to music and, continually, conversing. The word to describe this kind of presentation of life is 'photographic'. The parallels between the products of the portrait photographer and Victorian society drama are obvious in the narrowness of social assumptions and in the isolated and static nature of the images each present; above all, however, their harmony is founded on a common belief in the value and fascination of a detailed study of appearance.

6 VIEWS OF THE KNOWN

A pony and trap is bowling along a road over high, lonely country; where the moor dips glimpses of the sea appear; along the slopes close-woolled sheep crop, raising their heads at the intruder. A bend in the road brings suddenly in full view the sea and a great headland. The trap stops and a man descends carrying first a tripod and next a square leather box from which he removes and assembles a mahogany extending-box camera; another man follows holding against his chest a smaller box. He confers with his assistant: they need not wait; the light is good. After some ranging about the tripod is planted, the camera head screwed on, and the shoulder of the headland studied as it appears upside down in the ground-glass screen. A rectangular plate holder is taken from the smaller box and inserted in the camera and the lead sheath withdrawn; the viewing screen is studied again and the shutter tripped. Another exposure is made and in moving the tripod the photographer notes with satisfaction that people are gathered on the beach far below, among the oddly formal rows of boats. Down he and his assistant go, with their heavy, delicate equipment. Shiny-hatted fishermen and merchants in aprons are bargaining over the catch spread on the stones; the

Fishing boats on the beach at Brighton by Frith *c*. 1870.

scene of men, boats and baskets provides a picturesque middle ground for a composition framed by headland and bay. Returned to the road, well exercised, the photographers enjoy lunch from a basket and then, turning the pony's head, set off for the coastal town where they had rented the trap that morning. They stop en route to make an exposure at the ruin of a small fifteenth-century chapel; a local woman keeping a lemonade stall is prevailed upon to enter the picture, with her parasol, in the guise of a visitor and strengthen thereby the claim of the ruin to be an attraction. The trap journeys on towards the town, greeted, as it approaches, by the reflected light of the declining sun shining from the windows of a great new hotel, in pink stone, standing on the cliff. The photographer reminds himself to take the hotel front early in the day and the railway station, if

there is not too much bustle, and the new municipal offices might be added. Then they must be off by train to the manufacturing town inland, where churches, parks and monuments are waiting to be added to his collection of local photographs which will sell for years to come — until the fashionable crowd seen strolling on the esplanade dwindle into quaint, dated figures on an old postcard.

The roving nature of the Victorian views photographer's work makes him appear a bolder figure than his studio-bound cousin, the portraitist. There is evidently a wider contact with life, and some of the compositions, notably the views of natural scenery with their strong formations and open skies, suggest a freedom of attitude that contrast with the rather fussy decorum of studio portraiture. Historically, there is basis for this spirit in the work of the

Cliff House hotel and the beach, San Francisco, photographed by W. H. Jackson.

The Scottish Highlands caught in a typical views photograph by Francis Frith.

expeditionary photographers discussed in an earlier chapter. Some views photographers were simply domesticated adventurers, settled into a reduced sphere of travel, others, in tune with the advertising phrase 'Portraits and Views', a common rubric, varied their studio work with local outdoor scenes.

The word was perhaps as frequently applied to foreign scenes as to domestic—as in Felice Beato's *Album of Photographic Views of Japan* (1862)—and both kinds answered in some degree the public's hungry curiosity about the world. But there are differences sufficient to justify regarding them as two kinds of photographic work. The expeditionary photographer acted, in relation to the general public, as a surrogate: he journeyed into foreign parts, exotic and wild, and brought back fragments of remote cultures and glimpses of fabulous forms

of nature. Frequently his subjects had never before been photographed and never been seen by European eyes. The best work of this kind conveys a sense of a moment of unique perception arising, one feels, from the challenges to the photographer of rare subject matter, technical difficulties and the special requirements of the expedition. The views photographer worked under less intense pressures and served a market much closer to the subject matter. The close presence of the public, breathing, as it were, on the photographer's neck, appears to have had an inhibiting effect: the pressures of conventional expectations, rather than the exceptional challenges of the subject, have most weight. 'In the early days,' recalls a late-Victorian photographer looking back at the 1860s and 1870s, 'a photographer never thought it worth his while

to point his camera at objects that were not "of interest". It might be a building having historical interest, or architectural beauty, or it might be a well-known and favoured landscape celebrated far and wide for its beauty"[1] The result of this assumption is a limited and repeated subject matter within a busy commerce. The capturing of a well-known scene is an enterprise similar in spirit to the entrapment, in a portrait, of a celebrity. A great deal of views photography for the mass market shares the values of celebrities photography: it provides souvenirs, satisfies curiosity, and demonstrates the owner's acquaintance with a larger world.

Despite the evident reduction of photography's potential in this trade, a great deal of value and interest lies in the pictures. The essential and unsurpassed capacity of the photograph to imitate life allows for discovery both in its time and today: the simple dislocation of public expectation and convention can accomplish this. We see, for instance, a photographer from Notman's, the established Montreal firm, going out to photograph scenes and views from Nature. His chosen region, the rivers and lakes of eastern Canada, provides him with ample material for an album of views which are put on sale in Canadian towns and

Ottawa as a frontier town by a Notman photographer.

cities: they show the photographer in a canoe, with his equipment, and scenes of silent lake and forest which, unexceptional to Canadian eyes as scenes, would strike the European, accustomed to landscapes of cultivated Nature, as views of the primeval forest itself. Again, photographs from frontier towns in the U.S. West or around the British Empire taken in the late nineteenth century are often clearly modelled on European conventions of a view: they are shot straight down a main street, or directly confront a newly-erected building: subjects of local importance and pride. What they reveal, however, by implicit contrast with the Champs Elysée, or Madison Square, and through the direct, bald manner of the photograph, are scenes expressive of the raw frontier. Through such photographs one can measure, indeed, the waves of Europeanised culture passing round the world: photographs from fashionable spas in eastern North America in the 1870s resemble, in their views of promenades and gardens thronged by well-dressed ladies and gentlemen, photographs made about the same time in Europe; the expert will detect differences in the style of clothes and buildings but the style of life is clearly similar. In photographs of the Californian coast in the 1890s we see beaches crowded with people and conveyances and overlooked by the massive castellar structures of grand hotels, cousins of the same imitations of Balmoral Castle and the *châteaux* of the Loire as are found in views of resorts along European coastlines.

Moreover, the photographic view offers to the modern student a double revelation of nineteenth-century taste: it presents in its contents scenes of publicly approved social life —life in its Sunday clothes, on the promenade —while at the same time offering us an instance, in itself, of a social instrument for forming that behaviour. Photographs from Victorian Britain are particularly useful as a coherent study of taste—and the formation of taste—being less marked by the anomalies caused by distance than those from North America. In Britain, photographs of thronged esplanades, tea-gardens, castles, and natural wonders such as the Cheddar Gorge, hung on the walls of the homes of the wealthy for many years before, reduced in size, they were bought by city clerks to be sent home through the post, scrawled on the reverse with jaunty messages. That taste in photographic views was largely established by the wealthier classes—the fashionable among the country gentry and the city bourgeois—was inevitable, for these classes in the early period of photography, were the travelling, holiday public.

View photographs were made as souvenirs for this middle-class travelling public. Beach photographers drove a popular trade in comic by-the-sea portraits for the day and weekend excursionists—when the railway introduced excursion tickets—but it appears to have been a mark of genteel taste to buy views; only the better off could really afford to build up album collections, or frame large prints for their walls. Through the 1860s and 1870s landscape photographs could cost, depending on size, anywhere from 6d. to 3s. 6d. (Henry Taunt, for instance, sold 'Shilling Views' of the Upper Thames in this period.) Costs of material and processing were high (in 1878 the cost to the photographer of factory-prepared dry plates was 25s. a dozen) and the gathering of views was a laborious and time-consuming affair. Publication on a large scale was necessary and a handful of firms with the necessary capital dominated the trade in Britain (Joseph Cundall in London; Francis Frith, Reigate; James Valentine, Dundee; George Washington Wilson, Aberdeen).

Francis Frith's career and work is particularly interesting because it spans the high, heroic days of the photographer-adventurer (in which he travelled up the Nile and through the Holy Land) and the sedate High Victorian period in which he travelled about England by rail and pony trap. Frith's commercial success did not lie in photographic artistry (a recent biographer terms him a 'non-photographer') but in the thoroughness with which he worked, photographing everything possible that might stand up to the term 'A View', producing clean, matter-of-fact photographs, extremely crisp in detail, and organising a distribution network of retail outlets throughout the British Isles: village post-offices and booksellers in the main. His photographs were sent to Saxony for mass reproduction by the collotype process; hundreds of prints were run off daily on the rotary presses which came into use in 1873.

The culmination of these developments in views photography—specialist photographers, numerous retail outlets, and fast, cheap reproduction—was the postcard with a view on the back. This format was developed on the Continent in the 1880s but did not come into use in Great Britain until postal regulations were amended in 1901 (when Frith, Valentine and other companies became postcard publishers). The subject-matter for this essentially twentieth-century phenomenon was established in the Victorian period.

Among the forces which influenced this taste are the twin sentiments of nationalism and romanticism.[2] While rail and steamer made foreign travel easier and probably widened the social range of young Victorians making the Tour, that essential part of fashionable eighteenth-century education of the gentleman, a countering sentiment in favour of exploring the wilder regions of one's own country, developed. Matthew Arnold might follow the traditional path through the Alps (writing verses on the same mountain passes which were the subject of the young Wordsworth's poetry), but he also took walking holidays in the Cotswolds, as did many of his fellows at Oxford.

University undergraduates were particularly susceptible to the appeal of this kind of communing with nature; the walking holiday

was established—and remains—as a morally elevating activity which is part of English life. In the Victorian period it demonstrated a cultivated sensibility, manly vigour and a proper sense of England. That hearty Christian patriot, Charles Kingsley, summed it up:

While we see God's signet
Fresh on English Ground
Why go gallivanting
With the nations round.

These lines, which suggest that the British Isles were a divinely-appointed tourist region, appeared on the frontispiece of British guide books, which were published in great numbers in the period.

In these guide books the cult of 'sweet England' is developed — sweet because small in

A crisp detailed view of Warwick Castle by Francis Frith.

scale and domesticated by human associations over the centuries. Well-known beauty spots are discussed with detailed and tender care and view photographers evidently follow the same approach: a matter of a few feet could be of crucial importance in planning a photograph of a view which has been discussed, written about and read by thousands of enthusiasts. The writer of a guide to the Peak District, for instance, discussing Dovedale in tones of high admiration ('the most beautiful and harmonious blending of rock, wood and water within the limits of the four seas') advises his readers that from the stepping stones at Sharplow Point 'a lovely view up and down the dale is obtained, the southern vista being blocked by the pyramid of Thorpe Cloud'. Francis Frith found his way to this spot and in

his photograph we see the southern vista, precisely as described with the stepping stones across the Dove in the foreground and the cone of Thorpe Cloud rising to close the scene in the background. (An interesting and endearing extra detail of this photograph is the evidence of the Victorian tourist trade—donkeys, refreshment stands—in operation along the bottom edge of the picture.) Similarly, the guide book and photographer appear to be in harness as Flamborough Head on the Yorkshire Coast is explored. After noting the long, treeless promontory of the headland, the guide takes the visitor on 'a descent to the North Landing' and exclaims on arrival 'Here be boats and boatmen!' Frith's camera records the long promontory and, from beach level at one of the landings, the boats and boatmen.

A guide-book view of Dovedale in the English Peak District by Francis Frith.

Topography makes obvious and immediate appeals to the eye, of course, and it would be surprising if guidebook and camera did not record the same features. Further, visitors seeking souvenirs want the familiar and obvious. But, when all is said and done, the camera remains a flexible instrument, capable of revelations and discovery and of being employed creatively. If view photographs do not go beyond what is to be expected in guide books it is a limitation, more or less deliberate, of these capacities. This truth is borne out by the existence of what are virtually genres of landscape photographs where a subject has been taken and worked up to evoke feelings and ideas beyond the literal appearance of things.

'Here be boats and boatmen!'—the phrase from the Flamborough Head guidebook is,

despite its implied excitement, a bald, undeveloped statement. Naturally Frith's photographs present far more than this; they are packed with particular detail—men, ponies, nets, canvas and a fleet of beached cobles, the small fishing-boat of the north-east coast (with sharp, high bow and flat aft section) in which a crew, perhaps just a man and his boy, might stay at sea for a week in the summer. We can learn from these photographs. The working world, against which one is brought here, is not a usual subject for view photography; fishermen, however, possess a special sanction: the tangle of ropes, men and canvas on a foreshore expresses the romance associated by Victorians with the seafaring life.

Other photographs, both amateur and professional, exploit the subject of the

Flamborough Head, Yorkshire by Francis Frith.

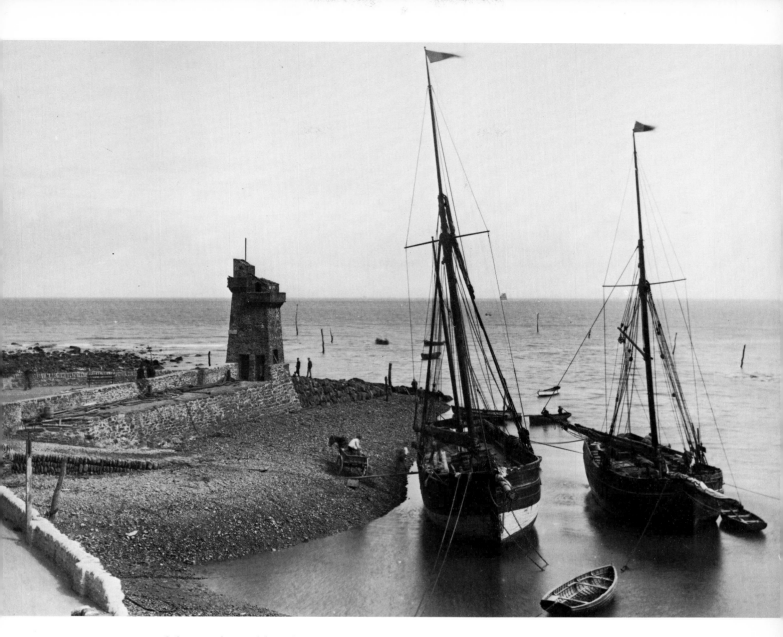

A calm haven on the North Devon coast captured by Francis Bedford.

fisherman's world and develop the primitivist sentiment that the good life is the simple, hard life. Many photographs of boats and the sea express a quite different vision—calm, meditation, a sense of haven—which stands in strong contrast to evocations of storm and hardihood, but which comes, nevertheless, within the conceptual framework of romantic attitudes. The photographs of Francis Bedford in particular, taken along the bare coastline of North Devon, express a sense of elemental pause and of timelessness: man and his works are at one with nature. A coasting ketch, heeled over against the shingle of a beach harbour, discharges its cargo; the scene is simple in its elements yet rich: the boat, yielding to rope and plank, appears as alive as the carter's horse waiting, head turned, to pull the load, and,

distanced as the camera is, the action is contemplated rather than dramatised. In effect, the meeting of sea and shore, of boat and cart, links man and nature in a simple, yet fundamentally profound occurrence, an act repeated through the centuries, particular in its ordinary, immediate purpose—and photography is unsurpassed in conveying the ordinariness of a scene—and also general in its expression of a crucial accommodation. High-pitched as this interpretation may be, loading too great a burden on a simple view, Victorians were accustomed to read just such large meanings into small, everyday acts and were encouraged to do so.

For the urban middle class these meditative and timeless views of men and boats must have had appeal in the escape they offer

from the time-harried present: and further, the sight of a boat pulled up on a beach (a scene which is depicted so frequently in Victorian photography as to be almost a motif) combines romantic expectation and readiness—and a highly pleasing balance of rounded hull and sloping shore—with a tone quite its opposite, a plangent sense of melancholy naturally arising from perception of an object stranded, out of its element. Here we are close to Matthew Arnold's territory. No generation appears to have felt more intensely than the mid-Victorian the unsettling effects of the rush of time, and the chief poetic spokesman for this anxiety, Arnold, used again and again the metaphors of tide and wave and the locale of the lonely shore.

In the same mood the cottage, particularly the thatched-roof cottage, enjoyed a rise in social stature during the Victorian period which was not due alone to its picturesque appearance. In the town the detached house became the rule for new domestic architecture of any pretension and this fashion conferred status on the single cottage. Further, in the eighteenth century 'the labourer's humble cot' stood at the opposite end, in social terms, to the site of 'the ducal Pile', and this location was justified on physical grounds also, the cottages being mean and foul. In the nineteenth century this position was taken over by the back-alley slums of the great towns and, at the same time, a greatly enlarged professional middle class—solicitors, clerks, doctors, military men, civil servants, ladies of modest means—began to choose country retirement rather than a small house in town, and converted and renovated many cottages, farmhouses and millhouses.

Townscapes present other, rather different, historical movements and social realities. Take Bingley, the Yorkshire woollen town

An almost ethereal beach and sea-scape in Cornwall by Francis Bedford.

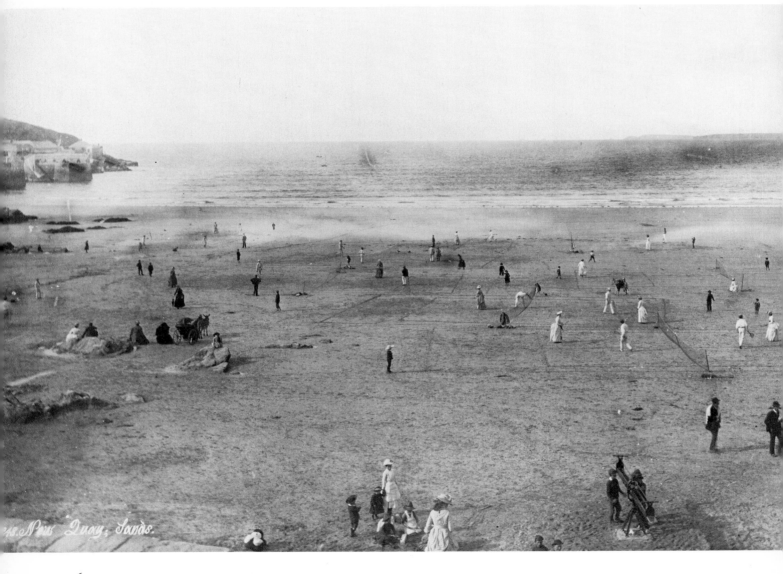

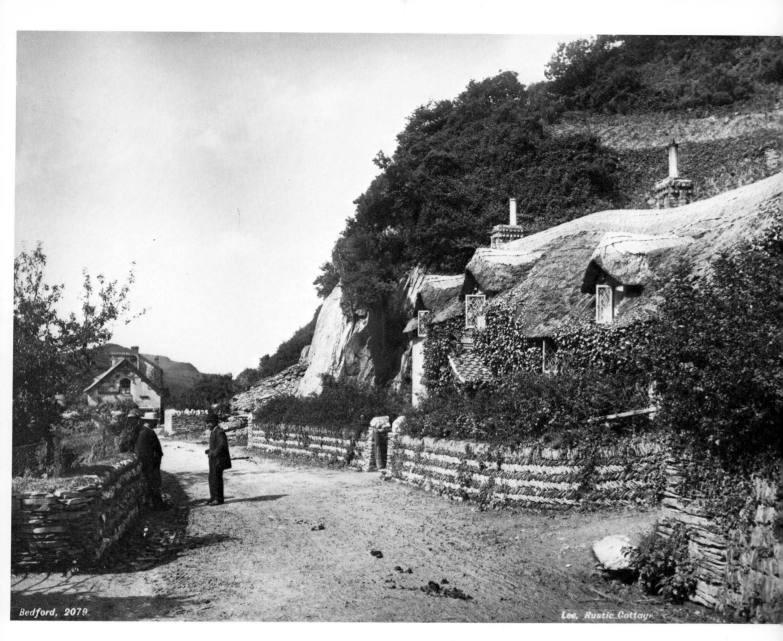

Bedford, 2079.

Lee, Rustic Cottage

The thatched cottage became an expression of rural tranquillity in the views photograph. (Francis Bedford)

in the valley of the river Aire. A comprehensive Frith view thrusts the contemporary character of the town at an observer. Dominating it, and holding the middle of the picture, is the chimney and barracks-like buildings of the mill; in the foreground, and beyond the mill chimney, rooftops in rows indicate the houses of workpeople, while climbing up the far slopes can be seen mansions, standing in their own grounds, of the mill-owning class. Another Frith view taken fron a bridge over the Aire presents quite a different view: essentially this is an earlier Bingley. We see the river which drove the first mills fringed by punts below the wall of a small workshop or warehouse; the twin lights of the church belfry are visible where the tower rises above roof and tree. (This fifteenth-

century church was renovated in the Victorian period and a stained-glass window installed, designed by Morris and Burne-Jones.) This lower view presents a country town, modest and pretty, and a sense of unchanging rural certainties; while the panorama shows how small a corner this scene occupies in industrial Bingley.

In another view, taken only a dozen miles from Bingley, a smoking chimney and another unmistakable mill building buttress a foreground view of greensward dotted by sheep and the white forms of cricketers. Frith's photograph is rich in content: his view is of Saltaire, the mill (and adjacent town) built by a Yorkshire magnate, Sir Titus Salt, who shifted his famous alpaca and mohair mills from the centre of Bradford in 1853 to a site, open and

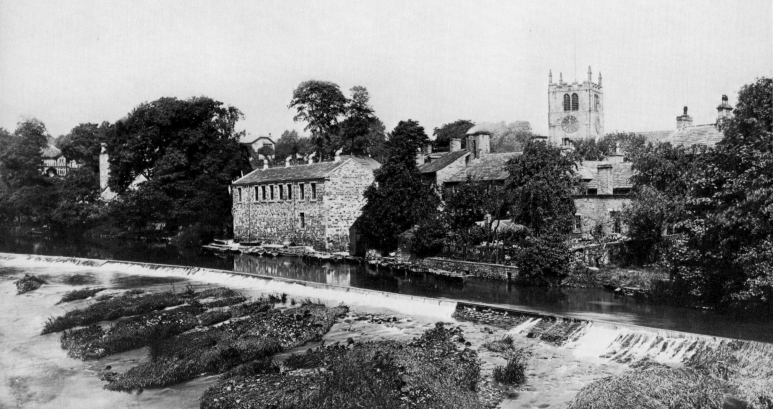

salubrious, in the moorland valleys near Shipley. Sir Titus was one of a number of prosperous Victorian industrialists who sought to expunge criticism of the factory system by creating, when the time came to expand, a model factory community. Much money was spent on Saltaire: the mill, designed by a celebrated engineer, Sir William Fairbairn, was made fire-proof, with cast-iron roof and pillars, and an exterior, as we can see from the photograph, trimmed in a stylish Italianate manner (one chimney is in the form of a starved campanile). This photographic view, taken some thirty years after the building of the mill, would have gratified Sir Titus, for it appears to demonstrate the realisation of his vision: on the new industrial village green sheep graze, content, no doubt to give up their wool when required, and the time-honoured village game is played by men who place their support and faith on the firmly-outlined mill buildings and smoking chimneys which rise behind them.

While industry gathered communities around it and raised towers higher than church spires there was also considerable Victorian energy devoted to church building, refurbishing, and the adaptation of church architecture to buildings of public use: libraries, railway stations, town halls—even hotels—were often given an ecclesiastical air through the spread of the fashion for the Gothic (or, as it was called in England, Early English) architectural mode. This enthusiasm is splendidly apparent in the great Gothic edifice which the rich manufacturers of Manchester chose to build as their new Town Hall in the 1860s. This 'large-scale exercise in High Victorian Gothic' as Nikolaus Pevsner calls it, raises a stiff nose, a tower 286 feet in height, above Albert Square; because of its triangular ground plan the building, seen in Frith's views, appears to be all façade and no body. Certainly these photographs, looking over the past horse-cabs and pedestrians, insignificant properties in the scene, emphasise the

The Gothic rigour of Manchester
Town Hall by Francis Frith.

Opposite
Victorian street furniture
celebrated by Francis Frith.
Bridge Street in Chester.

The pomp of Victorian death:
the Glasgow necropolis by
Francis Frith.

starched-and-pleated shirtfront quality of the face of the building. One grasps also another aspect of Victorian Gothic: it does not soar lightly; height expresses itself in weight and power; it presses upward from a firmly secured base.

Views photographs also show us the streets of towns as they sprout new and elaborate forms of street furniture: not lamp standards alone, though these were a continuing feature of municipal improvement, but also combined lamp standards and drinking fountains, clock-towers which were also lamp standards and weather-vanes, multiple-use water outlets, with horse troughs, dog basins and fountains. Photographers, with that special Victorian interest in the pomp and circumstance of death, entered cemeteries and took views of upthrusting funerary monuments: obelisks, columns and raised urns; new bridges, avenues and squares bristled with bronzes of emblematic figures.

Perhaps the culminating moment of a century's efforts in the development and use of new materials, new power and new technology is caught in a Frith view of the bridge across the Firth of Forth. The characteristic manner of a Frith photograph, clear detail, matter-of-fact tone, works extremely well in this instance to allow the dramatic structure to make its own impact. What appears to be a strong morning light, which casts sharp deep shadows, strengthens the dramatic movement of the three leaping cantilever spans which carry the bridge's great weight (38,000 tons of mild steel) across the Firth. The bridge was opened by the Prince of Wales in 1890 and in the same year Baddeley's *Scotland*, a thoroughly detailed guide, printed the resultant alterations in train schedules and the following comment: 'It is rather as a magnificent monument of engineering skill than from an aesthetic point of view that the bridge is to be admired, as it is distinctly ugly'. The huge support structure

A monument to nineteenth-century technology: the Forth Bridge in Scotland by Francis Frith.

The nineteenth-century resort:
Scarborough by Francis Frith.

of steel tubes offended Mr Baddeley's eye and it is true that this superstructure is brutally large in its scale by contrast with the line of the railway track it carries and with the houses at the foot of the viaduct at North Queensferry.

With views of railway line and viaducts we are being brought back to the urban, organised world from which the views photographer made his departure to collect picturesque scenes among the forms of nature. In these urban centres, in the period, from the 1860s to the 1890s in particular, the forces of order were paving, draining, lighting, redeveloping and generally conquering the agglomerations of the ages, placing the ornately finished stamp of Victorian visual decorum on streets and squares. Frith's views of Scarborough demonstrated the weight with which this stamp fell upon resort towns which often, in their sea-front development, were entirely Victorian. (The old town of Scarborough, for instance, lay inland, in the lee of the headlands and turned away

from the sea.) The long approaches of Frith's views, sweeping over long stretches of sand and sea, emphasise the massive and monumental quality of the great buildings.

View photographers were not what we would call documentary cameramen, but they were so industrious, their work so extensive, and their photographs so open in their vision that we can see this great combat of the century proceeding: the struggle between order and disorder, decorum and spontaneity. For many of the features discussed here fit into this pattern — the city and the country, the monumental and the picturesque, the mechanical and the natural, the fashionable and the vulgar. Not all the oppositions are clear, and a further rotary movement appears to be continually overturning the sets: the bluff, rude shapes of fishing boats, heavy with dark sails, disappear; we see a high-Victorian symbol of affluence, a steam yacht, steel-hulled, with neat, sharp lines, white awnings and a single dark funnel; this vision is

133

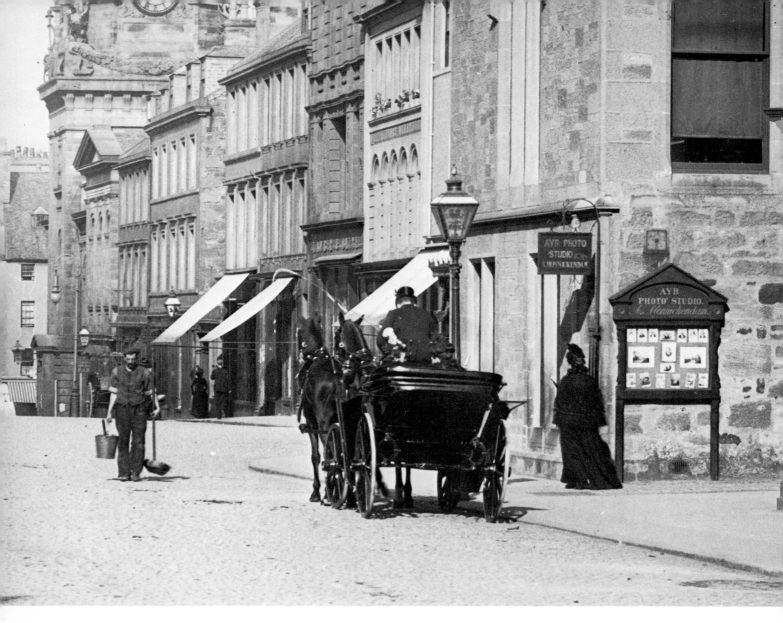

overborne by fleets of smoke-puffing tugs, ferries and coasters which present a different profile but in their energy and spirit seem close to the luggers and ketches they replace. Similarly, the face of the Victorian city can wear opposite aspects: one view shows the contained, regular plate-glass fronts of a row of shops, and the lamp standards, evenly spaced, on the pavement before them: all is order. Another view looks down the street, which has the appearance of a dramatic natural feature, a gorge perhaps; one side is light and the other in shadow, and through the slanted patterns of light move swaying, top-heavy shapes of horse-omnibuses and cabs: despite its matter-of-fact title 'The High Street, ——gate', the photograph communicates a sense of urban pace, excitement and romance. Examined like this the form of the view shows surprising variety and richness and restores, to a banal commercial term, something like the original vigour and significance of the word 'views'.

The stiff formal front of a Victorian street with a photographic studio in the foreground: Ayr, Scotland by Francis Frith.

7 THE LANGUAGE OF THE ORDINARY

Victorian photographers who lived in cities, with the roaring street beyond the studio window, possessed at hand a rich and complex subject matter. But the previous chapters have worked to little effect if they have not suggested how firm were the barriers of convention and of commercial necessity which prevented a photographer of normal interest from going beyond portraits and views for his subject matter. As for the amateur, his usual range of interest extended from amusement at one end, chiefly found in the photographing of family and friends, to the taking at the other, artistic end of sentimental scenes and the recording of historic buildings. The commercial views photographer in a sense recorded ordinary life in his views of great houses, public buildings, parks and the main thoroughfares of cities, but there is little of domestic everyday ordinariness in these views. Certainly, because there was no market incentive, the views photographer rarely ventured into the back streets where the bulk of the urban population lived, when men lounged at doors in shirtsleeves and children tumbled near the wheels of passing carts. These streets were unfashionable and no art was as sensitive, in the

The conventional view of city life: Madison Square, New York by Byron, 1901.

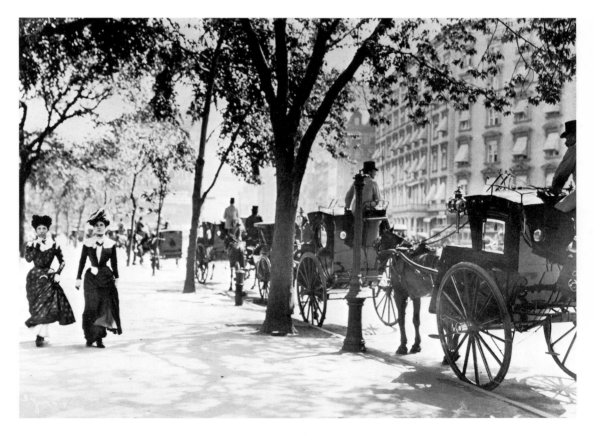

Victorian period, to fashion as photography.

Of course there were exceptions—exceptional causes and exceptional photographers—which gave rise to the body of views of ordinary life which has come down to us. It is slender in bulk by contrast with the portraits of the period, slender even by contrast with a branch of portraiture such as theatre photography, and uneven both in technical accomplishment and degrees of social penetration. The lesser virtues, pertinacity, thoroughness—the possession of luck, even—play a significant part in a form of reportage which must take its subjects often as chance dictates. From a series of barren and monotonous views one may pluck, occasionally, a single photograph superbly rich in its social interest and startlingly superior to the surrounding pictures. Such unevenness is not the product of chance alone: it betrays the uncertainty with which documentary photography was practised in the last century. Where no established market exists, and there is little sense of popular taste or guidance from established art forms, who is to say what is a good photograph?

While social documentary was an incompletely understood form of expression and comment there nevertheless existed pressures which thrust it into life. The whole technical direction of photographic development in the century, towards ease and rapidity of operation, brought into existence cameras suitable for capturing glimpses of ordinary life. A continuing pressure was also exerted by the optimistic spirit of progress manifesting itself in improving, reforming ideas and, their necessary accompaniment, social inquiries. The unfashionable territory of the back streets need only appeal to the philanthropists and the social investigator for the photographer to appear in their wake, detailing and recording. These photographers were commonly from the local studio, and were commissioned to a task without possessing special expertise. They entered the back streets, it appears, in the same spirit as expeditionary cameramen journeying in strange lands, for one of the commonest documentary photographs of the century shows a line of back-street dwellers, generally women and children with, perhaps, a man lurking in the rear, who are ranged across the middle of the composition, gazing expectantly into the camera. From the 1860s to the end of the century, and from every great city, comes this photograph; it always seems worth looking at because of the candid directness with which the subjects give themselves up to the camera—like those foreign aboriginals photographed for the first time by expeditionary photographers. Often the composition is perfunctory—spoiled sometimes by movement—because the photographer's commission is not the back-street denizens but the recording of some new engineering marvel, a railway viaduct, a gasometer or, late in the century, an electricity generating station, which overshadows the houses of the mean streets; the photographer turns his camera on the people only to end the children's badgering. Ironically, it is these by-blows that the social historian hopes to find and not the deliberately conceived views of gasometers.

A number of deliberately photographic incursions were made into areas notorious for their insanitary and dilapidated state, and from these come photographs which show the camera penetrating beyond the row of denizens—the Back-Street Tableau—to provide more varied views, sometimes vividly pictorial. Thomas Annan's photographs of Glasgow tenements, commissioned by that city's Improvement Trust in the 1860s, are so firmly and sensitively composed for picturesque effect that they create strikingly memorable views of alleyways, dramatically shadowed, and tenement cliffs fluttering with washing hung to dry. The same dramatic glances down alleyways and glimpses of teeming courtyard life are found in the work of Jacob Riis, made 30 years later, and a continent away. Riis, a newspaper reporter possessed of no photographic experience, entered the tenements of New York's Lower East Side on a mission of revelation, and literally threw light into dark corners with his camera and clumsy flashlight equipment—and a magnesium flare set off in a frying-pan.

Both of these well-known photographic enterprises produced photographs which are acknowledged as fine examples of documentary art. Between these dates must have occurred many similar photographic expeditions of which the memory and records are lost. One which has survived is a series of photographs, little-known, of back-court Birmingham taken in the mid-1870s during the planning of extensive slum clearances directed by the town's energetic mayor, Joseph Chamberlain.[1] The area to be cleared of derelict housing and workshops, erected during the rapid expansion of industry in the Midlands of Britain a century before, extended on either side of a narrow arterial alleyway known as 'the Gullet'. It is clear from

Backstreet London caught in a startling pose. The photograph was taken by an unknown photographer commissioned to record the construction of an electrical generating station.

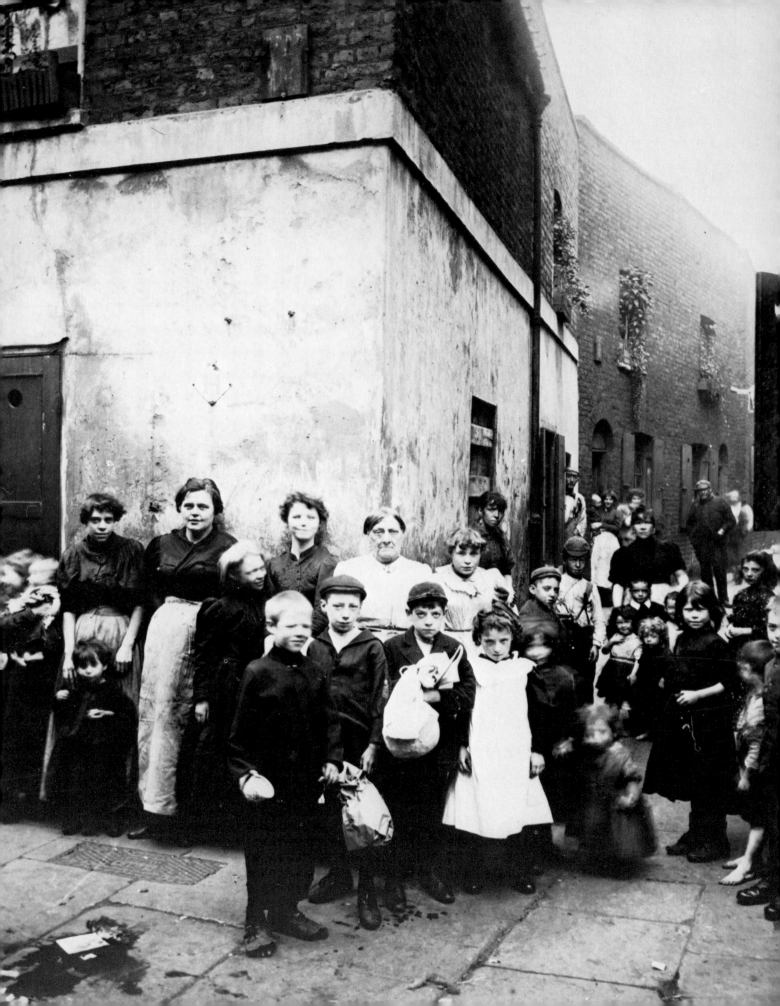

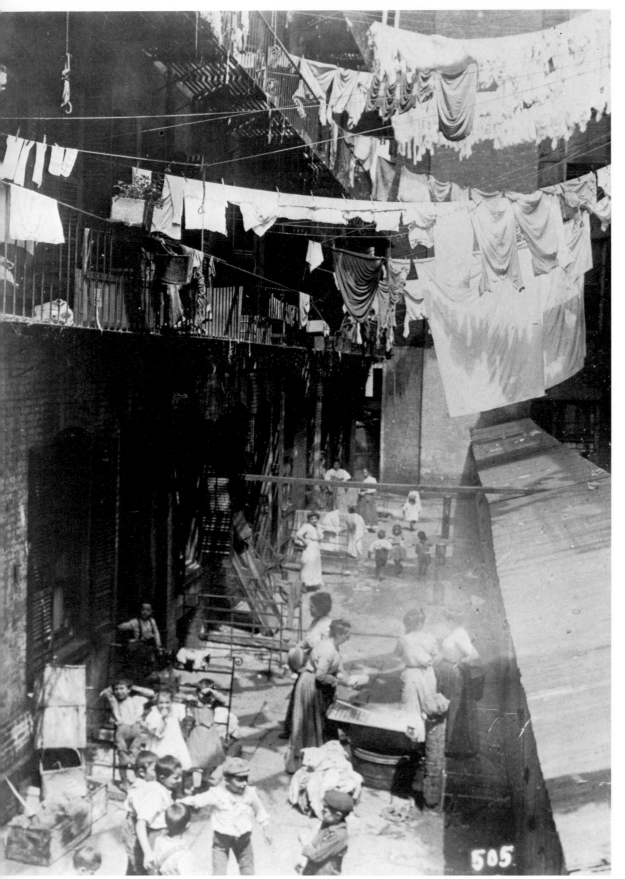

Opposite
A first use of the camera in a social crusade. One of a series of photographs of Glasgow slums taken by Thomas Annan in the early 1860s for the Glasgow City Improvement Trust.

Tenements of the New York Lower East Side photographed by Jacob Riis in 1903.

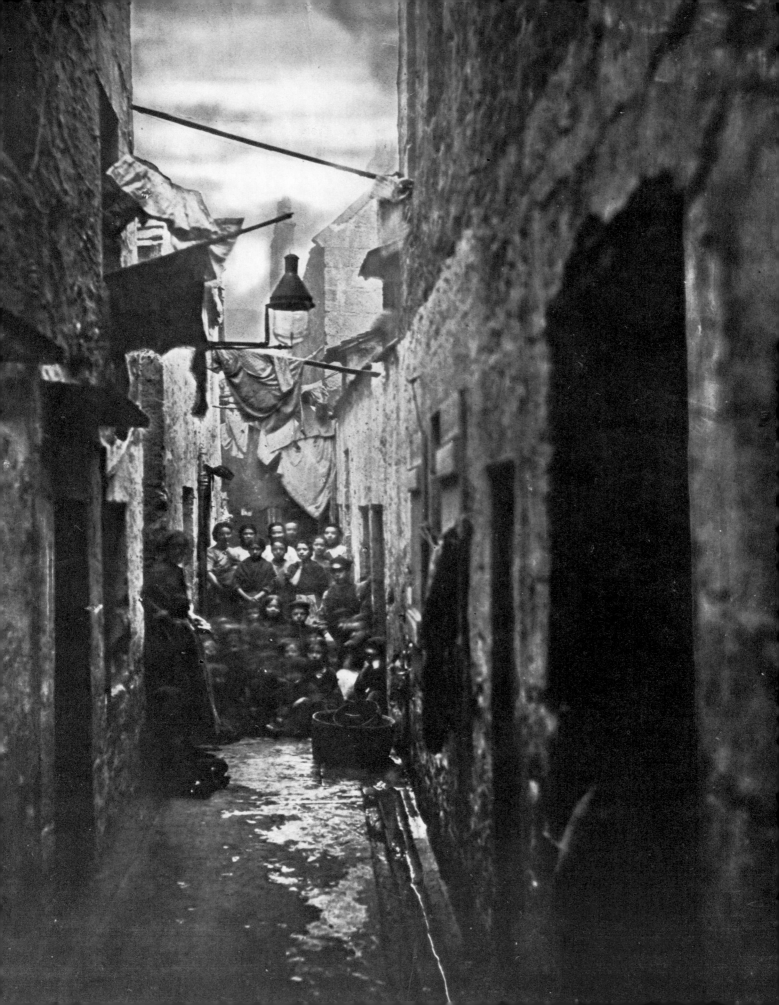

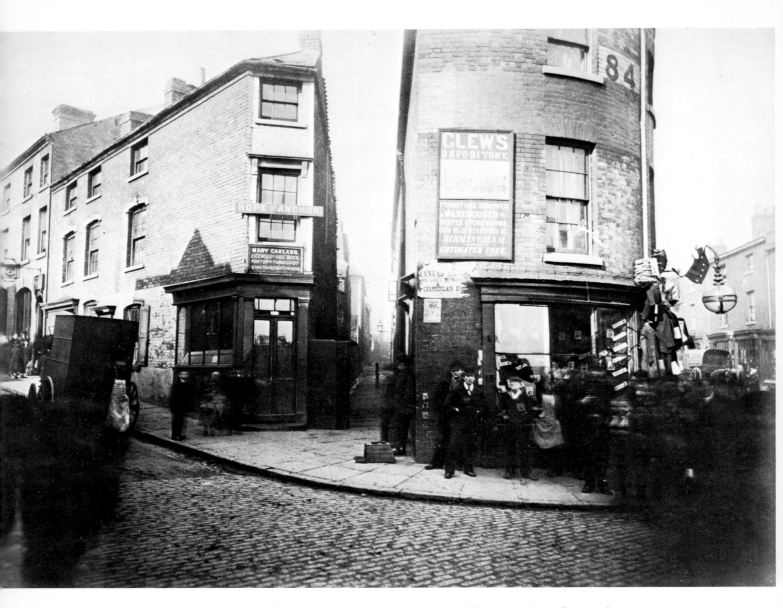

the photographs that comprehensiveness— court-by-court documentation—was uppermost in the photographer's mind: methodically the series leads the viewer along the Gullet and down the tributary alleys and courtyards. Inevitably, many of the photographs are repetitive and empty of interest. But some few hold the eye: usually these depict back-court inhabitants, but that is not invariably so; sometimes an arresting statement emerges from a simple view of a crumbling brick wall, or the sight of a solitary window in a bare wall, hung with a curtain on a string, evidence of human care. One photograph shows an apparently empty courtyard in which a bundle of rags lies at the foot of a wall. The bundle, although almost dropped off the bottom of the frame, attracts the eye and on inspection reveals itself as a group of small children, three or four years

of age perhaps, huddled together. So nearly passed over by the camera, this tremendous detail charges the scene with human significance. From this photograph one can draw some of the principles of documentary art, adumbrated rather than realised, for in its imperfections the Birmingham slum series provides a better aid to understanding the form than the more accomplished work of Annan, where the artistry, so naturally executed, conceals itself, or the revelations of Riis, which are often based on startling content.

The link with documentation is evident, for the routine, perfunctory positioning of the camera makes for compositions which are single-minded, direct and blunt, plainer even than those depictions of inert buildings beloved of view photographers who, at the least, sought to register imposing dimensions. Naturally

The Gullet, Birmingham, 1875 by Burgoyne.

A Birmingham back-yard with a huddled group of children in the foreground. The principles of the documentary begin to emerge from this photograph.

enough there is also a demonstrated disregard, where people have placed themselves in the camera's view, for the conventions of the studio: subjects are not posed, centrally, and with regard to social or occupational status; they simply appear, disclosed, as it were, by the camera. For the most part, in this series, the perfunctoriness of approach and abandonment of conventions produces photographs which are void of impact; occasionally, as if by accident, one possesses effect, but always the views reveal the possibilities of a new form. If the camera were moved closer, to shoot through a screen of aproned women at the courtyard beyond, or positioned to make dramatic use of the receding lines of an alleyway, striking and authentic photographs could be made of the world of the poor. But this is to examine the photographs with an eye accustomed to documentary.

For most Victorians, photography of the poor meant studio-composed scenes of the kind produced by Oscar Rejlander.[2] This genial Swede who had settled in England had been a painter before he took up photography and the scenes of simple, touching sentiment which were his forte undoubtedly reflect, in the manner of their composition, the practice of a studio painter. One of Rejlander's favourite juvenile subjects was the street-boy. Many children lived by their wits in the streets of mid-nineteenth-century London—by sweeping crossings, running errands, holding horses' heads, turning cartwheels: those were the respectable occupations; in addition they stole, begged and simply lounged at corners until moved on by the police. To the well-to-do they were a street nuisance but artists and writers of the day, chiefly those of the light comic

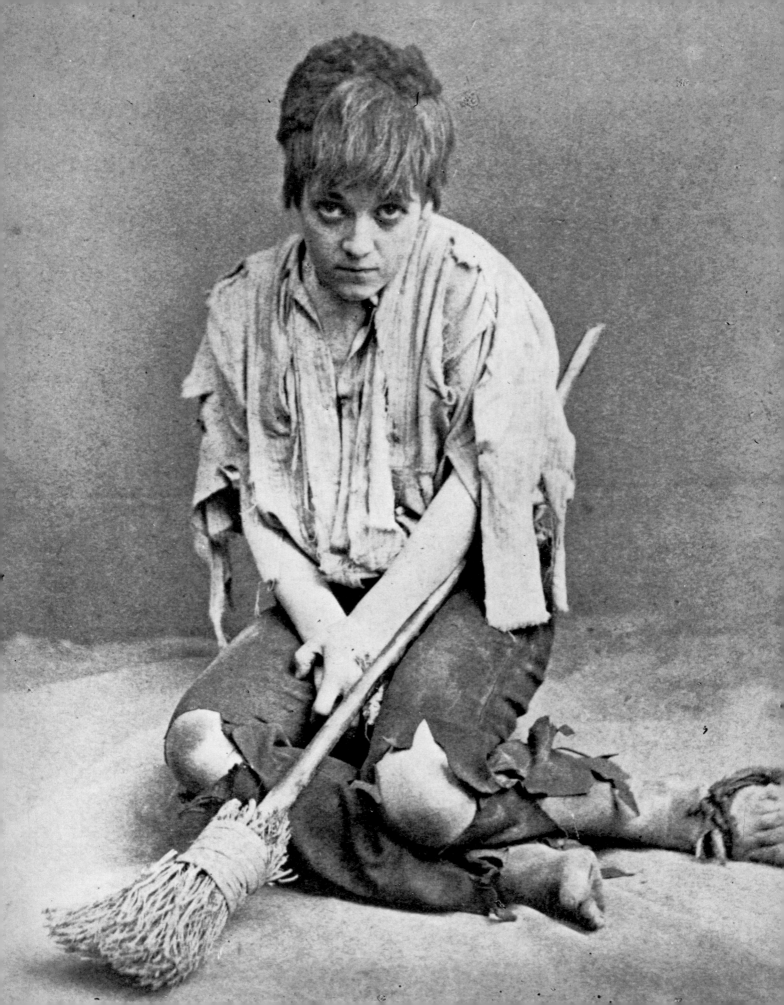

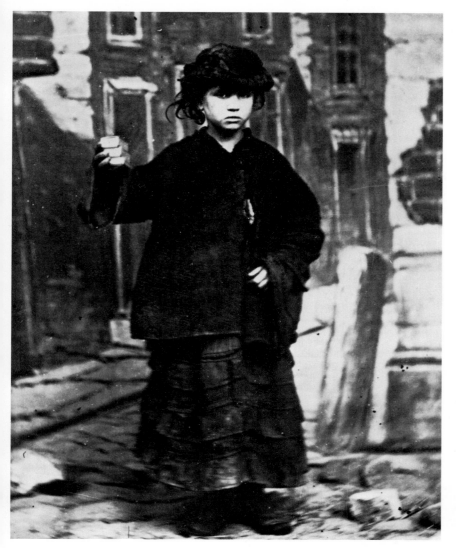

Katie Smith, Barnardo's favourite model for publicity photographs.

Opposite
A theatrical publicity photograph of 'Poor Jo' in the style of Oscar Rejlander.

crouched in an attitude of despair. The photograph, taken up by the public, was dubbed Poor Jo, after the street-sweeper of Dickens's *Bleak House*. The photograph exemplifies the contrived staginess and extravagant posturing of much pictorialist photography of the 1850s and 1860s.

It is worth pausing over Poor Jo for a moment, for the popular acceptance of the photograph reveals an inadequate appreciation of the special properties of photography. Authenticity, for instance, which today is regarded as essential in a photographic appeal to social conscience, appears to scarcely matter, and genuineness of detail, the test of the authentic, is neglected so long, one infers, as the general impression is right. And even this general impression, the idea of the photograph expressed in the boy's pose, is not taken directly from life we have evident reason to believe, but from images established by popular literature and entertainment.

Rejlander's imitators, for he had played an innovative role in introducing low-life material into photography, took up the stagiest aspects of his work: the broadly-conceived poses in which emblematic figures displayed their meaning to the audience at the back of the gallery, so to speak, in emphatic, unmistakable tones. The mathematics lecturer and story-teller, C. L. Dodgson (or Lewis Carroll) borrowed some of Rejlander's clumsiest features in posing Alice Liddell, with smudged cheeks and torn clothing, as a pathetic beggar-girl.[4] The same theatricality was adopted by a man of quite different temperament from that of the shy Rev. Dodgson, Dr J. T. Barnardo, Evangelical preacher and medical student, who brought an extraordinary flamboyance of manner into the field of philanthropy. Possessing a natural flair for publicity he perceived the possibilities of the photograph as an aid in his continuing campaign for funds for his East End Juvenile Mission. A local photographer executed the work, but Barnardo, and his wife, appear to have often played a significant part in the composition of these publicity shots.[5] Barnardo used children received into his charge; against painted backcloths of urban decay, or with properties of boxes and barrels littered about them, the rescued children were posed, their clothes rent and their faces dirtied to imitate the condition of their neglect. Barnardo had a favourite model for these photographs, a thirteen-year-old girl, Katie Smith, with large eyes and a round, soft face. She was portrayed in various poses, sometimes

periodicals—a confessedly Bohemian crowd—took them up and used them in their work.[3] The street-boy was a useful emblematic figure: on his respectable side an emblem of social neglect, and on the other, disreputable side, a defiant rogue, with an attractive swagger—Dickens's Artful Dodger. The street-boy might appear in a political cartoon in *Punch*, shown ragged and shivering on the steps of Parliament; a few pages on his other half is found, a jaunty, irreverent figure upsetting the dignity of any of a range of types of self-satisfaction—policemen, clerics, swells, and powdered foot-men. Rejlander took over these established images; his models are shown turning hand-stands or jauntily signalling broom-in-hand, to a prospective customer when they are not depicted in poses expressive of pathos. One of these latter gained Rejlander fame. It is a view of a boy huddled on a doorstep, his white limbs showing through rents in his trousers, his body

as a crossing-sweeper, broom in hand, and sometimes as a match-seller, thrusting her wares with nervous diffidence towards the camera.

Barnardo's publicity photographs were widely circulated: they were sent to subscribers to the mission and likely donors as part of annual reports; they were also packaged and sold in sets (5s. a dozen) for the albums of philanthropists and they were carried, pasted on collection boxes, through the streets. Anticipating modern advertising, Barnardo formed some of these photographs into 'Before and After' shots which showed the boy or girl first in rags and subsequently in respectable work-clothes, displaying an air of industry. These remarkably bold publicity methods attracted widespread attention and also the jealousy of other city missionaries who found themselves cast into shadow. Rumours of fraud and deception circulated and Barnardo was obliged, in 1876, to agree to a public hearing. One of the charges of deception concerned photographs of Katie Smith who, it was revealed in evidence,

had never sold matches at all. Barnardo was obliged to concede this point but he defended himself vigorously nevertheless on the grounds of artistic licence and general truth; it was not technically possible, he said, to photograph many of the worst cases just as they arrived at the refuge, and besides, Katie Smith lived in circumstances which might well have brought her, as it had others, to sell matches in the street. The tribunal members disagreed: photography, they said, implied actuality and Barnardo had been deceptive in creating 'artistic fictions'.[6]

The Barnardo case, raising as it does fascinating questions about art and society, remains pertinent to today's photography, but it lay too far ahead of major trends in documentary to be regarded as an important judgement in photo-history. Its immediate sequel however is interesting. Under the tribunal's rebuke the impresario-missionary curtailed the making of publicity photographs designed to wring the hearts and loosen the purse-strings of the public. But he continued to use photography in

Opposite
A dossier photograph of one of Barnardo's charges.

A little vagrant becomes a little workman. One of Barnardo's 'Before and After' shots.

E. E. J. M.
Home for Working & Destitute Lads.

No. 27.—ONCE A LITTLE VAGRANT.
(*The same lad as on card No. 28.*)

E. E. J. M.
Home for Working & Destitute Lads.

No. 28.—NOW A LITTLE WORKMAN.
(*The same lad as on card No. 27.*)

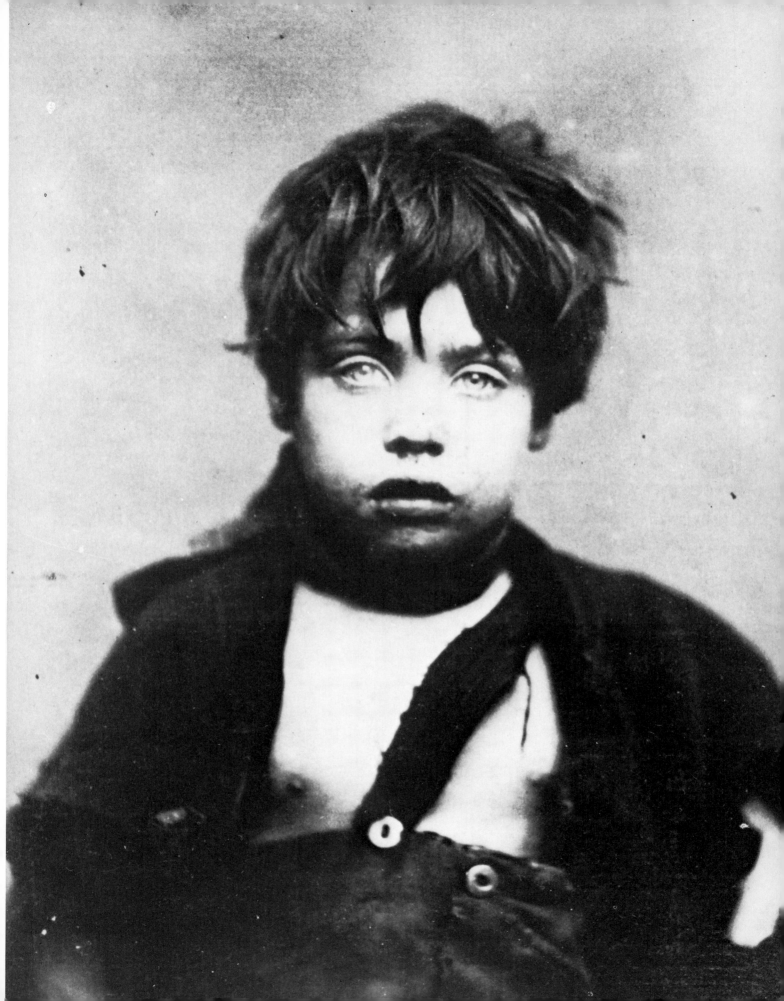

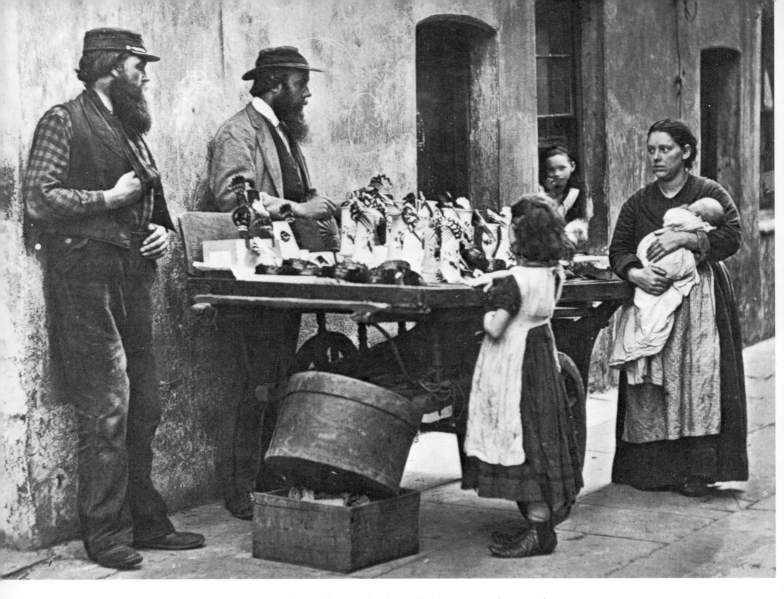

Street selling in London by John Thomson, 1877.

his mission for purposes of documentation and identification. Each entrant's photograph—a plain head-and-shoulders view—was attached to a dossier: over the decades thousands of these portraits, as matter-of-fact in their composition as the information sheets to which they were attached, have accumulated in the Barnardo files. As they lie in the photographer's workbooks in rows they form an astonishingly expressive archival treasure.[7] The standard and perfunctory posing encourages the eye to move rapidly along the rows but ever and again this movement is checked. Children crushed by circumstances—pathetic wet-nosed creatures—are revealed in their naked helplessness, while by contrast bold individuals, boys and girls of independent air, stand forth firmly. The collection is a magnificent testimony to the power of the camera to gain direct access to individual personality and condition. Paradoxically, the simple candour tapped by these blunt methods of documentation makes a more immediate appeal to the sympathies than the theatrical wretchedness of Barnardo's earlier set-pieces from the studio.

The moral of the Barnardo story, photographically, is to let well enough alone. But such restraint, though obvious enough as a virtue today, would be an unlikely flower to come upon in the hothouse of Victorian religious philanthropy, where tones were always pitched high and it was a pious duty to feel intensely. What the pictorialist tradition needed was not a reinforcement of its preoccupation with feeling but rather the corrective balance of truth attained through some form of realism. Such a model in fact existed in the decade of the 1870s in the work of John Thomson who, on his return from photographic travels in Asia (*China and Its People*, 1873), went into the streets of London to photograph people at their daily work. His locales are various—roaring City

streets, quiet corners, suburban parks, markets—and his subjects are naturally the varieties of professional street-folk—vendors of all kinds, street musicians, cabbies, porters, sandwich-boardmen.[8] Simplicity and naturalness characterise these views: often there is no action—a row of flower sellers stand behind their baskets, a hackney cabman sits waiting in a deserted street, a barrowman gazes evenly at the camera. These plain studies evidently require boldness—the courage to be simple—and tact; indeed, where quite complicated scenes are depicted—street-sellers serving customers, men and women gathered drinking and talking outside a back-street pub—the degree of tact necessary to accomplish these with unforced naturalness must have been quite extraordinary. The subjects do not seem self-conscious, though they must have been aware of Thomson's large, tripod-mounted camera and deliberate procedure.

What required, from Thomson, strenuous patience was achieved relatively easily 20 years later by Paul Martin through advances in technology which made instantaneous street views possible. Martin, an art engraver with an early interest in photography, took up the camera professionally as his trade died. He made striking use of the portability of the hand cameras coming on to the market in the 1890s. With his camera wrapped as a parcel, Martin went into the streets and along the beaches of popular resorts, recording the life about him.[9] While technology made such photography easier Martin had to overcome barriers of convention. The facility of the new equipment—hand cameras and roll film—had cheapened the product in the view of those who maintained a High-Victorian high seriousness about their art. Martin had to listen to a great deal of high-faluting talk at the amateur camera club of which he was a member and was warned against sinking 'to the level of snaps'. That he was able to ignore such admonitions was due perhaps to his slightly displaced position in terms of both culture and class. He was of French parentage but of English upbringing, and further, as a skilled artisan of pronounced

Paul Martin on the beach at Yarmouth, England 1892.

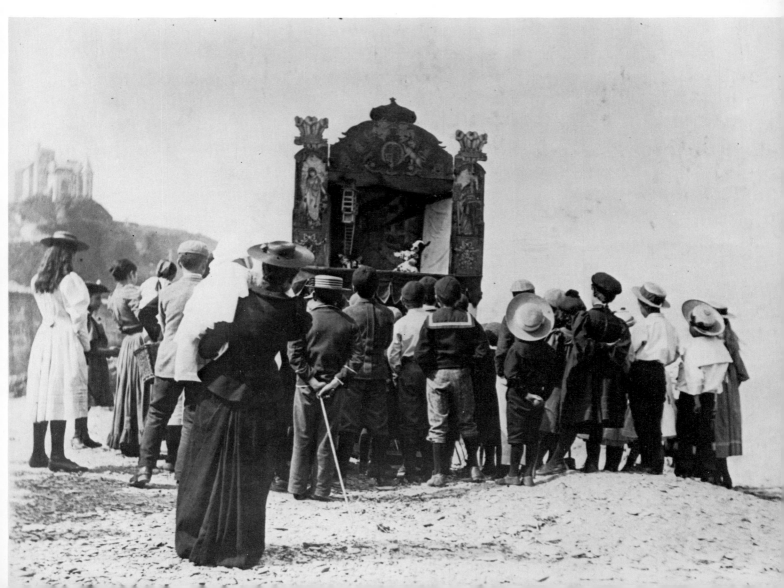

artistic leanings — but an artisan for all that — he was not quite the usual gentleman enthusiast of the camera clubs. For these reasons he appears to have been a natural observer, an outsider always peering in as he went about the streets — an inconspicuous bowler-hatted gent with a parcel under his arm.

In one sense Martin was thoroughly traditional. He picked up the genre of the street scene more or less where Thomson had left it — one of his first published series took as its subject one-man street businesses and the content and approach is scarcely distinguishable from Thomson's views of street-folk. Other Martin photographs look back even further, to the themes and images that guided Rejlander: we again find street-children, bare-footed and impudent, challenging the camera's gaze. Martin's particular contribution to this field of work is his extension of the subject matter through the penetration his concealed camera allowed him. He entered, in particular, the world of lower-class amusement and exploited the natural gaiety and unguarded informality he found there: children dance at a street-corner, beach-strollers gather before a Punch-and-Judy, couples flirt and embrace. Characteristically, Martin is good-humoured and not cruel in his exposé of the ordinary people at play: he celebrated the jovial spirit of life and had photo-reproduction been in a more advanced state would have enjoyed great popular success in photo-magazines such as *Picture Post* and *Life*. There is evidence of this

Cockney street urchins from East London by Paul Martin.

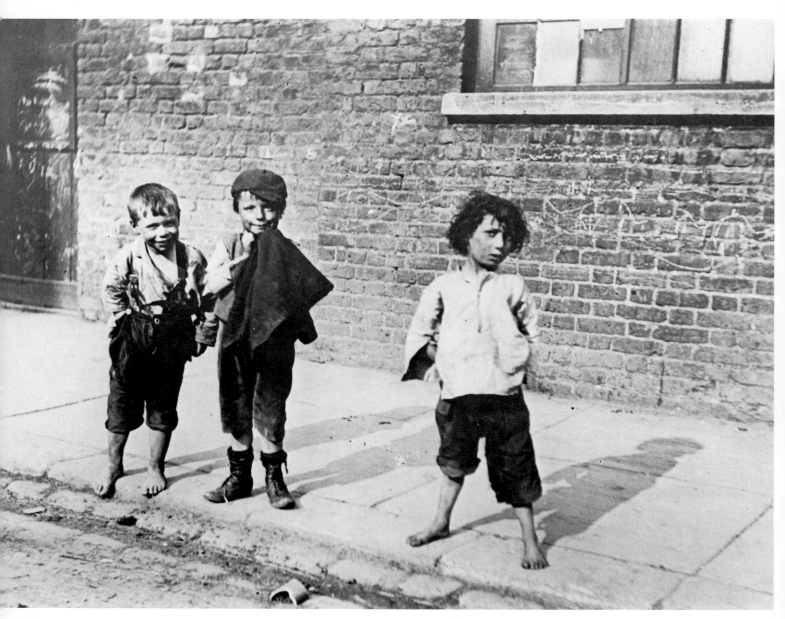

popular appeal in the crowds that gathered, and had to be moved on by police, when an enlargement of one of his photographs of cockney girls on holiday, dancing to the music of a mouth-organ, was exhibited in the window of a London photographer. But there was no mass vehicle, such as a periodical could provide, for work of wide appeal like this, and Martin's later professional career was as hum-drum as that of the general run of commercial photographers.

Along with his expansion of the content of the street scene—his beach scenes are thoroughly urban in spirit, the city as the seaside—Martin displays a nice artistic sense of the possibilities inherent in the special properties of the metropolis, its pace, patterns of movement and groupings of people. There is a most skilful use of foreground and background to create excitement in photographs of apparent compositional simplicity: newspaper-sellers and other stock characters of the city corner are photographed squarely head-on, and stand isolated and motionless before the screen of moving traffic, part of the confusion and at the same time separate and individual. Seen like this, quite ordinary people become charged with enigma and significance. Martin appears to be aware, also, of the simple fascination of detail—that essential quality of documentary. Some of his views of people are so plain and static that their interest lies almost entirely in the detail—the knobbly variety, for instance, of a row of faces watching a beach concert. This

A magazine seller at Ludgate Circus, London by Paul Martin.

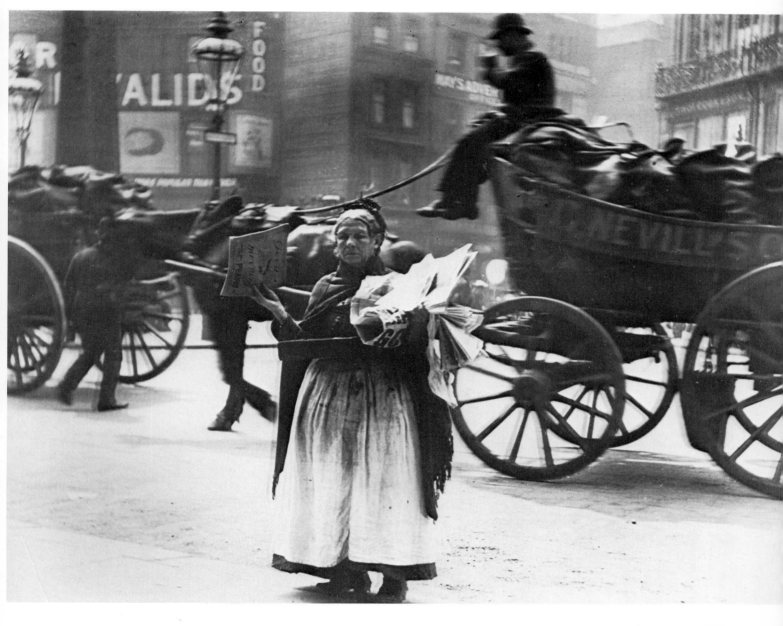

faith in the detail of ordinary life is a further expression of the attitude of affection and respect which Martin displays towards the world he made his subject matter, a feeling which is probably of equal significance to his technical mastery and innovation.

A feeling for the subject, but a feeling much more intense in nature, also lies behind the work of Jacob Riis, the very existence of whose photographs is due to an extra-photographic impulse: a reformist's determination to reveal the conditions of life of New York's Lower East Side—conditions of neglect, squalor, privation and overcrowding. The note of revelation sounds in the title of his best-known book—*How the Other Half Lives* (1890). That was a worn and familiar phrase even when Riis used it and this familiarity offers a clue to the reason why a reporter like Riis took up the difficult and to him untried practice of photography—it was a novel technique of social revelation that, in its novelty and its graphic power might break through the crust of indifference and shock and move the public.[10] Like Dr Barnardo, Riis spoke and wrote of his work in high-pitched and dramatic tones; it was a battle or a crusade. But a significant difference between the two lies in the fact that Riis took his camera into the field and thereby subjected himself and his technique—what he possessed of one—to the pressures of contingency.

Although Riis was a novice he evidently brought certain pictorialist conventions to his task: his views of street urchins are firmly set in the Rejlander mode, their elements—huddled bodies in doorways, bare feet and ragged pants—are organised into compositions of emblematic meaning. Against these predictable and weak photographs, thoroughly conventional, should be set, for contrast, Riis's blunt, raw photographs of derelicts photographed in the basements of police shelters for the homeless. The subjects, sometimes so abjectly wretched as to appear unaware of the camera, are photographed with little ceremony, head-on, against a whitewashed wall: the impact is stunning, a testimony yet again to the formidable candour of the documentary camera. A third range of Riis photographs, the most popular today, makes use of the dramatic excitement of penetration: in these views the camera plunges the eye down tenement alleyways, past lurking figures, and through the doorways of low drinking dives.

But perhaps the most interesting product of the meeting between Riis's moral indignation and the conditions he encountered in the field are his photographs of ordinary tenement life. Of all the tones achieved in the photographs the one which is absent is the fervent tone of the crusader; through the prose of *How the Other Half Lives* blows the hot zeal of the reformer, but the photographs, brutal, exciting or even poignant are free from its insistent breath. They engage the mind on their own terms, as it were, and not those of Riis, and this autonomy gains strength as the images multiply. An example is found in Riis's treatment of the question of home or 'cottage' industry: it is apparent from the text that Riis regards this kind of labour, which kept women and children toiling long hours for little pay, as oppressive—a denial of the life it is intended to support. But the photographs are not malleable to Riis's touch: they do not work towards one single, overwhelming judgement; each, rather appears to bring new information. Particularities and differences make themselves felt as the camera moves from one tenement apartment to the next, from a Jewish block to an Italian, from seamstresses to leather workers. As the perspective widens and an impression of a larger world, composed of many different compartments, begins to emerge the arguments made by Riis fade, not invalidated by any means, but subsumed into a vision of humans struggling, with various capacities and in various ways, against oppressive circumstance. The tone naturally modulates: indignant exclamation dissolves into contemplation; the viewer stands in direct and immediate relation to the subject.

In its candour the work of both Martin and Riis represents the finest achievement of social realism in the century, and magnificently anticipates modern photography. Yet equally significant is the relative narrowness of its view of society. Martin's people, as Thomson's before him, are the street-trading classes of the metropolis; Riis's subjects, equally urban, are somewhat more sensational in their brutality or their wretchedness. Traditionally, over the centuries, the city has been the locale used by the arts in the development of forms of realism and it is not surprising that photography, moving in this direction, should draw upon the same tradition in the nineteenth century. The naturally dramatic elements of the city were there in plenty in the period: energy and pace, extremes of social contrasts, the felt weight of a mass population. Underlying the photographs of Martin, in particular, exists the assumption that the street scene is the natural expression of these conditions and forces: a photograph of a street market, crowded and bustling, is a view of

A New York derelict and her bed photographed in a police shelter by Jacob Riis.

The interior of a New York tenement. A superb Riis photograph shows how an Italian family worked, slept and cooked in the same room.

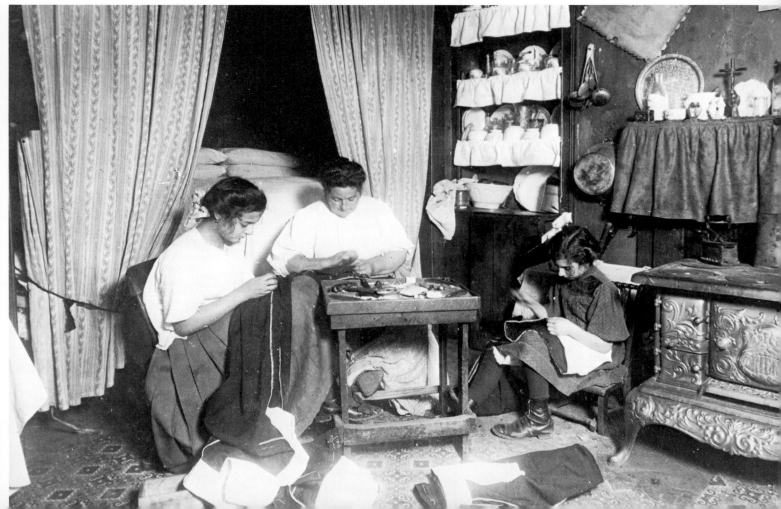

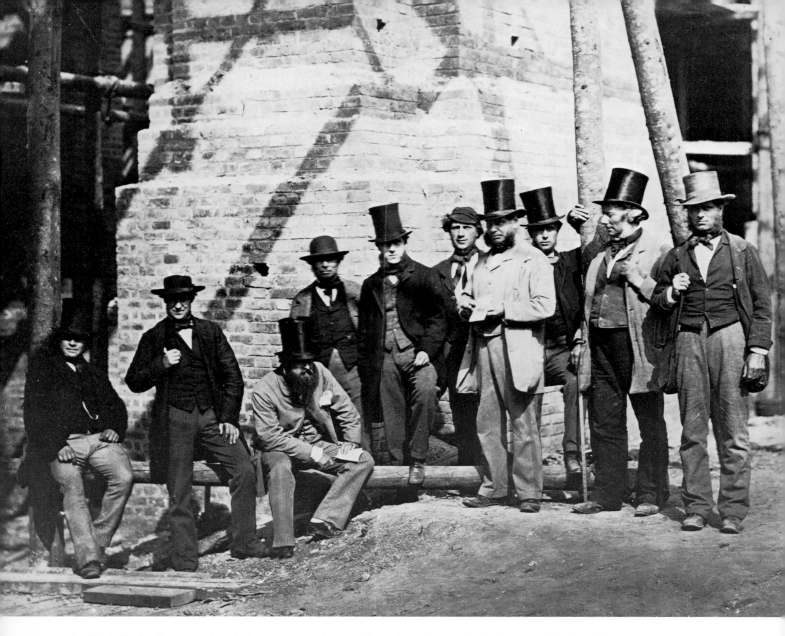

real life. Riis feeds upon the darker strand of this tradition: the city, in his more sensational work, is a tangled wilderness, alive with dangers and horrors.

The documentary impulse need not be bound by these limits of concept or geography but it finds a coherent body of material there to be worked and reworked. From outside this traditional area comes a very large and varied body of photographs, arising from many causes and occasions, which reveals ordinary life and in manner might be termed documentary. Moving in this ill-defined area it is possible to discern some patterns of subject and theme: from what might be called industrial photography, for instance, emerges the figure of the Victorian artisan, his rough-coated bearing expressive of sturdy readiness. Many photo-

graphs of workmen, shirtsleeves rolled to the elbow, tackling the roadways with pick and shovel, come from the last decades of the century under the impact of successive waves of technological change: the laying of water, sewer, gas and electricity pipes and conduits and of tram tracks. These events were minor sensations in the life of small towns and attracted both the commercial photographer from his shop and the enthusiast from the camera club.

These local historians do not appear to have deliberately depicted the labourers as heroes; however, tram tracks, in general, possess little appeal and the workman, a firmly-planted figure at the heart of the confusion, amidst the traffic of the streets and the idling onlookers, naturally assumes importance. Those photographers with a conscious regard for the dignity

Victorian artisans and foremen on the construction site of the 1862 International Exhibition in London.

Opposite
A workman dwarfed by the scaffolding of the 1862 International Exhibition.

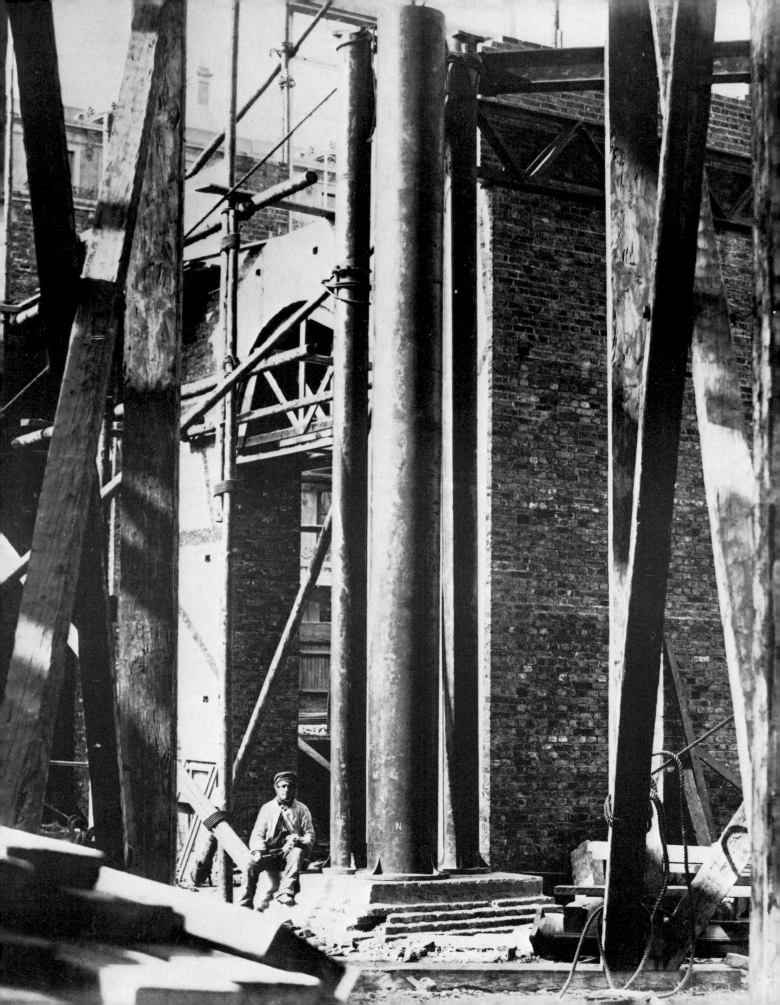

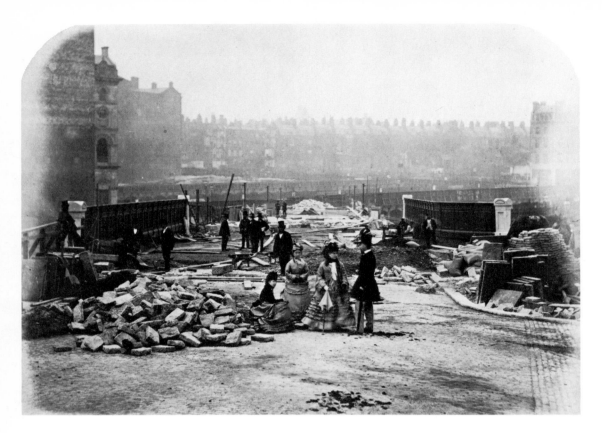

of labour found in this figure a useful device for expressing their theme. A particularly satisfactory setting for construction photographs was the international exhibition. From the Great Exhibition of 1851, in London, to the world's fairs and expositions which besprinkle the calendars of two continents in the 1890s, photographers found their way to these sites and recorded the preparations from the muddy beginnings to completion. At their best these records idealise the workman. In views of the 1862 International Exhibition under construction in London we see the workman placed frequently to provide a human scale, and more significantly, to assert human achievement, he being the visible creator of these cathedral-sized structures of iron and glass, buttressed, during construction, by huge baulks of timber; in turn the workman, a small but resolute figure amidst the neo-Gothic forest of pillars, often appears as strong and bold as the new buildings.

When studio and social decorum dominated the photograph this idealised figure dwindles: the workman becomes defined simply in terms of occupational role, holding the tools of his trade or standing to his task as if on parade. In views of the construction of the Holborn Viaduct—the world's first urban road flyover, a giant undertaking in the London of the 1860s—

the enterprise is trivialised by the decorous approach of the photographer. The workmen are invariably kept firmly in their place, so to speak, and we see them as mechanically distributed attendants to the bulky caissons or gathered stiffly about the hoists, unnaturally posed and unimpressive, seemingly ineffective figures. By contrast, a group of visiting dignitaries is arranged as if in a drawing-room: the gentleman stands turned towards the ladies in a pose of severe solicitude, while one lady reclines on the rubble as if she had found a sofa. These photographs indicate how unaccustomed studio photographers were, in general in mid-Victorian Britain, to a documentary approach even when facing a scene of challenging vitality in its action and forms.

While labouring men who worked in the open were subjects accessible in a technical sense to the camera, another convention, that of popular sentiment, appears to have strengthened the appeal of particular groups, notably the fishermen. Photographs of nineteenth-century fishermen abound: they are so numerous as almost to constitute a separate genre and come from every period and location. In the British Isles the Edinburgh calotypists Hill and Adamson were early in the field, and their views of Scottish fishermen, plain frontal compositions which are both graceful and honest,

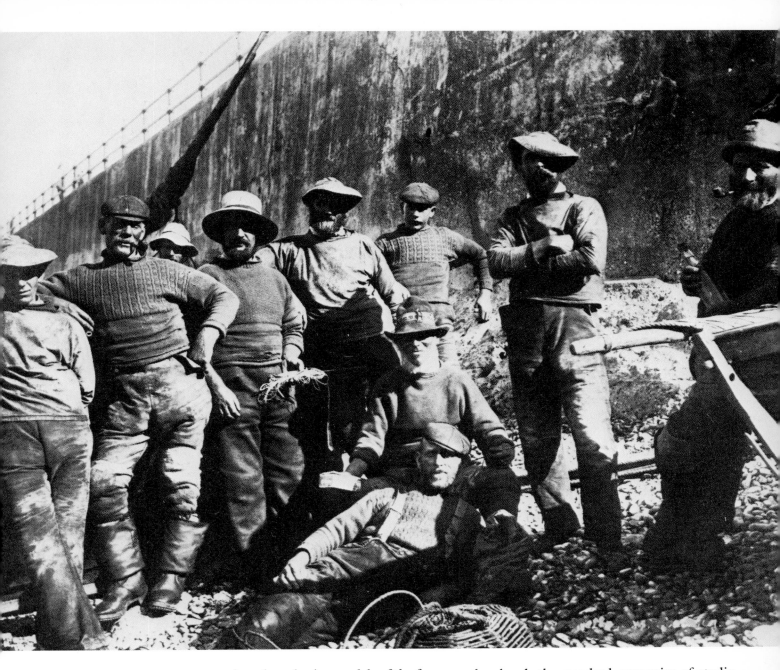

Norfolk lobster fishermen in a bold, manly pose by Francis Frith.

appear to have been lasting models of the form. In their wake Frith photographed south coast fishermen, whose ports were rapidly changing into popular sea resorts at the time, and Sutcliffe of Whitby made remarkably fine compositions of the men of the Yorkshire fishing fleets.[11] The work of these men comprehends many differences of intent and of technique but these variations do not obscure a common approach: depiction of the fishermen as strong, self-reliant figures. They lean, typically, against the bows of their vessels, piles of net and cordage at their feet, and gaze openfaced into the camera, bold and manly.

Idealisation on the one hand and, on the other hand, the standard categories of studio pose: these appear to be the alternative possibilities when a Victorian cameraman approaches the working-man. What one would like would be non-typifying photographs alive with the spirit of inquiry and revelation, true documentary. One finds this further possibility emerging towards the end of the century when camera technology allows a looser approach. It is evident in the work of a little-known English photographer, S. W. A. Newton; commissioned to record the building of the Great Central line to London, he took his bicycle and journeyed up and down the right of way.[12] Industrial photography of the kind that today

illustrates company brochures and annual statements often has its reach limited to statements of the obvious and respectable. Newton somehow escaped this deadening hand; his photography serves first the objects it confronts. His landscapes are alive with an awareness of the new visual poetry to be found in the peculiar topography created by the railway: the angles and perspectives of cuttings and embankments. He also approaches with sensitivity the men who shape this new terrain, finding his groupings in the natural pattern of their work: navvies, in a row along a hillside, chop out a cutting, plate-layers bend as one back to lift a length of steel. And Newton draws still closer, greeting the men with his camera as they sit along the warm hollow of a cutting, passing a jug of beer, and he photographs the huts where they sleep and the lean-tos where they shelter from the rain and brew tea. The working environment makes itself felt in a variety of tones and rhythms: ranging from the crowded, dusty site of the terminus to quiet spur lines where the gangs take their break on shady green banks.

Open-air work features far more prominently in Victorian photography than indoor, for obvious reasons: this causes a serious distortion of the comprehensive view of life gained through photographs, for the period may justly be called the Factory Age. In addition to their relative inaccessibility for technical reasons, factories in general lay under the reproach of modern ugliness, and consequently life on the workshop floor is scarcely more common a subject for the graphic artists than for the photographer. But company pride could bring the camera within the factory gates.

Newton captures the rhythm and appearance of the labouring life of the railway navvy.

This motive does not, of course, lead to the production of photographs of the worst factory conditions, or even of an average state of affairs: photographs from the archives of Cadbury's, the chocolate-makers, illustrate the point.[13] We see white-robed maidens strolling among the elms that border the lawns of the archery butts and the tennis courts or gathered with matronly ladies in the arcade of a refectory. They might appear to be models for a Pre-Raphaelite painting of a heavenly choir but they are factory girls of Bournville, the model works and village built by the Cadbury family, beginning in the mid-1870s.

The great fact of factory life, that its labour was heavily female, is brought out in these photographs, but the green-swarded recreational areas were unquestionably an exception: Bournville was an oasis of enlightenment in terms of care for employees; outside lay darkest England. The Cadbury photographs include interior views: we see the girls rolling marzipan, packing chocolates and operating nailing machines; the large rooms full of girls demonstrate how thoroughgoing was the policy of sex separation. The Cadburys, intent upon creating a truly model factory—free from the taint of sexual immorality commonly associated with a mixed labour force—provided separate working, eating and recreation areas for men and women. It is no accident, therefore, that the Bournville photographs show scenes suggestive of a convent, or perhaps, the female academy created by Tennyson in *The Princess*: these industrial photographs express a social attitude, the Victorian preoccupation with the defences of maiden purity. This is a theme of recurring interest in the writings of social investigators.

Girls working in the marzipan room of the Cadbury's chocolate factory, Bournville, England.

Opposite
An incongruous studio setting for
a female Lancashire colliery
worker arranged by A. J. Munby.

The very large literature arising from investigations of women engaged in heavy labouring work has no comparable photographic parallel. There are enough photographs in existence to record the fact that women worked at mines—though on surface work—until late in the century, shovelling and sifting coal, and at a number of other dirty and disagreeable occupations. But the notion of women being obliged to labour at such hard, unpleasant work did not fit the general sentimental and aesthetic concepts of the age; far from providing an occasion for an employer's boast, the existence of female labourers does not seem to have flattered the nineteenth-century's sense of itself. On the other hand no crusader with a camera saw fit to reveal the condition of women labourers, with perhaps the single exception of the eccentric A. J. Munby whose interest ran in the contrary direction.[14] Munby celebrated the labouring woman in poems and sketches; he caused bewilderment at photographic studios through his curious tastes: at a London studio he appeared with a dustwoman, heavy-booted and carrying her dinner-can; on leaving he was accosted by a series of men offering more

suitable models for pornographic poses. These marvellously incongruous studio portraits of women labourers standing against drawing-room backgrounds, rich in interest themselves, indicate how much is missing from the Victorian photographic record.

One highly visible world forms an exception, and that is the countryside, where women worked commonly at harvest-time and frequently through the year as regular field hands alongside men. Country life as a whole had a special sanction and many of its aspects were extensively photographed. While in earlier centuries it was a city commonplace to hold the country as a brutal and benighted wasteland, a change occurred in the nineteenth century with the development of a widespread sentiment in favour of rural life as the repository for simple, unchanging truths. Paradoxically, the fact of change, even visible change in the countryside itself in the form, for instance, of the new steam-powered threshing machines, did not alter the appeal offered by the land; rather, it added a glow of nostalgia. The old ways, in this view, must be recorded before they passed away; this impulse fostered the photographing

A charcoal burner's family home
in the Forest of Dean, England
*c.*1890.

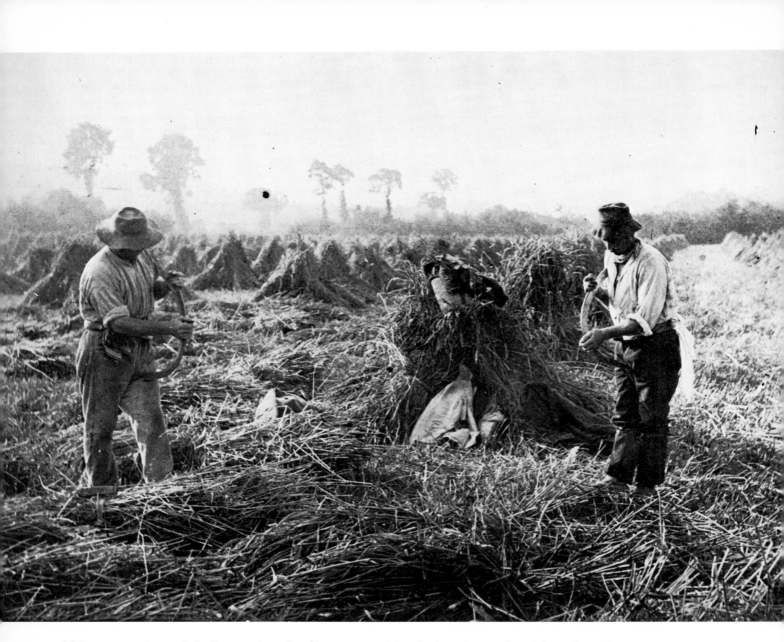

The dignity and reality of harvest workers in Herefordshire, England, 1890.

of folk ceremonies and similar atavisms by Sir Benjamin Stone and kindred spirits, and the recording of old crafts, charcoal burning, for instance in the Forest of Dean, which appeared to face extinction.[15] A common extension of that romanticism which feeds—a perverse appetite of urban civilisation—upon the lure of the primitive led also to cultivation of the gipsies as photographic subjects. A substantial body of photographs from the late-nineteenth century, when the cult of the open road was at its height, records gipsy vans in lanes and clearings, and gipsy bands around the camp fire.

There are many photographs from the period, however, which do not cater obviously to ideas of the romantically picturesque and which deal with country life in general, and even with gipsies, in an itemising, factual manner. This is the work of many local photographers, professional and amateur, who appear to simply accept the country as an appropriate subject and set about making a photographic inventory, as it were, of its features. Cottages, market crosses, farmers' gigs, ox-teams, ploughing, shearing, threshing: so much of the normal life of the country is recorded—far more than, say, the normal life of a London suburb in the same period—that the pervasive sentiment for rural certainties evidently runs even under this plain and factual style. Some of the most frequently photographed scenes— ploughing with a team is one—became established as expressive images of country life and have been worked and re-worked into our day by art photographers.

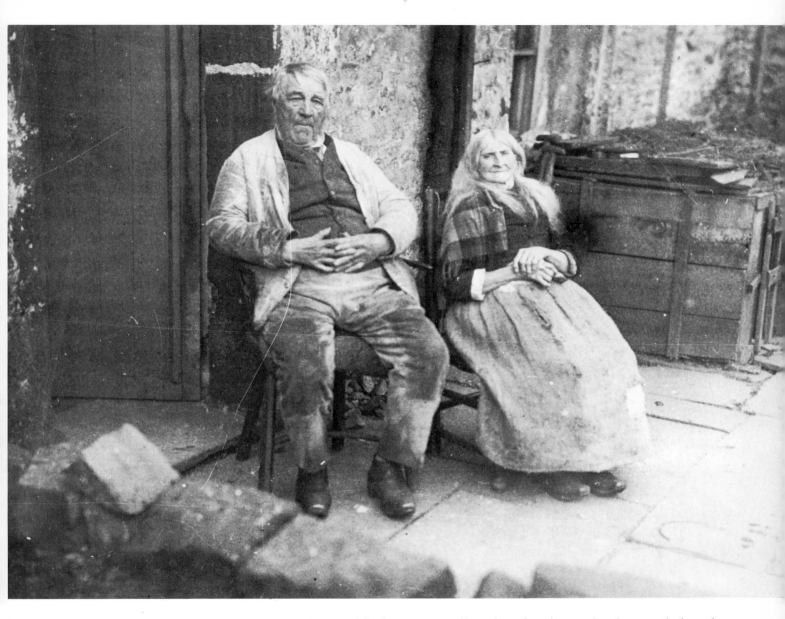

A sentimental pose of English cottagers which suggests the burdens of rural life.

Harvesting, as the natural apex of the farm year, was much photographed, and it is from these views of the harvest being brought in that we gain our visual knowledge of women field hands, their figures curiously archaic due to the wide bonnet wrappers worn to protect the face from the sun, their mushroom shapes dotting the harvest field. The men who worked in the fields, scythe or reaping hook in hand, were natural subjects for photographers like P. H. Emerson who sought to express their dignity and to evoke feelings and ideas that went beyond the literal.[16]

The idealising impulse is more frequently detectable behind photographs of rural life than town life of the nineteenth century. Such photography might therefore seem more vulnerable to failure. But the camera in the field, when

allowed to be rigorously clear-eyed, has the capacity to save compositions from the moralising sentiment of the photographer. An aged couple shown at their cottage door is a familiar picture from the period designed—so the composition seems to tell us—to express contentment, the satisfaction of a full life and a sense of duty done. But the camera, passing through the metaphor as if through air, fastens on the particular details before it: the dirt-stained, worn clothes, the countenances, blunt or sharp, and the heavy set of bodies. The eye may be furnished, in these details, with a more affecting truth about rural life than the generalised sentiment of the photographer.

It evidently took the Victorians, both the photographers and the public, some time to learn this visual language based upon detailed

particulars, and to appreciate the spirit of exam-
ination and discovery in which it best functions.
The city, notably in the unlovely world of the
back streets, offered material best suited to
encourage awareness of the revelatory powers
of the camera. But in all areas where the camera
was taken into the field to record the ap-
pearances of ordinary life the photographers,
and in turn their public, were being brought up
against the actual, and being forced towards an
awareness of its power and the problems it
brings. In other branches of photography well-
established traditions of decorum and expec-
tation masked the difficulties. But in the
recording of ordinary life there could be no
evasion of the problems of actuality, a difficult
medium in which to work. The products of the
Victorian documentary camera, in their ex-
treme unevenness, ranging between sophisti-
cation and painful ineptness, reflect most
sensitively the keenness of the struggle of a new
art to find itself.

NOTES

CHAPTER 1

1. Photography was admitted for exhibition by the Academy of Fine Art in Paris for the first time in 1859; it was greeted by Baudelaire with a stinging attack in the *Revue Française*. The poet did not allow his hostility to prevent him from sitting for a portrait by his friend Nadar.

2. In Great Britain's census for 1851 there were 51 persons identified by occupation as photographer; in 1861 this had risen to 2,879. See Helmut Gernsheim's *History of Photography* (London, 1969), p. 234.

3. *The Photographic Journal*, January 21, 1854. The journal was founded in 1853 as the *Journal of the Photographic Society of London*.

4. S. N. Carvalho, a Baltimore daguerreotypist, accompanied Fremont across the plains and the mountains in 1853–4; his plates have not survived but daguerreotypes of the American West exist from an earlier though less well-known expedition by Sitgreaves in 1850.

5. N. P. Lerebours, a Parisian optical-instrument maker, equipped several parties of artists and writers bound for Mediterranean lands as early as 1839.

6. Taken respectively by Edward Anthony, Ferrier and Soulier, and George Washington Wilson.

7. Published as *Animal Locomotion* with a text by a professor of physiology, Dr H. Allen, in 1887.

8. The history of the invention and use of gelatin emulsion in photography is long and complicated. It was the work of many, of whom two may be mentioned, Dr R. L. Maddox, who revealed the practicability of the process in the early 1870s, and John Burgess, a London photographer, who ushered it into production for general sale.

9. The Kodak advertising slogan was 'You Press the Button, We Do the Rest'.

10. Fenton simply put up his equipment for sale, and slipped quietly away—see A. and H. Gernsheim, *Roger Fenton* (London and New York, 1954)—but Emerson published, flamboyantly, a black-bordered pamphlet 'The Death of Naturalistic Photography' (1891). In this he told the public that 'the limitations of photography are so great that although the results may, and sometimes do, give pleasure, the medium must rank the lowest of all arts'.

CHAPTER 2

1. Alison and Helmut Gernsheim, *History of Photography* (London, 1969), p. 269.

2. George F. Stanley (ed.), *Mapping the Frontier: Charles Wilson's Diary* (Toronto, 1970).

3. Weston J. Naef's *Era of Exploration* (Boston, 1975) contains a full description of the early Yosemite photographers, to which I am indebted.

4. Beaumont Newhall, *William H. Jackson* (New York, 1974), p. 138.

5. J. W. Tyrell, *Across the Sub-Arctics of Canada* (Toronto, 1908).

6. Quoted in Bill Jay's *Francis Frith: Victorian Cameraman* (Newton Abbot, 1973), p. 16.

CHAPTER 3

1. The Waterlow album is held in the Victoria and Albert Museum Library (cat. X620).

2. She was the daughter of William Hickson of Fairseat, Wrotham, Kent.

3. The V and A catalogue describes the photographs as the work of an amateur; it is true there are no studio marks, but the practice of commercial studios varied before the *carte-de-visite* period and it is unlikely, anyway, that all the photographs came from one source. The catalogue misleads in dating the album 1848–*c*.1864 since a civic invitation card at page 70 is dated 1867; a more reasonable terminal date would be *c*.1870.

4. Sidney Hedley Waterlow was elected Alderman of the City of London, 1863; Sheriff 1866–67; Lord Mayor 1872–73. He was knighted in 1867 and made a baronet in 1873; he renovated and occupied Lauderdale House, Highgate in the 1860s and donated it to St Bartholomew's Hospital; later the grounds were given to the L.C.C. as a public park; a statue of Sir Sidney stands in the park today.

5. George Smalley, *Life of Sir Sidney Hedley Waterlow* (London, 1909).

6. In *Wilson's Photographic Magazine* (LVI), 1909, Shaw wrote: 'There is a terrible truthfulness about photography. The ordinary academician gets hold of a pretty model, paints her as well as he can, calls her Juliet and puts a nice verse from Shakespeare underneath and the picture is admired beyond measure. The photographer finds the same pretty girl, he dresses her up and photographs her, and calls her Juliet but somehow it is no good, it is still Miss Wilkins, the model. It is too true to be Juliet'.

7. This album is held in the Victoria and Albert Museum Library (cat. X730) and is simply described as '*cartes-de-visite, c*.1870'. The photographs are standardised in *carte-de-visite* size (approx. 2½ in. × 3 in.) and cabinet size (approx. 5 in × 7 in.), and this uniformity gives an impersonal air to the album. A reasonable dating would be *c*.1860 to 1877.

8. The *British Gazeteer* gives a population for Hooton Levett, Nr. Maltby, West Riding of 73 in 1900 (ten fewer than for 1800).

9. For details of Sarony's fashionable studio (and his commercial success) see Helmut and Alison Gernsheim, *The History of Photography* (London, 1969).

10. This album is held in the Victoria and Albert Museum Library (cat. X621) and is described as an 'album of portraits, views of Salisbury, Oxford, Wimpole, etc. with hand-painted illumination, *c*.1860–70'. The Hall, at the period of this album, was the residence of Charles Philip Yorke, fourth Earl of Hardwicke (1799–1873) and his wife Susan (*née* Liddell, 1810–1886).

11. This album is held at the International Museum of Photography, George Eastman House, Rochester, New York (cat. 05.22/13785).

12. Henry James experienced his first popular success with the story of an American innocent abroad, *Daisy Miller* (1878).

CHAPTER 4

1. Mrs Cameron generously credited David Wilkie Wynfield, a painter and amateur photographer, with first revealing the possibilities of the close-up portrait to her in his studies of fellow painters (see Helmut and Alison Gernsheim, *The History of Photography* (London, 1969)). Her work is bolder and more powerful than Wynfield's.

2. Gernsheim, *History of Photography*.

3. Cecil Woodham-Smith, *Queen Victoria: her life and times* (London, 1972).

4. Hippolyte Taine, *Notes on England* (London, 1957). (Originally published in 1857.)

5. H. Baden Pritchard, *The Photographic Studios of Europe* (1882; reprinted New York, 1973). Baden Pritchard's articles were first published in the weekly *Photographic News*, London.

6. H. J. Rodgers, *Twenty-Three Years Under a Skylight* (1872; reprinted New York, 1972).

7. H. Baden Pritchard, *About Photography and Photographers* (1883; reprinted New York, 1973).

8. Baden Pritchard, 'Mr. Alderman Mayall' in *Photographic Studios of Europe*.

9. 'Messrs. W. and D. Downey', *Photographic Studios of Europe*.

10. Lytton Strachey, *Queen Victoria* (Harmondsworth, 1971).

11. Baden Pritchard, 'Mr. Jabez Hughes of Regina House, Ryde', in *Photographic Studios of Europe*.

12. Gernsheim, *History of Photography*.

13. Baden Pritchard, 'Douceurs', in *About Photography and Photographers*.

14. Cornelius Napier, first baron of Magdala, saw much hard campaigning in the Indian Mutiny; his title is after the fortress city of Abyssinia which he took and burned in a punitive expedition in 1867.

15. Cecil Woodham-Smith, *Florence Nightingale* (London, 1951).

16. Taken by A. J. Pool, a Somerset wheelwright, engineer and early photographer.

17. Mrs Cameron's model is Alice Liddell, daughter of an Oxford dean, and favourite of the Rev. C. L. Dodgson (Lewis Carroll), who photographed her many times, as well as celebrating her in the creation of *Alice in Wonderland*.

18. A copy of this album is in the British Museum.

19. Dinah Maria Mulock, a minor Victorian writer, is best known for her novel *John Halifax, Gentleman* (1857).

CHAPTER 5

1. Very large collections of theatrical photographs are held in the Enthoven Collection, Victoria and Albert Museum, London and the Theatre Department, Museum of the City of New York.

2. The *Theatre* used the Woodburytype process, which was also used in the same period for the illustration of a theatrical directory, C. E. Pascoe's *Actors and Actresses of the British Stage*.

3. The *Theatre*, January 1884, pp. 48–49, 53.

4. September 18, 1887, as Hermione in *The Winter's Tale*.

5. The *Theatre*, October 1884, pp. 166–171; she spoke at the Social Science Congress, Birmingham.

6. M. Sarcey, *Quarante Ans de Théâtre* (Paris, 1900), V, p. 372.

7. Maurice Baring, *Sarah Bernhardt* (New York, 1934).

8. *Dearer Than Life* by Henry J. Byron, a prolific dramatist for the popular stage, opened at the Queen's Theatre (now demolished) in January 1868.

9. Told in Clement Scott (ed.), *From the Stage Door* (London, 1889).

10. Ellen Terry, *Memoirs* (London, 1933), p. 269, judged that much of Irving's impact upon audiences was an effect of his 'beauty', which she describes at length.

11. In a curtain speech on the final night of his lease of the Princess's Kean said that in one season he spent nearly £50,000 on productions.

12. 'Actor's Faces', The *Theatre*, December 1878, p. 355.

13. Edward Burne-Jones discussed schemes with Irving, and Alma-Tadema designed sets and costumes for *Cymbeline* (1896).

14. Terry, *Memoirs*, p. 147.

15. G. B. Shaw, *Our Theatres in the Nineties* (London, 1932), I, p. 282.

16. Terry, *Memoirs*, pp. 84, 234.

17. Shaw, *Our Theatres in the Nineties*, I, p. 202.

18. Clement Scott, *The Drama of Yesterday and Today* (London, 1899) I, p. 504.

19. George Rowell, *The Victorian Theatre* (Oxford, 1956), p. 101.

CHAPTER 6

1. Quoted in A. H. Wall, *Artistic Landscape Photography* (originally published 1896; reprinted New York, 1973), p. 16.

2. In Wall's *Landscape Photography*, a compilation of articles previously published in the *Amateur Photographer* and the *Practical Photographer*, we can read how deeply a Romantic attitude to nature was implanted in photographers' attitudes. In a chapter on the photography of water, for instance, Wall demands the necessary exclusion of 'traces of human habitation, no sign of cottage or farm, cattle or cultivation, but everything suggestive of wild freedom and impetuous action'.

CHAPTER 7

1. These photographs are in the Local Studies Archives, Birmingham Library; for a Victorian account of the slum clearances see Robert K. Dent, Old and New Birmingham (1880).

2. See Edgar Yoxall Jones, *Father of Art Photography* (Newton Abbott, 1973).

3. 'They lived as the pariah dog lives' wrote George Hodder in his *Life of Lord Shaftesbury*, 'Everybody exclaimed against the nuisance but nobody felt it to be his business to interfere'.

4. See Helmut Gernsheim, *Lewis Carroll, Photographer* (New York, 1969).

5. Thomas Barnes, who had a studio on Mile End Road, Whitechapel, began this work for Barnardo about 1870.

6. Dr Barnardo's periodical *Night and Day* (1 November, 1877) gives a full account of his defence and the board's award.

7. The collection is held by the Photographic Department, Dr Barnardo's, Tanner Lane, Barkingside.

8. Thomson's *Street Life in London* (1877, reprinted New York, 1969) was originally issued in monthly parts; its author, in choosing the street folk for his subjects, cites Henry Mayhew's *London Labour and the London Poor* (1849–50, 1861–62) as his model.

9. See C. H. Gibbs-Smith's introduction to Paul Martin's *Victorian Snapshots* (London, 1939), and Bill Jay's *Victorian Candid Camera* (Newton Abbott, 1973).

10. Photographically, Riis probably made most public impact with his use of slides in public lectures; only a few poor half-tone reproductions appeared with his articles and books, and it is only with modern reproduction methods that his photographs have been given a wide audience. The originals are at the Photography Department, Museum of the City of New York.

11. See Bill Eglon Shaw (ed.), *Frank Meadow Sutcliffe* (Whitby, 1974) for the first compilation in book form of Sutcliffe's work.

12. L. T. C. Rolt, *The Making of a Railway* (London, 1971) discusses the building of this line and reproduces many photographs from the Newton collection, now held by the Leicester Museums and Art Gallery.

13. These photographs are now in the Local Studies Archives, Birmingham Library.

14. Munby was opposed to legislation that would prevent women from doing heavy manual labour; see Derek Hudson, *Munby: Man of Two Worlds* (London, 1972).

15. For a discussion of the record photography movement see Bill Jay's introduction to *Customs and Faces* (London, 1972).

16. In his *Naturalistic Photography* and its sequel *The Death of Naturalistic Photography* (reprinted together, New York, 1973) Emerson provides a fascinating study of a late Victorian struggling with the problem of actuality.

SUGGESTIONS FOR FURTHER READING

The most useful general histories of photography in English are Beaumont Newhall's short, excellent *History of Photography* (1964) and Alison and Helmut Gernsheim's comprehensive *History of Photography* (1969). Both are revised and expanded versions of earlier works and represent decades of experience by specialists in the field of photo-history. Other very rewarding books by the same authors are B. & N. Newhall's *Masters of Photography* (1958) and H. Gernsheim's *Creative Photography: Aesthetic Trends 1839–1960.* Narrower in their perspective, but thorough and stimulating are Robert Taft's *Photography and the American Scene* (1938; 1964); C. H. Gibbs-Smith's compilation of Paul Martin's *Victorian Snapshots* (1939) and Ralph Greenhill's *Early Photography in Canada* (1965). Weston J. Naef's *Era of Exploration* (1975) contains a full discussion, to which I am indebted, of photography in the American West and John Szarkowski's *Looking at Photographs* (1974) serves as a delightful primer in the analysis of photographs.

A marked revival of interest in nineteenth-century photography has caused the publication of many new studies of individual photographers and led to the re-issue of works long out of print. The following list, not comprehensive, complements or extends the approach of this book.

Peter Castle, *Collecting and Valuing Old Photographs* (1973).

Peter H. Emerson, *Naturalistic Photography* and *The Death of Naturalistic Photography* (1889, 1890; 1973)—theoretical struggles of a famous late Victorian photographer.

Alison & Helmet Gernsheim, *Roger Fenton* (1954)—Crimean War photographs.

Helmut Gernsheim, *Lewis Carroll, photographer* (1969)—studies of little girls, and of Oxford dons by the author of *Alice in Wonderland.*

Bill Jay, *Customs & Faces: photographs by Sir Benjamin Stone* (1972); life and work of the leader of the Record Photography movement which attempted to document late Victorian life and surroundings.

——*Victorian Cameraman: Francis Frith's View of Rural England 1850–1898* (1973).

——*Victorian Candid Camera: Paul Martin 1864–1944* (1973).

Edgar Yoxall Jones, *Father of Art Photography: O. G. Rejlander 1813–1875* (1973).

Beaumont Newhall, *William H. Jackson* (1974); America's most famous Western photographer.

Graham Ovenden (intro. by M. Henderson) *Hill & Adamson Photographs* (1973); Scottish calotypists of the late 1840s.

Tristram Powell (ed) *Famous Men and Fair Women; Victorian Photographs by Julia Margaret Cameron* (1926; 1973).

H. Baden Pritchard, *About Photography and Photographers* (1883; 1973). *The Photographic Studios of Europe* (1882; 1973); articles by a Victorian journalist which first appeared in the weekly *Photographic News,* London.

Bill Egdon Shaw, *Frank Meadow Sutcliffe* (1974); the work of a distinguished but little known Yorkshire photographer of the late nineteenth century.

Henry J. Rodgers, *Twenty-Three Years Under a Skylight* (1872; 1972); memoirs of an or-

dinary small-town photographer in the Eastern U.S.

John Thomson, *Street Life in London* (1877; 1969); a pioneer work of photo-documentary.

Arnold H. Wall, *Artistic Landscape Photography* (1896; 1973); a compilation of articles published in the nineteenth-century photographic journals.

Gordon Winter, *A Country Camera 1844–1914* (1966); revealing but unpretentious photographs made by a variety of—usually—unknown hands.

INDEX